ESSAYS ON THE BLURRING
OF ART AND LIFE

The Publisher
wishes to acknowledge
with gratitude the generous
support of the
Lannan Foundation
in funding the
Lannan Series of Contemporary Art Criticism,
which is devoted to presenting
the writing of contemporary
critics as well as that of
early writers who helped
to shape contemporary
art criticism.

I

Sadakichi Hartmann: Critical Modernist
edited by Jane Calhoun Weaver

II

The Hydrogen Jukebox: Selected Writings of Peter Schjeldahl
edited by MaLin Wilson

III

Allan Kaprow, *Essays on the Blurring of Art and Life*
edited by Jeff Kelley

ESSAYS ON
THE BLURRING OF
ART AND LIFE

ALLAN KAPROW

Edited by Jeff Kelley

UNIVERSITY OF CALIFORNIA PRESS

BERKELEY LOS ANGELES LONDON

University of California Press
Berkeley and Los Angeles, California

University of California Press, Ltd.
London, England

Library of Congress Cataloging-in-Publication Data
Kaprow, Allan.
 Essays on the blurring of art and life / Allan Kaprow ; edited by
Jeff Kelley.
 p. cm. — (Lannan series of contemporary art criticism ; 3)
 Includes bibliographical references and index.
 ISBN 0-520-07066-6
 1. Arts, American. 2. Arts, Modern—20th century—United States.
 I. Kelley, Jeff. II. Title. III. Series.
 NX504.K36 1993
 700′.973′09045—dc20 93-18080

Printed in the United States of America
9 8 7 6 5 4 3 2 1

The paper used in this publication meets the minimum requirements of
American National Standard for Information Sciences—Permanence of Paper
for Printed Library Materials, ANSI Z39.48-1984. ♾

CONTENTS

ILLUSTRATIONS

ACKNOWLEDGMENTS

The idea for this book, which is long overdue, grew out of a retrospective "exhibition" of Allan Kaprow's Happenings, called Precedings, that I organized for the Center for Research in Contemporary Art at the University of Texas at Arlington in 1988. Funded by the Lannan Foundation, Precedings raised ironic questions about the nature of an artist's career and how it is remembered in the history and community of art—especially if no objects remain from that career. In this case, it was the artist who remembered—who retrospected—thereby making obvious the fragility of human memory and the contingency of official history. He interpreted—he reinvented—his own career, which exists as a kind of art-world fiction anyway.

For all their art-world infamy, the Happenings of the late fifties and early sixties were attended/experienced by relatively few. But to the extent that they played into a counter-cultural need for a new (or perhaps ancient) communal, youthful performative space, what began as works of avant-garde art had become, by 1966, everything from anti-war protests and Bobby Kennedy to "life" itself. Sensing the obsolescence of his newly invented art form as early as 1961, Kaprow wrote: "Some of us will probably become famous. It will be an ironic fame fashioned largely by those who have never seen our work." He was right. Happenings soon became a species of mythology, the subjects of rumor or gossip. Hoping to prolong his experiment into the meanings of everyday life, Kaprow reconciled himself to letting go of the avant-garde genre he'd become identified with, confessing: "I shouldn't really mind, for as the new myth grows on its own, without reference to anything in particular, the artist may achieve a beautiful privacy, famed for something purely imaginary while free to explore something nobody will notice."

Indeed, as the century draws to a close, one still hears the question, "What ever happened to Allan Kaprow?" Life has happened to Allan Kaprow, his life, "something nobody will notice," and it has happened

to him as the subject matter of his practice as an artist. Instrumental to that practice has been his writing, which might be thought of as notes on the margins of an experimental career. Given the absence of conventional works of art from that career, these essays constitute perhaps its most visible aspect, the intellectual, nonexperimental reflections on experiments in "lifelike" art. They may provide us the best opportunity for retrospection that Kaprow will allow. It has been a privilege to compile them.

That privilege must be shared with those who have helped make this book: Bonnie Clearwater, who, as the executive director of the Lannan Foundation in 1987, helped fund Precedings and identified the University of California Press as a publisher that might be interested in this book; Scott Mahler, who was the first editor at UC Press to take an interest in Kaprow's writing and work; Deborah Kirshman, the clear-minded editor and gentle taskmaster for what this project has finally become; Peter Selz, whose ongoing interest in my thinking as I was trying to sort it out was a source of great faith; Hung Liu, to whom I am married, whose friendship with Kaprow and whose marriage to me have helped keep my relationship with this project in balance; and, finally, Allan Kaprow himself, whose book this really is. His work, his openness, his advice, and his friendship have written themselves across the margins of my life these past few years. Though I first met him in 1970, during a Happening at Cal Arts, and though I later attended the University of California, San Diego, where he taught, only recently has his influence made my life more meaningful. That is the nature of elders: they are always around, doing something nobody will notice until, as adults, we suddenly feel the need for their memory and experience, for which no other version of history will do. Allan Kaprow is such an elder. As the twentieth century ends, perhaps it is time for us to begin noticing what he's been thinking about all these years—in his "beautiful privacy."

INTRODUCTION

We all make notes to ourselves between the lines and along the margins of our favorite books. Often such notes—in their scribbles and abbreviations—belie our urgency about holding on to insights before they fall back between the pages of the book or into the fissures of the mind. We assume that we will use them later, but mostly we forget. If we run across them some years hence, they seem like half-decipherable artifacts of prior thought, less urgent, more hasty, than we recall.

But with some, we rewrite the book in terms of ourselves. We distill a clause from a paragraph, and if it resonates with whatever else we read and write and think and do, it becomes in time an operating principle, a philosophical stance. Allan Kaprow took his stance in the yellowed margins of a small black book that looks as if it had been checked out of a library thirty years ago and never returned. It is *Art as Experience* by the American philosopher John Dewey, and in it, around 1949, the young, ambitious artist and philosophy graduate student penciled in his thoughts as he read, including, among many, such phrases as "art not separate from experience . . . what is an authentic experience? . . . environment is a process of interaction." While skipping across the surface of Dewey's broad ideas, these inscriptions nonetheless carry a certain weight, like subheadings for pages not yet written. One feels in them the tug of re-cognition as it pulls the artist away from the philosopher's text and toward the margins, where his own thinking begins to take shape. With these and other scribbles, Kaprow grounds himself in American pragmatism and forecasts the themes of his career.

Not that he knew it at the time. In fact, Kaprow found Dewey confusing at first. The philosopher's "categories" weren't clear: mind and body, knowledge and experience, subject and object were all mixed up. They kept circulating through Dewey's writings like reminders of what philosophy was supposed to be seeking. For Dewey, intelligence and values were matters of adaptation to human needs and social

circumstances that arise from "the particular situations of daily life." Indeed, Dewey reconceived philosophy itself as an intellectual expression of conflicts and choices *in* culture. This was not, initially, what the young artist-scholar was looking for. He wanted categories that were clear.

But Dewey was as inelegant as culture itself, for what he had said was that the arts, as practiced in the industrial West, had set themselves apart from the experiences of everyday life, thereby severing themselves from their roots in culture and human nature: "Objects that were in the past valid and significant because of their place in the life of a community now function in isolation from the conditions of their origin." While this severance perhaps indicated a deeper split in Western culture between matters spiritual and practical, its effect on the modern arts had been to idealize "esthetic" experience by assigning it to certain classes of culturally sanctioned objects and events. These, in turn, were sequestered from the currents of communal life according to the boundaries of taste, professional expertise, and the conventions of presentation and display. For artists, communal memory, ceremonial place, and ritual action were transformed into historical time, esthetic space, and artistic intention. Indeed, even the capacity to *have* an esthetic experience had been estheticized, becoming the purview of experts. Thus severed from its genius loci, art per se became the exclusive site of esthetic experience.

For most of his career, Allan Kaprow has been working to shift that site from the specialized zones of art toward the particular places and occasions of everyday life. For him the modernist practice of art is more than the production of artworks; it also involves the artist's disciplined effort to observe, engage, and interpret the processes of living, which are themselves as meaningful as most art, and certainly more grounded in common experience. (In fact, they *are* common experience.) Although famous first as the inventor of Happenings—a late-fifties art form in which all manner of materials, colors, sounds, odors, and common objects and events were orchestrated in ways that approximated the spectacle of modern everyday life—and since then as a stubborn avant-gardist who, like a spy behind enemy lines, keeps reversing the signposts that mark the crossroads between art and life, Kaprow might best be described as an artist who makes lifeworks. For him, the contents of everyday life—eating strawberries, sweating,

shaking hands when meeting someone new—are more than merely the subject matter of art. They are the meaning of life.

Since 1953 Allan Kaprow has been writing about the meaning of life. In that time, which spans the contemporary history of American art, he has published over sixty essays, pamphlets, artist's statements, and a book (*Assemblages, Environments, and Happenings*, 1966). Taken together, his writings represent a sustained philosophical inquiry into the nature of experience and its relationship to the practice(s) of art in our time. They show us the author's development as an artist as well as developments in contemporary art from the author's perspective. That perspective—across the space of four decades—is unique in taking its measure of life's meanings from outside art and inside common experience. Because Kaprow sees most art as a convention—or a set of conventions—by which the meanings of experience are framed, intensified, and interpreted, he attends as an artist to the meanings of experience instead of the meanings of art (or "art experience"). Because the meanings of life interest him more than the meanings of art, Kaprow positions himself in the flux of what Dewey called "the everyday events, doings, and sufferings that are universally recognized to constitute experience."

The contemporary history of American art is also the history of how contemporary experience has changed. Because experience for Kaprow is the medium of his practice—contracting and expanding into the most intimate and communal spaces and occasions—changes in its fabric since 1950 have necessarily wrought changes in his practice as an artist. When he first began to write—which is also when he was making abstract paintings with bits of torn paper melded into their surfaces and when he was studying art history with Meyer Schapiro at Columbia—television had not yet transformed our private spaces into spheres of disembodied pseudo-public spectacle, communications technology was still largely anchored to an industrial infrastructure, there was no question of depletable resources or greenhouse gases, computers were primitive at best, people still watched newsreels in local theaters, feminism was something from the twenties, we had not yet gone into space (nor had the Russians), cars had steel dashboards and no seat belts, and in general we believed our own press as Americans. As a society, we were less aware than we are now of the depth of our discontent, although racism, addiction, and violence within the

family were rampant. Nearer the realms of art, New York was the art world's new capital, and one or two critics held sway. Out on Long Island, Jackson Pollock was flinging skeins of paint across canvases laid out on the floor of his barn, and the points where that slick black enamel overshot the edge of the canvas marked the boundaries of avant-garde experience at that moment.

One of the themes of Kaprow's essays is the changing nature of experience with the rise and proliferation of mass "communications" technologies and the corresponding ascendancy of the "image" in both art and communal—or at least commercial—life. As an artist who grounds his art in an interpretive interplay of body and mind, of doing and reflecting on what has happened, Kaprow approaches new technologies openly, even optimistically at first, sensing in their networks and reverberations a new capacity for art to reach out beyond its conventional limitations; indeed, it was his interest in experimental music that brought him to John Cage's class in 1957. Yet insofar as those technologies reinforce the passive/receptive role of an audience in relation to a performer—and in fact inscribe that power relation into the future they represent—Kaprow ends by backing away from their slick appeal and even criticizing artists' unimaginative use of them and the ways they preempt actual participation. What he wants is more than the "scatter" phenomenon in which modern materials (as in Robert Morris's felt pieces of the late sixties) and modalities (as in the video experiments of the early seventies) disperse energy and fragment perspective in reaction to the rectangular shape of the gallery. In other words, he wants more than antiformalism: he wants the shapes, thresholds, and durations of experience itself—the conventions of consciousness and communal exchange, whether personal habits or a Labor Day parade—to provide the frames in which the meanings of life may be intensified and interpreted. Briefly seduced by the allure of new technologies, Kaprow ultimately sees them as theoretical models—or, better yet, as metaphors of feedback and interactivity—for a truly participatory art with its sources in everyday experience.

Like many of his generation, Kaprow wanted a "new concrete art" to replace the old abstract order—an order articulated in the writings of Clement Greenberg and by then known as formalism. More a brand of American esthetic fundamentalism than a critical theory, formalism advocated the systematic elimination of any and all artistic conventions not essential to the viability of a given medium (mostly painting).

Storytelling, for example, or political subject matter would be peeled away from the surfaces of modern art, revealing the deeper existential tensions of the object itself. In typical American fashion, art was reduced to a physical criterion, which was then elevated to a metaphysical condition by an evangelical monologue.

Kaprow's views on formalism are more complex and go to the question of experience. Not simply an antiformalist—that is, one who "replaces the appearance of order with the appearance of chaos"—he maintains a Platonic faith in the "vaguely mystical attributes" of forms at the same time that he rejects the "dreary formulas" of academicism by which tasteful art is produced. Still, he sees the historical contest between form and antiform—a metaphor of the ancient struggle between reason and madness, heaven and hell—as finally irrelevant to the indeterminancy of modern experience. "At its root," he writes, "the problem with a theory of form is its idea of wholeness," and "when it turns out that the whole can't be located precisely . . . either all hell has broken loose or we're in another ball game." That new ball game is our unprecedented experience of the shrinking planet and the "urgent fantasies of integration, participation, and signification" such experience brings about. And with it, perhaps, we come to know a new kind of madness—eco-systemic?—for which reason and order are no longer cures. In the last analysis, Kaprow regards the very idea of form as "too external, too remote," to inform a time when artists must look to the "nonart models" of communication for insight into the changing nature of experience.

In "The Education of the Un-Artist, Part III," from 1974, Kaprow writes, "The models for the experimental arts of this generation have been less the preceding arts than modern society itself, particularly how and what we communicate, what happens to us in the process, and how this may connect us with natural processes beyond society." What an elegant and pragmatic set of measures. Perhaps they constitute the priorities of modern experience. As a sequence, they mark stages in the acquisition of consciousness, knowledge, and meaning. What else would one want to know besides the eternal and unanswerable *Why?* And is it not compelling that this set of priorities—a means and a message, a process of transformation, and the hope of transcendence—though drawn from society rather than art, still sounds a lot like what artists do?

In this essay Kaprow identifies five models of communication,

rooted in "everyday life, and nonart professions, and nature," that may function as alternative ways of conceiving the creative enterprise. These are situations, operations, structures, feedback, and learning—or commonplace environments and occurrences, how things work and what they do, systems and cycles of nature and human affairs, artworks or situations that recirculate (with the possibility of change and inter-action), and processes like philosophical inquiry, sensitivity training, and educational demonstrations. Although Kaprow locates these models in the works of other artists, it is clear that as a cluster they constitute his own measure of experience.

But in 1949 his measures were less clear, and Dewey's "unclear categories" provoked more questions than answers. On page eleven of *Art as Experience* Kaprow underlined a passage that reads, "Even a crude experience, if authentically an experience, is more fit to give a clue to the intrinsic nature of esthetic experience than is an object already set apart from any other mode of experience." Next to this passage he scribbled the question, "What is an authentic experience?" One senses here a slight frustration, born less of a philosophical interest in esthetics than of a young artist's confusion about the nature of experience itself—which makes sense, coming at a time when the au-thenticity of the artist's experience was said to be the mythic content of modern Expressionist painting (the kind of painting Kaprow then did). Out of this frustration, though—and out of the question it pro-voked in Kaprow's mind—came a subtle shift in emphasis away from art and esthetics toward the "categories" of everyday life. Though his search was masked at the time as a nearly romantic quest for authen-ticity, Kaprow—the life-long pragmatist—was looking for analogues of art in nonart experience. Perhaps reading Dewey deflected him from artistic statements and toward pragmatic questions. In any case, he found his analogues several chapters later.

There, in an insight rooted in good common sense, Dewey con-trasted the often inchoate flow of experience in general with *an* ex-perience, whose boundaries, density, and duration set it apart, giving it particular qualities and a sense of internal volition that make it memorable. "A piece of work," he writes, "is finished in a way that is satisfactory; a problem receives its solution; a game is played through; a situation, whether that of eating a meal, playing a game of chess, carrying on a conversation, writing a book, or taking part in a political campaign, is so rounded out that its close is a consummation and not

a cessation." For Dewey, experiences could have an emotionally satis-
fying sense of "internal integration and fulfillment reached through
ordered and organized movement"—that is, they could have esthetic
qualities. Though Kaprow was less interested than Dewey in esthetics
per se, the idea that experiences could have shapes, beginnings and
ends, "plots," moods, patterns—meanings—must have influenced him
deeply, leading him as a practicing artist to a philosophical inquiry into
the given natural and/or social "forms" of common experience. A
quarter-century later, his five models of communication emerged as
the core curriculum in the education of the un-artist.

It is in this sense that Kaprow is a formalist. A work of art, like
an experience, has its limits; the questions are, what kind of limits and
do they model themselves after those in other art or in life? The
difference between Kaprow's sense of form and the brand of formal-
ism that continues to dominate academic thinking across the land is
that for him forms are provisional. Academic formalism, by contrast,
is finally a secular essentialism driven by a closed fundamentalist belief
system intent on self-purification through rituals of rational renunci-
ation (what better monkishness for the late-modernist academy?). If
Greenberg had written of a modernist "law" by which conventions
not essential to the validity of a medium "be discarded as soon as they
are recognized," then Kaprow turned that prescription on its head—
not by resorting to chaos, but by setting out to systematically eliminate
precisely those conventions that *were* essential to the professional iden-
tity of art (a reverse renunciation). In their place he embraced the
conventions of everyday life—brushing teeth, getting on a bus, dress-
ing in front of a mirror, telephoning a friend—each with its own
formal, if provisional, integrity. Ultimately, Kaprow's notion of
"forms" is that they are mental imprints projected upon the world as
metaphors of our mentality, not as universal ideals. Templates for
modern experience, they are situational, operational, structural, subject
to feedback, and open to learning.

Implicit in the provisional nature of these templates is Kaprow's
faith in the communicative function of art. But in the arts, commu-
nication tends to flow in one direction, from the artist through a me-
dium toward an audience. We the audience find we've been "com-
municated" to, and what has been communicated to us is something
of the artist's creative experience. But implicit in communication is a
reciprocal flow, and reciprocity in art, more verb-like than noun-like,

begins to move esthetic experience toward participation. Of course, we can say that any artwork, no matter how conventional, is "experienced" by its audience, and that such experience, which involves interpretation, constitutes a form of participation. But that's stretching common sense. Acts of passive regard, no matter how critical or sophisticated, are not participatory. They are merely good manners (esthetic behavior?).

Actual participation in a work of art courts anarchy. It invites the participant to make a choice of some kind. Usually that choice includes whether to participate. In choosing to participate, one may also be choosing to alter the work—its object, its subject, its meaning. In choosing not to participate, one has at least acted consciously. In either case, the work has been acted upon (which is different from thinking about acting). Though the artist sets up the equation, the participant provides its terms, and the system remains open to participation. To Kaprow, participation is whole: it engages both our minds and bodies in actions that transform art into experience and esthetics into meaning. Our experience as participants is one of meaningful transformation.

If a central theme runs through Kaprow's essays, it is that art is a participatory experience. In defining art as experience, Dewey attempted to locate the sources of esthetics in everyday life. In defining experience as participation, Kaprow pushed Dewey's philosophy—and extended his own measures of meaningful experience—into the experimental context of social and psychological interaction, where outcomes are less than predictable. Therein, the given natural and social forms of experience provide the intellectual, linguistic, material, temporal, habitual, performative, ethical, moral, and esthetic frameworks within which meaning may be made.

From his vantage point in the thirties Dewey saw the task ahead as one of "recovering the continuity of esthetic experience with the normal processes of living." For him, that continuity lay in the recognition that refined esthetic consciousness is grounded in the raw materials of everyday life, the recovery of which would require an excavation of the sources of art in human experience. Yet to many American artists of the thirties Dewey's philosophy of art and experience seemed like an isolationist call to reject European modernism and return to the themes and styles of urban and rural commonness. Indeed, some of Dewey's descriptions of the sources of the esthetic in

everyday life might have come out of the paintings of Sloan or Shahn or Sheeler or Benton: "the sights that hold the crowd—the fire-engine rushing by; the machines excavating enormous holes in the earth; the human-fly climbing the steeple-side; the men perched high in air on girders, catching and throwing red-hot bolts." Scenes like these appealed to American regionalists. They were modern but not European, hence not modern*ist*. Still, if they'd been scripted by the Italian Futurist Marinetti, they would have sounded like a mechanistic opera in a cult of the machine. With Dewey, the firemen and crane operators and window washers and welders are in there, rushing and balancing and climbing and tossing; his writing is about their experience. We hear Gershwin.

And we also hear Kaprow. In 1958 he wrote "The Legacy of Jackson Pollock," his first important essay. Its subject is a threshold Pollock could not cross but probably "vaguely sensed" and constantly brushed up against. It existed where the edge of the canvas met the floor (or the wall, if the picture was hanging). Across that edge Pollock flung endless skeins of paint, each one reaching past the representational "field" of painting to encompass the space—no, the place— beyond it. Literally, that place was the artist's studio; metaphorically, it was the boundary of avant-garde experience and quite possibly the end of art.

"The Legacy of Jackson Pollock" remains for some Kaprow's seminal essay. It is certainly his most prodigious and prophetic. Indeed, it may have done more to actually change art than any essay of its era. It is both a eulogy and a manifesto, reflecting back but leaping forward. With its strategic use of "we," it presumes to speak for a generation. With its lines of prosaic description, it threatens to break into a grand but common prayer. This is Kaprow coming down off the mountain, rewriting the book on Pollock, setting the stage for what he's about to do as a Happener—with cardboard, chicken wire, crumpled newspaper, broken glass, record players, recorded sounds, staccato bursts of words, and the smell of crushed strawberries.

What Kaprow saw in Pollock was a stillborn desire, secretly held by his own generation, to "overturn old tables of crockery and flat champagne." At the same time, he pointed out that the great painter's death came, not "at the top," but when both Pollock and "modern art in general [were] slipping." Kaprow saw in this slippage a pathetic tragedy opening into a profound comedy. The tragedy, not Pollock's

alone, was that of art's growing incapacity to be about, in, and of the rest of life—an effect of the proscriptive climate enforced by formalist art critics. In a penetrating insight Kaprow, then not yet thirty, wrote that "Pollock's tragedy was more subtle than his death," seeing a leap Pollock had sensed but not taken. For pulling back from that leap—into the environmental and performative implications of Pollock's "overall" paintings—or for not knowing how or even whether to proceed beyond the space he had made for himself, the great painter drank and drove himself to his death.

After pausing respectfully at that monumental threshold, Kaprow took the leap for him: beyond the media of art and into the objects and materials of everyday life; beyond the space of painting and into the places of human social exchange; and beyond the actions of the artist and into a shared moral environment where every act, whether conscious or incidental, has meaning. For Kaprow, these were the esthetic dimensions of common experience, which was itself the profound comedy he found beyond the space of Pollock's painting.

In one of the few examples of art writing as prophecy, Kaprow surveys the scene beyond the entangled web of Pollock's painting, two years after the great painter's death and one year before the first Happening:

> Pollock, as I see him, left us at the point where we must become preoccupied with and even dazzled by the space and objects of our everyday life, either our bodies, clothes, rooms, or, if need be, the vastness of Forty-second Street. Not satisfied with the suggestion through paint of our other senses, we shall utilize the specific substances of sight, sound, movements, people, odors, touch. Objects of every sort are materials for the new art: paint, chairs, food, electric and neon lights, smoke, water, old socks, a dog, movies, a thousand other things that will be discovered by the present generation of artists. Not only will these bold creators show us, as if for the first time, the world we have always had about us but ignored, but they will disclose entirely unheard-of happenings and events, found in garbage cans, police files, hotel lobbies; seen in store windows and on the streets; and sensed in dreams and horrible accidents. An odor of crushed strawberries, a letter from a friend, or a billboard selling Drano; three taps on the front door, a scratch, a sigh, or a voice lecturing endlessly, a blinding staccato flash, a bowler hat—all will become materials for this new concrete art.

Much of Kaprow's early work emerges from this paragraph: but if it points to Happenings, the genre that would make him famous, it also marks his passage as a writer. Its rhythms play out the parallel creative forces that have governed Kaprow's writing ever since—of empiricist and expressionist, scientist and prophet, academic and visionary, statistician and storyteller. Stylistically these parallels manifest themselves, on the one hand, as a patient, even tedious, accumulation of observable data—for example, "In short, part-to-whole or part-to-part relationships, no matter how strained, were a good 50 percent of the making of a picture (most of the time they were a lot more, maybe 90 percent)"—and, on the other, as a liberating, almost biblical, surge of passion, as when, caught up in a moment of avant-garde exuberance, Kaprow expanded the horizons of his new environmental art to include even "the vastness of Forty-second Street." At least through the essays of the sixties detailed observation suddenly gives way to blinding insights and flights of risky intuition. One senses here the threshold Pollock could not cross, which Kaprow has been crossing ever since.

In 1966 Kaprow wrote that if the task of the artist had once been to make good art, it was now "to avoid making art of any kind." A few years later, in the first of the "Un-Artist" essays, he wrote that nonart—lint gathering on the floor, the vapor trail of a missile—"is whatever has not yet been accepted as art but has caught an artist's attention with that possibility in mind." Between these rhetorical positions—the avoidance of art and the impossibility of avoiding nonart—lay an experimental ground where artists might forget their professional identity and art might lose itself in the paradox of being whatever else, besides art, it is like, whether sociology, therapy, or shopping. The prolongation of this paradoxical condition was the un-artist's goal.

From his vantage point in the early seventies Kaprow saw the task ahead as one of restoring "participation in the natural design through conscious emulation of its nonartistic features." In the second of his "Un-Artist" essays he charted a course from art to life that began with copying, moved through play, and ended with participation. Nonart, he said, was an art of resemblance in which an "old something" is re-created as a "new something that closely fits the old something." In other words, it's a thoughtful form of copying. Moreover, because life imitates itself already—city plans, for instance, are like the human

circulatory system and computers are like the brain—nonart is a matter of imitating imitation (this a decade before deconstruction). Given the mythologies of originality that underwrite the avant-garde, what better means of escaping "art" than by copying?

If there is a dirtier word than *copying* in the lexicon of serious art, Kaprow thinks it must be *play*. With its connotations of frivolity and childishness, play seems the antithesis of what artists are supposed to do. But Kaprow has always sought a certain innocence in his work, inviting humor and spontaneity, delighting in the unexpected. For him, play is inventive, and adults must be endlessly inventive to remember how to do it. Play is also instructive, since it imitates the larger social and natural orders: children play to imitate their parents' behavior and rules, societies to reenact ancient dramas and natural schemes. As a ritual reenactment of what Johan Huizinga calls "a cosmic happening," play at its most conscious level is a form of participation. As such, Kaprow sees it as a remedy for what he calls gaming (the competitive, work-ethical regulation of play) as well as for the ossifying routines and habits of industrial-age American education, which have less to do with learning and fun than with the "dreadfully dull work" of "winning a place in the world." With the work of art as a "moral paradigm for an exhausted work ethic," and with play as a form of educational currency that artists can afford to spend, Kaprow completes the education of the un-artist by assigning a new social role, that of the educator, a role in which artists "need simply play as they once did under the banner of art, but among those who do not care about that. Gradually," he concludes, "the pedigree 'art' will recede into irrelevance."

Is participation, then, the threshold at which art recedes into irrelevance? To participate in something is to cross the psychological boundaries between the self and other and to feel the defining social tensions of those boundaries. The experience of participating—especially when it is catalyzed in play—transforms the participant as well as the game. Participatory art dissipates into the situations, operations, structures, feedback systems, and learning processes it is like. In scanning the history of art, Kaprow likes to remember those strains of modernism that keep trying to lose themselves, playfully, in whatever else they are like. As an artist, he holds himself accountable for the thresholds he crosses. He is a true avant-gardist who actually follows

through on the crossings he invites himself to make—and invites us to participate in making.

Perhaps the most important measure of Dewey's influence lies in Kaprow's chosen identity as an "experimental artist," as one, that is, who tries to "imagine something never before done, by a method never before used, whose outcome is unforeseen." Such an artist commits to an experimental method over an inspirational medium or a determining style or product. Unlike the common definition of art—as a process and product that slides back and forth along a scale from the noun-like to the verb-like—Kaprow's definition of experimental art links it to experiences outside art, suggesting that he believes in the meaningfulness of all experience and of any art that might account for it. As an experimental artist he accounts for that meaningfulness with method.

Method is a style of making that tends toward the quantifiable and the mundane rather than toward the expression of extraordinary qualities. It is more like observation or calculation than revelation. As such, method allows Kaprow to replace the classical and romantic paradigms of art-style with the order and chaos of common experience, which is already full of life-style. Independent of the art meanings of medium, style, and history, method permits an engagement with the meanings of everyday life. Although not neutral—it is characterized by the problem-solving ideology of scientific optimism that was also Dewey's ideology—it is relatively flat compared with the subject matter it measures. It is the style, not of the artist-genius, but of the artist-accountant.

Accounting for the meanings of experience, however, can itself be a ritual act, its pragmatism an act of common faith. To carry cinder-blocks up and down the stairwell of a university art department until you've counted the number of years in your life, staying with each block for "a long time," is to experience the disintegration of a methodical act into an obsessive autobiographical rite. Method becomes a discipline by which experience is shaped and interpreted. It is a pragmatic version of the creative "act." Meaning emerges, not from the enactment of high drama, but from the low drama of enactment—not from the content in art, but from the art in content. Carry enough cinderblocks, follow the plan, and meaning will emerge. That is the common faith Kaprow has.

If Dewey's influence upon Kaprow can be reduced to a single phrase, it would be that "doing is knowing." What Kaprow hopes to know is the meaning of everyday life. To know that meaning, he must enact it every day. This is where pragmatism becomes a practice. Trust in the instrumentality of ideas, in the effectiveness of action, in the validity of experience, in the reality of the senses, in the contingency of values, and in the value of intuition is not merely "materialism." Though often seen as a crude nuts-and-bolts philosophy—especially by Europeans—American pragmatism can also be a methodical verification of existence.

A methodical verification of existence takes sustenance from Zen. Like Dewey's pragmatism, Zen mistrusts dogma and encourages education, seeks enlightenment but avoids formalist logic, accepts the body as well as the mind, and embraces discipline but relinquishes ego-centered control. In establishing discipline as a contemplative practice that opens the practitioner to knowledge, Zen loosely parallels the scientific method, in which controls are established in an experimental process that opens the researcher to phenomena. For Kaprow, pragmatism is the mechanics of Zen, and Zen the spirit of pragmatism.

In the late fifties the experimental music of John Cage best exemplified for Kaprow the merger of Zen and science, of passive contemplation and active experimentation. In Cage's music, the role of the artist shifted from that of the prosecutor of meaning to that of the witness of phenomena. Ironically, by eliminating traditional musical "discipline" from his performances, Cage appealed to another discipline: that of waiting, listening, and accepting. Though the link between Zen and Cagean esthetics is well known in the American arts, it was Dewey's pragmatism that best prepared Kaprow to accept it as method.

In "The Meaning of Life" Kaprow writes that "lifelike art plays somewhere in and between attention to physical process and attention to interpretation." The object of such attention is consciousness in its fullest sense. This sense of fullness is probably what Dewey found esthetic about experience. Ultimately, for Kaprow, it was not esthetics that gave meaning to life; it was life that gave meaning to esthetics. If his youthful ambition was once to be the "most modern artist in the world," Kaprow's mature achievement has been to shift the emphasis of that ambition from "most modern" to "in the world," *without* conceding his identity as an artist.

The history of that shift is the story of Kaprow's writing. His subjects evolved from avant-garde art to everyday life, his style from manifesto to parable, his eye from empiricist to witness, his body from expansionist to holist, his memory from historian to storyteller, his mind from intelligence to wisdom, and his heart from near-biblical surges of passion to passages of Zen-like contemplation. In these strains of emphasis one can hear Kaprow's primary influences, including Hans Hofmann (who gave him the compositional forces of "push and pull"), Meyer Schapiro (who taught him the value of a detailed formal and social analysis of art and art history), Marcel Duchamp (who, at a distance, left him the readymades), and, of course, John Cage (who inspired in him the discipline to sit back and watch it all happen).

But through them all one hears Dewey: his distinction between understanding and experiencing, his poetic feel for the prosaic textures of everyday experience, his embrace of scientific method, his critique of the institutions and conventions that separate art from life, his belief in progressive education, the often Coplandesque sweep of his ideas and the often Whitman-like roll of his prose, his willingness to forget art for the time it takes to remember esthetic experience "in the raw," his trust in the given social and organic outlines of experience, and his conviction that values emerge from social conflict, that intelligence is situational, and that philosophy can be socially diagnostic. Substitute a word here and there—say, *art* for *philosophy*—and these might be Kaprow's themes as well.

Art not separate from experience . . . what is an authentic experience? . . . environment is a process of interaction: by writing in the margins of Dewey's book, Kaprow set up theoretical thresholds that he would someday have to cross. In the years since he wrote his marginalia, writing itself has become instrumental to those crossings. As an experimental artist, Kaprow has written to hypothesize and interpret experiments in the meaning of life. Those experiments, as works of lifelike art, are intended to probe, test, and measure the boundaries and contents of experience. In turn, they are subjected to the test of rational analysis through language. The doing and the writing seem to move each other along—they are reciprocal, perhaps even causal, the way ideas and experiences resist and temper each other over time. As Dewey believed that ideas are instruments for dealing effectively with concrete situations, Kaprow sees language as a means to under-

stand the barriers of mind that segregate esthetic from everyday experience—not for the sake of philosophy, or for the life of the mind alone, but to facilitate meaningful action in life.

Though he is never mentioned in the writing, John Dewey is Allan Kaprow's intellectual father. Whereas the others were his mentors, the philosopher was his elder. Mentors guide us in our youth, and, though we remember them fondly, we outgrow their influence awkwardly. We can choose our elders, by contrast, only when we are adults—when choice is meaningful. We may stumble upon them too early, but once we have chosen them, they will never leave. Perhaps one of the reasons they stay is that we never tell them who they are for us, either because they're dead or busy or famous or far away. In fact we rarely meet them, inscribed as they are on the margins of our lives. But they *are* the mothers and fathers we would have chosen had we known.

Jeff Kelley
Oakland, California
1992

PART ONE

THE FIFTIES

The Legacy of Jackson Pollock
(1958)

The tragic news of Pollock's death two summers ago was profoundly depressing to many of us. We felt not only a sadness over the death of a great figure, but also a deep loss, as if something of ourselves had died too. We were a piece of him: he was, perhaps, the embodiment of our ambition for absolute liberation and a secretly cherished wish to overturn old tables of crockery and flat champagne. We saw in his example the possibility of an astounding freshness, a sort of ecstatic blindness.

But there was another, morbid, side to his meaningfulness. To "die at the top" for being his kind of modern artist was to many, I think, implicit in the work before he died. It was this bizarre implication that was so moving. We remembered van Gogh and Rimbaud. But now it was our time, and a man some of us knew. This ultimate sacrificial aspect of being an artist, while not a new idea, seemed in Pollock terribly modern, and in him the statement and the ritual were so grand, so authoritative and all-encompassing in their scale and daring that, whatever our private convictions, we could not fail to be affected by their spirit.

It was probably this sacrificial side of Pollock that lay at the root of our depression. Pollock's tragedy was more subtle than his death: for he did not die at the top. We could not avoid seeing that during the last five years of his life his strength had weakened, and during the last three he had hardly worked at all. Though everyone knew, in the light of reason, that the man was very ill (his death was perhaps a respite from almost certain future suffering) and that he did not die as Stravinsky's fertility maidens did, in the very moment of creation/annihilation—still we could not escape the disturbing (metaphysical) itch that connected this death in some direct way with art. And the

connection, rather than being climactic, was, in a way, inglorious. If the end had to come, it came at the wrong time.

Was it not perfectly clear that modern art in general was slipping? Either it had become dull and repetitious as the "advanced" style, or large numbers of formerly committed contemporary painters were defecting to earlier forms. America was celebrating a "sanity in art" movement, and the flags were out. Thus, we reasoned, Pollock was the center in a great failure: the New Art. His heroic stand had been futile. Rather than releasing the freedom that it at first promised, it caused not only a loss of power and possible disillusionment for Pollock but also that the jig was up. And those of us still resistant to this truth would end the same way, hardly at the top. Such were our thoughts in August 1956.

But over two years have passed. What we felt then was genuine enough, but our tribute, if it was that at all, was a limited one. It was surely a manifestly human reaction on the part of those of us who were devoted to the most advanced artists around us and who felt the shock of being thrown out on our own. But it did not seem that Pollock had indeed accomplished something, both by his attitude and by his very real gifts, that went beyond even those values recognized and acknowledged by sensitive artists and critics. The act of painting, the new space, the personal mark that builds its own form and meaning, the endless tangle, the great scale, the new materials are by now clichés of college art departments. The innovations are accepted. They are becoming part of textbooks.

But some of the implications inherent in these new values are not as futile as we all began to believe; this kind of painting need not be called the tragic style. Not all the roads of this modern art lead to ideas of finality. I hazard the guess that Pollock may have vaguely sensed this but was unable, because of illness or for other reasons, to do anything about it.

He created some magnificent paintings. But he also destroyed painting. If we examine a few of the innovations mentioned above, it may be possible to see why this is so.

For instance, the act of painting. In the last seventy-five years the random play of the hand upon the canvas or paper has become increasingly important. Strokes, smears, lines, dots became less and less

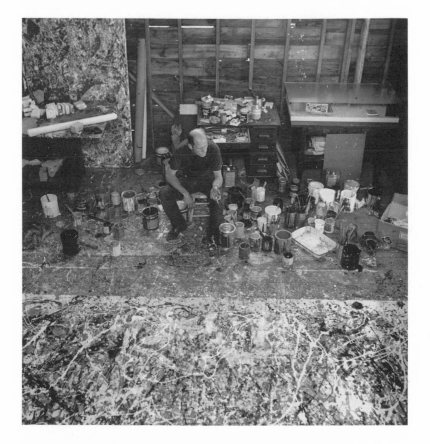

Fig. 1 Jackson Pollock in his studio, 1950. *Photograph by Hans Namuth.*

attached to represented objects and existed more and more on their own, self-sufficiently. But from Impressionism up to, say, Gorky, the idea of an "order" to these markings was explicit enough. Even Dada, which purported to be free of such considerations as "composition," obeyed the Cubist esthetic. One colored shape balanced (or modified or stimulated) others, and these in turn were played off against (or with) the whole canvas, taking into account its size and shape—for the most part quite consciously. In short, part-to-whole or part-to-part relationships, no matter how strained, were a good 50 percent of the making of a picture (most of the time they were a lot more, maybe 90 percent). With Pollock, however, the so-called dance of dripping,

3

slashing, squeezing, daubing, and whatever else went into a work placed an almost absolute value upon a diaristic gesture. He was encouraged in this by the Surrealist painters and poets, but next to his their work is consistently "artful," "arranged," and full of finesse—aspects of outer control and training. With the huge canvas placed upon the floor, thus making it difficult for the artist to see the whole or any extended section of "parts," Pollock could truthfully say that he was "in" his work. Here the direct application of an automatic approach to the act makes it clear that not only is this not the old craft of painting, but it is perhaps bordering on ritual itself, which happens to use paint as one of its materials. (The European Surrealists may have used automatism as an ingredient, but we can hardly say they really practiced it wholeheartedly. In fact, only the writers among them—and only in a few instances—enjoyed any success in this way. In retrospect, most of the Surrealist painters appear to have derived from a psychology book or from each other: the empty vistas, the basic naturalism, the sexual fantasies, the bleak surfaces so characteristic of this period have impressed most American artists as a collection of unconvincing clichés. Hardly automatic, at that. And, more than the others associated with the Surrealists, such real talents as Picasso, Klee, and Miró belong to the stricter discipline of Cubism; perhaps this is why their work appears to us, paradoxically, more free. Surrealism attracted Pollock as an attitude rather than as a collection of artistic examples.)

But I used the words "almost absolute" when I spoke of the diaristic gesture as distinct from the process of judging each move upon the canvas. Pollock, interrupting his work, would judge his "acts" very shrewdly and carefully for long periods before going into another "act." He knew the difference between a good gesture and a bad one. This was his conscious artistry at work, and it makes him a part of the traditional community of painters. Yet the distance between the relatively self-contained works of the Europeans and the seemingly chaotic, sprawling works of the American indicates at best a tenuous connection to "paintings." (In fact, Jackson Pollock never really had a *malerisch* sensibility. The painterly aspects of his contemporaries, such as Motherwell, Hofmann, de Kooning, Rothko, and even Still, point up at one moment a deficiency in him and at another moment a liberating feature. I choose to consider the second element the important one.)

I am convinced that to grasp a Pollock's impact properly, we must be acrobats, constantly shuttling between an identification with the hands and body that flung the paint and stood "in" the canvas and submission to the objective markings, allowing them to entangle and assault us. This instability is indeed far from the idea of a "complete" painting. The artist, the spectator, and the outer world are much too interchangeably involved here. (And if we object to the difficulty of complete comprehension, we are asking too little of the art.)

Then Form. To follow it, it is necessary to get rid of the usual idea of "Form," i.e., a beginning, middle, and end, or any variant of this principle—such as fragmentation. We do not enter a painting of Pollock's in any one place (or hundred places). Anywhere is everywhere, and we dip in and out when and where we can. This discovery has led to remarks that his art gives the impression of going on forever—a true insight that suggests how Pollock ignored the confines of the rectangular field in favor of a continuum going in all directions simultaneously, *beyond* the literal dimensions of any work. (Though evidence points to a slackening of the attack as Pollock came to the edges of many of his canvases, in the best ones he compensated for this by tacking much of the painted surface around the back of his stretchers.) The four sides of the painting are thus an abrupt leaving off of the activity, which our imaginations continue outward indefinitely, as though refusing to accept the artificiality of an "ending." In an older work, the edge was a far more precise caesura: here ended the world of the artist; beyond began the world of the spectator and "reality."

We accept this innovation as valid because the artist understood with perfect naturalness "how to do it." Employing an iterative principle of a few highly charged elements constantly undergoing variation (improvising, as in much Asian music), Pollock gives us an all-over unity and at the same time a means to respond continuously to a freshness of personal choice. But this form allows us equal pleasure in participating in a delirium, a deadening of the reasoning faculties, a loss of "self" in the Western sense of the term. This strange combination of extreme individuality and selflessness makes the work remarkably potent but also indicates a probably larger frame of psychological reference. And for this reason any allusions to Pollock's being the maker of giant textures are completely incorrect. They miss the point, and misunderstanding is bound to follow.

But given the proper approach, a medium-sized exhibition space with the walls totally covered by Pollocks offers the most complete and meaningful sense of his art possible.

Then Scale. Pollock's choice of enormous canvases served many purposes, chief of which for our discussion is that his mural-scale paintings ceased to become paintings and became environments. Before a painting, our size as spectators, in relation to the size of the picture, profoundly influences how much we are willing to give up consciousness of our temporal existence while experiencing it. Pollock's choice of great sizes resulted in our being confronted, assaulted, sucked in. Yet we must not confuse the effect of these with that of the hundreds of large paintings done in the Renaissance, which glorified an idealized everyday world familiar to the observer, often continuing the actual room into the painting by means of trompe l'oeil. Pollock offers us no such familiarity, and our everyday world of convention and habit is replaced by the one created by the artist. Reversing the above procedure, the painting is continued out into the room. And this leads me to my final point: Space. The space of these creations is not clearly palpable as such. We can become entangled in the web to some extent and by moving in and out of the skein of lines and splashings can experience a kind of spatial extension. But even so, this space is an allusion far more vague than even the few inches of space-reading a Cubist work affords. It may be that our need to identify with the process, the making of the whole affair, prevents a concentration on the specifics of before and behind so important in a more traditional art. But what I believe is clearly discernible is that the entire painting comes out at us (we are participants rather than observers), right into the room. It is possible to see in this connection how Pollock is the terminal result of a gradual trend that moved from the deep space of the fifteenth and sixteenth centuries to the building out from the canvas of the Cubist collages. In the present case the "picture" has moved so far out that the canvas is no longer a reference point. Hence, although up on the wall, these marks surround us as they did the painter at work, so strict is the correspondence achieved between his impulse and the resultant art.

What we have, then, is art that tends to lose itself out of bounds, tends to fill our world with itself, art that in meaning, looks, impulse seems to break fairly sharply with the traditions of painters back to at least the Greeks. Pollock's near destruction of this tradition may well

be a return to the point where art was more actively involved in ritual, magic, and life than we have known it in our recent past. If so, it is an exceedingly important step and in its superior way offers a solution to the complaints of those who would have us put a bit of life into art. But what do we do now?

There are two alternatives. One is to continue in this vein. Probably many good "near-paintings" can be done varying this esthetic of Pollock's without departing from it or going further. The other is to give up the making of paintings entirely—I mean the single flat rectangle or oval as we know it. It has been seen how Pollock came pretty close to doing so himself. In the process, he came upon some newer values that are exceedingly difficult to discuss yet bear upon our present alternative. To say that he discovered things like marks, gestures, paint, colors, hardness, softness, flowing, stopping, space, the world, life, death might sound naive. Every artist worth his salt has "discovered" these things. But Pollock's discovery seems to have a peculiarly fascinating simplicity and directness about it. He was, for me, amazingly childlike, capable of becoming involved in the stuff of his art as a group of concrete facts seen for the first time. There is, as I said earlier, a certain blindness, a mute belief in everything he does, even up to the end. I urge that this not be seen as a simple issue. Few individuals can be lucky enough to possess the intensity of this kind of knowing, and I hope that in the near future a careful study of this (perhaps) Zen quality of Pollock's personality will be undertaken. At any rate, for now we may consider that, except for rare instances, Western art tends to need many more indirections in achieving itself, placing more or less equal emphasis upon "things" and the relations between them. The crudeness of Jackson Pollock is not, therefore, uncouth; it is manifestly frank and uncultivated, unsullied by training, trade secrets, finesse—a directness that the European artists he liked hoped for and partially succeeded in but that he never had to strive after because he had it by nature. This by itself would be enough to teach us something.

It does. Pollock, as I see him, left us at the point where we must become preoccupied with and even dazzled by the space and objects of our everyday life, either our bodies, clothes, rooms, or, if need be, the vastness of Forty-second Street. Not satisfied with the suggestion through paint of our other senses, we shall utilize the specific substances of sight, sound, movements, people, odors, touch. Objects of

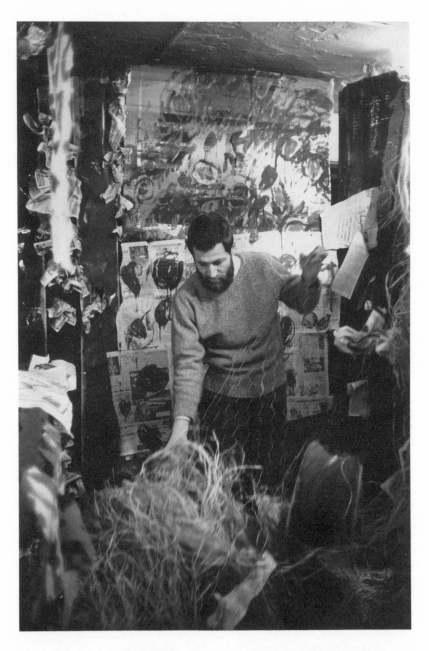

Fig. 2 Allan Kaprow in *The Apple Shrine*, 1960. *Photograph by Robert McElroy.*

every sort are materials for the new art: paint, chairs, food, electric and neon lights, smoke, water, old socks, a dog, movies, a thousand other things that will be discovered by the present generation of artists. Not only will these bold creators show us, as if for the first time, the world we have always had about us but ignored, but they will disclose entirely unheard-of happenings and events, found in garbage cans, police files, hotel lobbies; seen in store windows and on the streets; and sensed in dreams and horrible accidents. An odor of crushed strawberries, a letter from a friend, or a billboard selling Drano; three taps on the front door, a scratch, a sigh, or a voice lecturing endlessly, a blinding staccato flash, a bowler hat—all will become materials for this new concrete art.

Young artists of today need no longer say, "I am a painter" or "a poet" or "a dancer." They are simply "artists." All of life will be open to them. They will discover out of ordinary things the meaning of ordinariness. They will not try to make them extraordinary but will only state their real meaning. But out of nothing they will devise the extraordinary and then maybe nothingness as well. People will be delighted or horrified, critics will be confused or amused, but these, I am certain, will be the alchemies of the 1960s.

Notes on the Creation of a Total Art
(1958)

It has been inconceivable until recently to think of the arts as anything other than separate disciplines, united at a given moment of history only by vaguely parallel philosophical objectives. During certain periods in the West, notably the Middle Ages in the atmosphere and ritual of the church, the arts found a certain theological harmony—a blending perhaps, but not a total unity. Painting, music, architecture, ceremony—were each an identifiable genre. With the advent of the Renaissance, an emphasis on unique personal styles led to more specialization. Conscious thoughts about a total art did not emerge until Wagner and, later, the Symbolists. But these were modeled on the earlier examples of the church: essentially hierarchies of the several arts organized by master directors. The Bauhaus's experiments continued this approach, only modernizing the forms and subject matters. A total art could not come about this way. A new concept and new means were necessary.

Art forms developed over a long period and articulated to a high degree are not amenable to mixture: they are self-sufficient so far as their cohesiveness and range of expression are concerned. But if we bypass "art" and take nature itself as a model or point of departure, we may be able to devise a different kind of art by first putting together a molecule out of the sensory stuff of ordinary life: the green of a leaf, the sound of a bird, the rough pebbles under one's feet, the fluttering past of a butterfly. Each of these occurs in time and space and is perfectly natural and infinitely flexible. From such a rudimentary yet wonderful event, a principle of the materials and organization of a creative form can be built. To begin, we admit the usefulness of any subject matter or experience whatsoever. Then we juxtapose this material—it can be known or invented, "concrete" or "abstract"—to produce the structure and body of our own work.

For instance, if we join a literal space and a painted space, and these two spaces to a sound, we achieve the "right" relationship by considering each component a quantity and quality on an imaginary scale. So much of such and such color is juxtaposed to so much of this or that type of sound. The "balance" (if one wants to call it that) is primarily an environmental one.

Whether it is art depends on how deeply involved we become with elements of the whole and how fresh these elements are (as though they were "natural," like the sudden fluttering by of the butterfly) when they occur next to one another.

Paradoxically, this idea of a total art has grown from attempts to extend the possibilities of one of the forms of painting, collage, which has led us unknowingly toward rejecting painting in any form, without, however, eliminating the use of paint. In fact, the theory, being flexible, does not say how much of one element or another must be used. Because I have come from painting, my present work is definitely weighted in a visual direction while the sounds and odors are less complex. Any of these aspects of our tastes and experiences may be favored. There is no rule that says all must be equal. Although I expect that in the future a greater equivalence of these different senses will reduce the role that the visual side now plays in my own work, this result is not necessarily desirable for another artist. Any moment taken at random from life may have differently accented components: we may be primarily aware sometimes of the great number of sounds produced by a waterfall and at other times of the penetrating odor of gasoline. Someone trained as a composer may begin to create in this new art form by showing a preference for sounds over odors, but this person, at the same time, will not be dealing simply with the older art of music, any more than I believe I am engaged in the arts of painting, sculpture, or architecture.

In the present exhibition [Allan Kaprow: An Exhibition, Hansa Gallery, New York] we do not come to look *at* things. We simply enter, are surrounded, and become part of what surrounds us, passively or actively according to our talents for "engagement," in much the same way that we have moved *out* of the totality of the street or our home where we also played a part. We ourselves are shapes (though we are not often conscious of this fact). We have differently colored clothing; can move, feel, speak, and observe others variously; and will constantly change the "meaning" of the work by so doing. There is, therefore, a

never-ending play of changing conditions between the relatively fixed or "scored" parts of my work and the "unexpected" or undetermined parts. In fact, we may move in and about the work at any pace or in any direction we wish. Likewise, the sounds, the silences, and the spaces between them (their "here-" and "there-"ness) continue throughout the day with a random sequence or simultaneity that makes it possible to experience the whole exhibit differently at different times. These have been composed in such a way as to offset any desire to see them in the light of the traditional, closed, clear forms of art as we have known them.

What has been worked out instead is a form that is as open and fluid as the shapes of our everyday experience but does not simply imitate them. I believe that this form places a much greater responsibility on visitors than they have had before. The "success" of a work depends on them as well as on the artist. If we admit that work that "succeeds" on some days fails on other days, we may seem to disregard the enduring and stable and to place an emphasis upon the fragile and impermanent. But one can insist, as many have, that only the changing is really enduring and all else is whistling in the dark.

PART TWO

THE SIXTIES

Happenings in the New York Scene
(1961)

If you haven't been to the Happenings, let me give you a kaleidoscope sampling of some of their great moments.

Everybody is crowded into a downtown loft, milling about, like at an opening. It's hot. There are lots of big cartons sitting all over the place. One by one they start to move, sliding and careening drunkenly in every direction, lunging into one another, accompanied by loud breathing sounds over four loudspeakers. Now it's winter and cold and it's dark, and all around little blue lights go on and off at their own speed while three large brown gunnysack constructions drag an enormous pile of ice and stones over bumps, losing most of it, and blankets keep falling over everything from the ceiling. A hundred iron barrels and gallon wine jugs hanging on ropes swing back and forth, crashing like church bells, spewing glass all over. Suddenly, mushy shapes pop up from the floor and painters slash at curtains dripping with action. A wall of trees tied with colored rags advances on the crowd, scattering everybody, forcing them to leave. There are muslin telephone booths for all with a record player or microphone that tunes you in to everybody else. Coughing, you breathe in noxious fumes, or the smell of hospitals and lemon juice. A nude girl runs after the racing pool of a searchlight, throwing spinach greens into it. Slides and movies, projected over walls and people, depict hamburgers: big ones, huge ones, red ones, skinny ones, flat ones, etc. You come in as a spectator and maybe you discover you're caught in it after all, as you push things around like so much furniture. Words rumble past, whispering, deedaaa, baroom, love me, love me; shadows joggle on screens; power saws and lawn mowers screech just like the I.R.T. at Union Square. Tin cans rattle and you stand up to see or change your seat or answer questions shouted at you by shoeshine boys and old ladies. Long silences when nothing happens, and you're sore because you paid $1.50

contribution, when bang! there you are facing yourself in a mirror jammed at you. Listen. A cough from the alley. You giggle because you're afraid, suffer claustrophobia, talk to someone nonchalantly, but all the time you're *there*, getting into the act . . . Electric fans start, gently wafting breezes of New-Car smell past your nose as leaves bury piles of a whining, burping, foul, pinky mess.

So much for the flavor. Now I would like to describe the nature of Happenings in a different manner, more analytically—their purpose and place in art.

Although widespread opinion has been expressed about these events, usually by those who have never seen them, they are actually little known beyond a small group of interested persons. This small following is aware of several different kinds of Happenings. There are the sophisticated, witty works put on by the theater people; the very sparsely abstract, almost Zen-like rituals given by another group (mostly writers and musicians); and those in which I am most involved, crude, lyrical, and very spontaneous. This kind grew out of the advanced American painting of the last decade, and those of us involved were all painters (or still are). There is some beneficial exchange among the three, however.

In addition, outside New York there is the Gutai group in Osaka; reported activity in San Francisco, Chicago, Cologne, Paris, and Milan; and a history that goes back through Surrealism, Dada, Mime, the circus, carnivals, the traveling saltimbanques, all the way to medieval mystery plays and processions. Of most of this we know very little; only the spirit has been sensed. Of what *I* know, I find that I have decided philosophical reservations. Therefore, the points I make are intended to represent, not the views of all those who create works that might be generically related, or even of all those whose work I admire, but of those whose works I feel to be the most adventuresome, fruitfully open to applications, and the most challenging of any art in the air at present.

Happenings are events that, put simply, happen. Though the best of them have a decided impact—that is, we feel, "here is something important"—they appear to go nowhere and do not make any particular literary point. In contrast to the arts of the past, they have no structured beginning, middle, or end. Their form is open-ended and fluid; nothing obvious is sought and therefore nothing is won, except the certainty of a number of occurrences to which we are more than

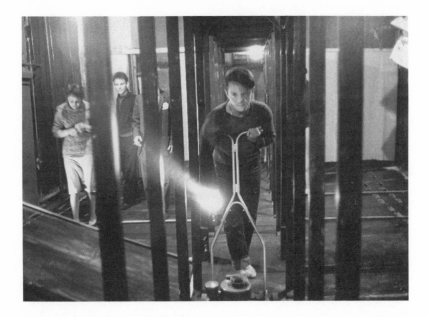

Fig. 3 Allan Kaprow, *A Spring Happening*, 1961. *Photograph by Robert McElroy.*

normally attentive. They exist for a single performance, or only a few, and are gone forever as new ones take their place.

These events are essentially theater pieces, however unconventional. That they are still largely rejected by devotees of the theater may be due to their uncommon power and primitive energy, and to their derivation from the rites of American Action Painting. But by widening the concept "theater" to include them (like widening the concept "painting" to include collage), we can see them against this basic background and understand them better.

To my way of thinking, Happenings possess some crucial qualities that distinguish them from the usual theatrical works, even the experimental ones of today. First, there is the *context*, the place of conception and enactment. The most intense and essential Happenings have been spawned in old lofts, basements, vacant stores, natural surroundings, and the street, where very small audiences, or groups of visitors, are commingled in some way with the event, flowing in and among its parts. There is thus no separation of audience and play (as there is even in round or pit theaters); the elevated picture-window view of

most playhouses is gone, as are the expectations of curtain openings and *tableaux vivants* and curtain closings . . .

The sheer rawness of the out-of-doors or the closeness of dingy city quarters in which the radical Happenings flourish is more appropriate, I believe, in temperament and un-artiness, to the materials and directness of these works. The place where anything grows up (a certain kind of art in this case), that is, its "habitat," gives to it not only a space, a set of relationships to the various things around it, and a range of values, but an overall atmosphere as well, which penetrates it and whoever experiences it. Habitats have always had this effect, but it is especially important now, when our advanced art approaches a fragile but marvelous life, one that maintains itself by a mere thread, melting the surroundings, the artist, the work, and everyone who comes to it into an elusive, changeable configuration.

If I may digress a moment to bring this point into focus, it may reveal why the "better" galleries and homes (whose decor is still a by-now-antiseptic neoclassicism of the twenties) desiccate and prettify modern paintings and sculpture that had looked so natural in their studio birthplace. It may also explain why artists' studios do not look like galleries and why when an artist's studio does, everyone is suspicious. I think that today this organic connection between art and its environment is so meaningful and necessary that removing one from the other results in abortion. Yet the artists who have made us aware of this lifeline deny it; for the flattery of being "on show" blinds them to every insensitivity heaped upon their suddenly weakened offerings. There seems no end to the white walls, the tasteful aluminum frames, the lovely lighting, fawn gray rugs, cocktails, polite conversation. The attitude, I mean the worldview, conveyed by such a fluorescent reception is in itself not "bad." It is unaware. And being unaware, it can hardly be responsive to the art it promotes and professes to admire.

Happenings invite us to cast aside for a moment these proper manners and partake wholly in the real nature of the art and (one hopes) life. Thus a Happening is rough and sudden and often feels "dirty." Dirt, we might begin to realize, is also organic and fertile, and everything, including the visitors, can grow a little in such circumstances.

To return to the contrast between Happenings and plays, the second important difference is that a Happening has no plot, no obvious "philosophy," and is materialized in an improvisatory fashion, like jazz,

and like much contemporary painting, where we do not know exactly what is going to happen next. The action leads itself any way it wishes, and the artist controls it only to the degree that it keeps on "shaking" right. A modern play rarely has such an impromptu basis, for plays are still *first written*. A Happening is *generated* in action by a headful of ideas or a flimsily jotted-down score of "root" directions.

A play assumes that words are the almost absolute medium. A Happening frequently has words, but they may or may not make literal sense. If they do, their sense is not part of the fabric of "sense" that other nonverbal elements (noise, visual stuff, action) convey. Hence, they have a brief, emergent, and sometimes detached quality. If they do not make sense, then they are heard as the *sound* of words instead of the meaning conveyed by them. Words, however, need not be used at all: a Happening might consist of a swarm of locusts being dropped in and around the performance space. This element of chance with respect to the medium itself is not to be expected from the ordinary theater.

Indeed, the involvement in chance, which is the third and most problematical quality found in Happenings, rarely occurs in the conventional theater. When it does, it is usually a marginal benefit of interpretation. In the present work, chance (in conjunction with improvisation) is a deliberately employed mode of operating that penetrates the whole composition and its character. It is the vehicle of the spontaneous. And it is the clue to understanding how control (the setting up of chance techniques) can effectively produce the opposite quality of the unplanned and apparently uncontrolled. I think it can be demonstrated that much contemporary art, which counts upon inspiration to yield that admittedly desirable verve or sense of the unselfconscious, is by now getting results that appear planned and academic. A loaded brush and a mighty swing always seem to hit the ball to the same spot.

Chance then, rather than spontaneity, is a key term, for it implies risk and fear (thus reestablishing that fine nervousness so pleasant when something is about to occur). It also better names a method that becomes manifestly unmethodical if one considers the pudding more a proof than the recipe.

Traditional art has always tried to make it good every time, believing that this was a truer truth than life. Artists who directly utilize chance hazard failure, the "failure" of being less artistic and more

lifelike. The "Art" they produce might surprisingly turn out to be an affair that has all the inevitability of a well-ordered middle-class Thanksgiving dinner (I have seen a few remarkable Happenings that were "bores" in this sense). But it could be like slipping on a banana peel, or going to heaven.

If a flexible framework with the barest limits is established by selecting, for example, only five elements out of an infinity of possibilities, almost anything can happen. And something always does, even things that are unpleasant. Visitors to a Happening are now and then not sure what has taken place, when it has ended, even when things have gone "wrong." For when something goes "wrong," something far more "right," more revelatory, has many times emerged. This sort of sudden near-miracle presently seems to be made more likely by chance procedures.

If artists grasp the import of that word *chance* and accept it (no easy achievement in our culture), then its methods needn't invariably cause their work to reduce to either chaos or a bland indifference, lacking in concreteness and intensity, as in a table of random numbers. On the contrary, the identities of those artists who employ such techniques are very clear. It is odd that when artists give up certain hitherto privileged aspects of the self, so that they cannot always "correct" something according to their taste, the work and the artist frequently come out on top. And when they come out on the bottom, it is a very concrete bottom!

The final point I should like to make about Happenings as against plays is implicit in all the discussion—their impermanence. Composed so that a premium is placed on the unforeseen, a Happening cannot be reproduced. The few performances given of each work differ considerably from one another; and the work is over before habits begin to set in. The physical materials used to create the environment of Happenings are the most perishable kind: newspapers, junk, rags, old wooden crates knocked together, cardboard cartons cut up, real trees, food, borrowed machines, etc. They cannot last for long in whatever arrangement they are put. A Happening is thus fresh, while it lasts, for better or worse.

Here we need not go into the considerable history behind such values embodied in the Happenings. Suffice it to say that the passing, the changing, the natural, even the willingness to fail are familiar. They reveal a spirit that is at once passive in its acceptance of what may be

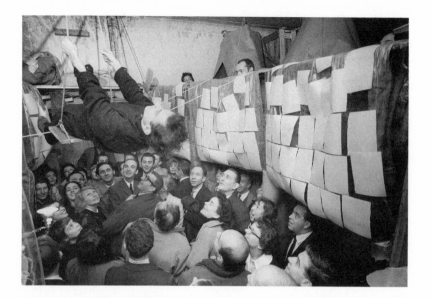

Fig. 4 Robert Whitman, *American Moon*, 1960. *Photograph by Robert McElroy.*

and affirmative in its disregard of security. One is also left exposed to the quite marvelous experience of being surprised. This is, in essence, a continuation of the tradition of Realism.

The significance of the Happening is not to be found simply in the fresh creative wind now blowing. Happenings are not just another new style. Instead, like American art of the late 1940s, they are a moral act, a human stand of great urgency, whose professional status as art is less a criterion than their certainty as an ultimate existential commitment.

It has always seemed to me that American creative energy only becomes charged by such a sense of crisis. The real weakness of much vanguard art since 1951 is its complacent assumption that art exists and can be recognized and practiced. I am not so sure whether what we do now is art or something not quite art. If I call it art, it is because I wish to avoid the endless arguments some other name would bring forth. Paradoxically, if it turns out to be art after all, it will be so in spite of (or because of) this larger question.

But this explosive atmosphere has been absent from our arts for ten years, and one by one our major figures have dropped by the

wayside, laden with glory. If tense excitement has returned with the Happenings, one can only suspect that the pattern will be repeated. These are our greenest days. Some of us will become famous, and we will have proven once again that the only success occurred when there was a lack of it.

Such worries have been voiced before in more discouraging times, but today is hardly such a time, when so many are rich and desire a befitting culture. I may seem therefore to throw water on a kindly spark when I touch on this note, for we customarily prefer to celebrate victories without ever questioning whether they are victories indeed. But I think it is necessary to question the whole state of American success, because to do so is not only to touch on what is characteristically American and what is crucial about Happenings but also partly to explain America's special strength. And this strength has nothing to do with success.

Particularly in New York, where success is most evident, we have not yet looked clearly at it and what it may imply—something that, until recently, a European who had earned it did quite naturally. We are unable to accept rewards for being artists, because it has been sensed deeply that to be one means to live and work in isolation and pride. Now that a new haut monde is demanding of us art and more art, we find ourselves running away or running to it, shocked and guilty, either way. I must be emphatic: the glaring truth, to anyone who cares to examine it calmly, is that nearly all artists, working in any medium from words to paint, who have made their mark as innovators, as radicals in the best sense of that word, have, once they have been recognized and paid handsomely, capitulated to the interests of good taste. There is no overt pressure anywhere. The patrons of art are the nicest people in the world. They neither wish to corrupt nor actually do so. The whole situation is corrosive, for neither patrons nor artists comprehend their role; both are always a little edgy, however abundantly smiles are exchanged. Out of this hidden discomfort there comes a stillborn art, tight or merely repetitive at best and at worst, chic. The old daring and the charged atmosphere of precarious discovery that marked every hour of the lives of modern artists, even when they were not working at art, vanishes. Strangely, no one seems to know this except, perhaps, the "unsuccessful" artists waiting for their day . . .

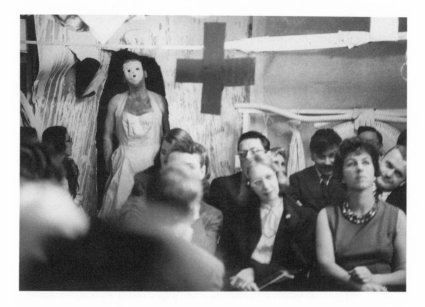

Fig. 5 Jim Dine, *Car Crash*, 1960. *Photograph by Robert McElroy.*

To us, who are already answering the increasing telephone calls
from entrepreneurs, this is more than disturbing. We are, at this writ-
ing, still free to do what we wish, and are watching ourselves as we
become caught up in an irreversible process. Our Happenings, like all
the other art produced in the last decade and a half by those who, for
a few brief moments, were also free, are in no small part the expression
of this liberty. In our beginning some of us, reading the signs all too
clearly, are facing our end.

If this is close to the truth, it is surely melodrama as well, and I
intend the tone of my words to suggest that quality. Anyone moved
by the spirit of tough-guyism would answer that all of this is a pseudo-
problem of the artists' own making. They have the alternative of re-
jecting fame if they do not want its responsibilities. Artists have made
their sauce; now they must stew in it. It is not the patrons' and the
publicists' moral obligation to protect the artists' freedom.

But such an objection, while sounding healthy and realistic, is in
fact European and old-fashioned; it sees the creator as an indomitable
hero who exists on a plane above any living context. It fails to appre-

ciate the special character of our mores in America, and this matrix, I would maintain, is the only reality within which any question about the arts may be asked.

The tough answer fails to appreciate our taste for fads and "movements," each one increasingly equivalent to the last in value and complexion, making for that vast ennui, that anxiety lying so close to the surface of our comfortable existence. It does not account for our need to "love" everybody (our democracy) that must give every dog his bone and compels everyone known by no one to want to be addressed by a nickname. This relentless craving loves everything destructively, for it actually hates love. What can anyone's interest in this kind of art or that marvelous painter possibly mean then? Is it a meaning lost on the artist?

Where else can we see the unbelievable but frequent phenomenon of successful radicals becoming "fast friends" with successful academicians, united only by a common success and deliberately insensitive to the fundamental issues their different values imply? I wonder where else but here can be found that shutting of the eyes to the question of purpose. Perhaps in the United States such a question could not ever before exist, so pervasive has been the amoral mush.

This everyday world affects the way art is created as much as it conditions its response—a response the critic articulates for the patron, who in turn acts upon it. Melodrama, I think, is central to all of this.

Apart from those in our recent history who have achieved something primarily in the spirit of European art, much of the positive character of America can be understood by the word *melodrama*: the saga of the Pioneer is true melodrama, the Cowboy and the Indian; the Rent Collector, Stella Dallas, Charlie Chaplin, the Organization Man, Mike Todd are melodrama. And now the American Artist is a melodramatic figure. Probably without trying, we have been able to see profoundly what we are all about through these archetypal personages. This is the quality of our temperament that a classically trained mind would invariably mistake for sentimentality.

But I do not want to suggest that avant-garde artists produce even remotely sentimental works; I am referring more to the hard and silly melodrama of their lives and almost farcical social position, known as well as the story of George Washington and the Cherry Tree, which infuses what they do with a powerful yet fragile fever. The idea is partly that they will be famous only after they die, a myth we have

taken to heart far more than the Europeans, and far more than we care to admit. Half-consciously, though, there is the more indigenous dream that the adventure is everything; the tangible goal is not important. The Pacific coast is farther away than we thought, Ponce de Leon's Fountain of Youth lies beyond the next everglade, and the next, and the next . . . meanwhile let's battle the alligators.

What is not melodramatic, in the sense I am using the word, but is disappointing and tragic, is that today vanguard artists are given their prizes very quickly instead of being left to their adventure. Furthermore, they are led to believe, by no one in particular, that this was the thing they wanted all the while. But in some obscure recess of their mind, they assume they must now die, at least spiritually, to keep the myth intact. Hence, the creative aspect of their art ceases. To all intents and purposes, they are dead and they are famous.

In this context of achievement-and-death, artists who make Happenings are living out the purest melodrama. Their activity embodies the myth of nonsuccess, for Happenings cannot be sold and taken home; they can only be supported. And because of their intimate and fleeting nature, only a few people can experience them. They remain isolated and proud. The creators of such events are adventurers too, because much of what they do is unforeseen. They stack the deck that way.

By some reasonable but unplanned process, Happenings, we may suspect, have emerged as an art that can function precisely as long as the mechanics of our present rush for cultural maturity continue. This situation will no doubt change eventually and thus will change the issues I address here.

But for now there is this to consider, the point I raised earlier: some of us will probably become famous. It will be an ironic fame fashioned largely by those who have never seen our work. The attention and pressure of such a position will probably destroy most of us, as they have nearly all the others. We know no better than anyone else how to handle the metaphysics and practice of worldly power. We know even less, since we have not been in the slightest involved with it. That I feel it necessary, in the interests of the truth, to write this article, which may hasten the conclusion, is even more fatefully ironic. But this is the chance we take; it is part of the picture . . .

Yet I cannot help wondering if there isn't a positive side, too, a side also subject to the throw of the dice. To the extent that a Hap-

pening is not a commodity but a brief event, from the standpoint of any publicity it may receive, it may become a state of mind. Who will have been there at that event? It may become like the sea monsters of the past or the flying saucers of yesterday. I shouldn't really mind, for as the new myth grows on its own, without reference to anything in particular, the artist may achieve a beautiful privacy, famed for something purely imaginary while free to explore something nobody will notice.

Impurity

(1963)

In the West "purity" and "impurity" have been important concepts for understanding the nature and structure of reality as well as for evaluating it. In the largest sense they have defined the goals of human and natural activity, explaining the world's events as an ethical passage from one condition to the other. No matter which concept has dominated the vision of a particular time, their fundamental polarity has always been clear. In the history of art such concepts have been crucial, because it is with them that the distinction between the ethical and the esthetic disappears. Today, although they are no less present in our thoughts, in our speech and writing they are apt to be imprecise, quasi-poetic, and allusive, in keeping with the changing perspectives of contemporary painting and sculpture. The more compelling goal of finding an adequate critical language for values in motion has taken precedence over what for the past were clarifying guidelines, constants amid change.

The accomplishments of this shift are obvious by now. But in pursuing almost exclusively a psychology of process in art criticism, we have found it difficult to perceive *where* the focal points of tension and release fall, however briefly. Dispersal thus replaces necessity; movement, vaguely imitating life, replaces energy. And while this testifies to a sort of freedom, it is an aimless freedom. Our art is more specific than this. It is committed on a more elemental plane than a criticism of subtlety alone can convey. I would propose that nothing that has been gained will be lost by once again incorporating into criticism the categories of purpose. Those of purity and impurity are still useful.

It is sometimes easier to see what a certain term means by comparing it to a related term—in this case, a contrary. When we use the word *pure*, we have in mind physical and structural attributes—like

clear; uncontaminated by admixture of foreign substances; unweakened by vitiating material; formal (rational, nonempirical). We also associate *pure* with moral qualities such as chastity, cleanliness, refinement, virtue, holiness, spirituality. Finally, a metaphysical connotation is involved, for purity suggests something beyond innocence or the clergy, namely what is abstract, essential, authentic, true, absolute, perfect, utter, sheer. These meanings may be found in any dictionary. And they are the qualities that, in varying degrees, also help make up our idea of the classical.

Impurity, then, is a second-hand state, a mongrel at best physically; therefore tainted morally; and metaphysically impossible by definition. From this concept we derive much of our image of the romantic. But just as evidently, when romantic thoughts prevail, *impurity* is scrawled over the earth as a truth of nature more honest than any classical artifice.

Thus, the two ideas involve one another, one takes its meaning from the implicit denial of the other, and neither can exist in fact without invoking the shades of its opponent. They are consecrated enemies, and as long as our language uses them, our acts will reveal to us the triumphant or tragic in our lives. This is part of our heritage from Freud, Nietzsche, and Schopenhauer, through Hegel and back to the Greeks. We may be forgetting the simplicity of its dialectic at a time when talk of something like purity is once more lively.

Some critics and artists maintain that such views are only figures of speech nowadays, misleading mental habits from the past that do not correspond to our actual way of looking at things. I must acknowledge the growing interest in Asian philosophies, in which such contraries do not function in conflict but exist as counterparts. But this interest, I think, has not reached sufficient magnitude to do away with our more historical attitudes; and among those who have sincerely adopted values different from the West's, the conversion is often celebrated in a way that places Eastern "enlightenment" over Western "darkness" in much the same way that our classicism likes to elevate itself over romanticism. That is to say, I am not certain that what has taken place is not simply a disguised (and perhaps revitalized) expression of purity as I have discussed it above.

* * *

Recently there has been a renewal of serious appreciation for what earlier had been broadly known as Purist painting, a style that suffered a decline for about fifteen years during the rise of Abstract Expressionism. The works produced today, apparently in the spirit and the letter of this tradition, are called by the very American-sounding name Hard Edge, which suggests something of the blunt truth these paintings wish to convey, as distinct from the finer sensitivities of the Europeans.

But whatever their differences, the evident strength of some of the Hard Edge artists seems to derive from many of the same means we recall from the earlier models: their pictures are clear edged; all of them are abstract and favor large, simple-shape themes; the vocabulary is either "geometric" or "biomorphic," or an amalgam of the two; color, like tone, is equally distinct from part to part; and brushwork is nonexistent, conveying the impersonal, immaterial character of the execution. The compositions appear stable and unequivocal; nothing intervenes to confound their objectivity. The strict limits of careful practice permit no irrelevant element, no unexplained move. The peculiar power of these works emanates from some fundamental (or synthetic) source, for their detachment from the immediate and spontaneous is final and irrevocable. Such paintings are—or at least appear—perfection itself.

Purist painting owes its authority not simply to a widespread interest at one time, and now again today, but, more important, to the theories and canvases of at least four major artists: Arp, Kandinsky, Malevich, and Mondrian. Although their views differ (and we do not pay enough attention to this fact), we cannot doubt now that it was Mondrian more than anyone who elevated this vision to so high a state of self-evidence that it communicated to everyone its general purpose even while withholding from most viewers its ritual and its value. Of the four, it is Mondrian who can claim to have imposed on all Purist painting a sense of duty, rigor, and aloofness and an aura of theology. And as with any theology, his art insists on its superiority—and its exclusiveness. One can indeed venture the guess that it was Mondrian who identified purity for us in modern painting and, further, that he

alone was able to carry its method of execution so far beyond itself that the method became a purification rite.

I believe that this was, in a wider sense, what Mondrian meant when he said: "I think the destructive element is too much neglected in art." Not only the painter's means but also the art object itself should evaporate through a process of mutual annihilation. From this destruction of particulars something of considerably greater importance would be unlocked. That something, that "rhythm" of existence he so often spoke of, may be difficult to apperceive, but Mondrian, fairly systematically, provided the steps for its revelation in the paintings themselves, and it is quite possible to infer from them what he was after, if not to experience it directly.

What is too little grasped is that, building upon the French tradition of using pictorial paradox (which had developed rapidly from Manet through Cubism), Mondrian turned this essentially compositional preoccupation to the opposite purpose of visionary emotion. We are all familiar with the conflicting concerns in the Cézanne-Cubist esthetic, such as fidelity to natural appearance versus the demands of form; three-dimensional space versus the flatness of the canvas; local color versus compositional color; sensation versus knowledge. These are not simply matters of technical interest, for by searching out what happens between nature, the artist, and the picture, artists discovered discrepancies. And by constantly manipulating their means in an attempt to bring these into some accord, they posed ultimate questions regarding the nature of reality.

I believe Mondrian was attracted to the French school because it never resolved these questions and because very likely it did not desire to resolve them. He wanted to, however, and thought it was possible; but I suspect that in fact he did not succeed, and had he succeeded, he would have found his life's work without meaning.

The answer for him lay at the "heart of the matter," in the continuous and polarized forces of the universe, not in the seeable world. But the seeable painting was to reveal it, however momentarily, for nothing else would. So he set himself the task of creating a visible vocabulary for what until then had been invisible.

The task was a test of his imagination as much as his insight—his ultimate creative act, without which he would never have made his point. This utterly simple hypothesis—that in the perpendicular relations of two straight lines, varying in length and width and axially

aligned with the ocean's horizon and with the force of gravity, the Truth was revealed—gave his work a coherency that the work of his contemporaries did not have. The equation is, above all, easy to see; and it is easy to feel from this cruciform relationship a vague Christian meaningfulness: it has an air of high seriousness from the start. And besides, it allows for endless transformation. Granting the intensity of belief its discoverer gave to it, it made pure painting possible for him and a possible idea for us.

In his root metaphor, Mondrian found a visible mark that would stand for nothing but reveal everything. He had the necessary instinctive powers of the real painter (plus expert technical skill) to carry this metaphor far beyond its simple statement. He could not have depended upon his almost maniacal faith in his discovery without this natural equipment, for only with it was he able to set the image in motion. His method, as I mentioned, was that of the strongest current of European painting: paradox. Indeed, as the use of this method increased in complexity, the metaphor became more self-evident. Where his predecessors and colleagues juggled puns on the objective and abstract elements in their paintings, he played his theme off against itself and succeeded in destroying it. That is to say, where they would construct their compositions from relations between things seen and things invented, he interrelated relations and thereby eliminated even these from the result. It was at this point that the "grand illusion" convinced the artist he had found pictorial Truth, but as I hope to indicate, it was much more a truth of human nature—for it was tragic.

Mondrian's use of paradox was unique and demanding. It is essential to look at this kind of painting with a prolonged and unblinking gaze. Here the immobilization of self that, expressively speaking, accompanies fixation or staring, is the appropriate state for seeing everything that is not immobilized in the work. With this preparation we can follow, in principle, the method in his works titled *Composition* (Fig. 6).

The principle is this: that anything initially graspable as a datum in the painting, from a single line to a view of the entire canvas at once, will slip from focus into a myriad of changing substances and positions. The result is a tabula rasa. For instance, if we try to isolate a line, we see it as a "thing" on a white ground. Then it reverses as the white becomes positive, revealing a dark space behind as two or more of the white planes draw apart.

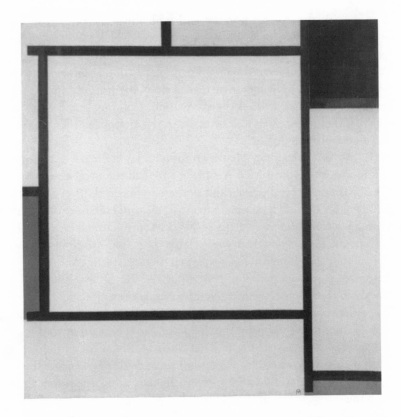

Fig. 6 Piet Mondrian, *Composition 2*, 1922. Oil on canvas, 21⅞″ × 21⅛″.
Solomon R. Guggenheim Museum, New York. *Photograph by David Heald.*

In areas comprising more than one element, what appears to be complete (closed) is incomplete. Rectangles formed by the crossing of four lines are not really finite but a grid of boundaries continuing beyond the area they incidentally contain. Similarly, those rectangles formed by the edge of the canvas and two or three lines can be completed anywhere outside the field, as Meyer Schapiro has observed in another context; that is, the picture edge is not felt to be a real caesura. Thus the "whole" painting is fragmentary despite its first appearance of clear composure.

Once we see the painting this way, we can no longer maintain the perception of the painting as flat, and large projections and recessions begin to play against this unmodulated surface. This effect is encour-

aged not only by the object-ground paradox but also by the painter's careful building up of the white paint higher than the shiny black lines, which, in turn, extend around the edge of the canvas and are lost from sight. As each line or plane (or area) is ascertained in depth, its position relative to neighboring elements becomes clear yet problematical, for these elements must be rechecked in the new context. A confusing memory pattern follows. Every reassignment of place becomes more provisional as the fluctuations increase under different velocities. Each point of departure changes as the focus shifts to account for some new arrangement perceived, so the departure point can no longer be where it was originally. There is therefore a semblance of extension, but no space, since its demarcations are unstable. Flatness returns. There is also no resolution in *this* plane, because the fluctuations on the surface continue to provoke the whole process again.

Such observations destroy for us the last identifiable shred of those remarkable "obvious" means Mondrian chose. Straight lines curve or bend diagonally into space; planes warp; surfaces appear variously opaque, filmy, or transparent; and colors dissolve into aftersensations of their complementaries.

I must insist here that we are not examining a skillful trick; nor is this hypnosis, though its mechanics may be dangerously close to those of hypnosis in demanding the utmost from acute attentiveness. What it means for us, the observers, is that in our natural way of relating ourselves to what occurs in a work of art, we become another unfixed point in unmeasurable space, one more reciprocating rhythm in a charged void. We are no longer rooted in time or in any space. Still, as long as we remain conscious of our task to account for every phenomenon in the work—and the number of these is endless—we are yet in this world, and the strain between losing and retaining our faculties increases as our attending gaze endures. A pleasure-pain principle very probably functions here, for as the struggle to remain attentive becomes greatest, esthetic emotion increases. *This* is the brink and the abyss, on the other side of which is purity.

Much has been made of Mondrian's supposed neo-Platonism, and, more particularly, of his Calvinism. The references suggest the type of philosophical artist he was. We should bear in mind, however, that the phrases "neo-Platonic philosophy" and "Calvinist doctrine" are not the things they refer to. They describe and elucidate higher states that can be attained under certain strict conditions and with special disci-

pline of thought and action, but they are not in themselves those high states. To the extent that philosophy and theology aspire to be wisdom as well as analysis or description, we may expect to be enlightened when we have understood what is said and when we have modified our existence according to the precepts learned. We like to assume that philosophers are wise from their philosophy and that those who are holy are personally acquainted with the spirit they preach. These assumptions may be valid, but the preparation and the enlightenment, however they may be connected, are still two different things. In the same way, Mondrian's paintings are philosophical and doctrinal. Properly understood and lived (as, we have every reason to suppose, Mondrian understood and lived them), they may be revelatory.

I will guess that for many of us his paintings are rewarding in the sense that they put us in touch with the possibility of a still richer reward. Doubtless, we would not choose to *possess* it, for the privations it entails are considerable. I will guess, too, that even for Mondrian it was very nearly the same; otherwise he would not have continued to paint after he discovered what he was seeking. States of blessedness are rarely given to anyone; they are sought. And those who we suppose have something divine are continuously seeking the greater fullness of a truth they know they shall never acquire completely. Mondrian's painting process, therefore, was essentially a purgatorial exercise of the loftiest kind, qualified and given meaning by the imperfection of the world he lived in and hoped to improve by his difficult example. That he was part of this world, as we all are, is implicit, and makes his works poignant. This is their romanticism and their impurity.

Thus the impure aspect of pure painting like Mondrian's is not some hidden compositional flaw but rather the psychological setting which must be impure for the notion of purity to make any sense at all. The success of a visionary like Piet Mondrian was due to the vividness with which he made the conflict manifest in every picture and at every stage of his career.

I should like now to consider a painting of 1955–56 by Myron Stout (Fig. 7) that finds its place in the modern Hard Edge school (although the artist dislikes the term). If there is to be an authentic pure painting, it must propose its purity in the most extreme and tense awareness of

human frailty. This operative condition is especially important in these unstable times. A painting that does not make this condition an active part of its conception, and even its technique, will either reduce to prettiness or will force an arbitrary terminology into the service of an idea: I mean it will reveal only its good intentions. Most paintings done in this mode fail, not because they aren't pure, but because they do not make clear what purity means.

Stout hardly resembles Mondrian. If he resembles anyone, it might be Arp, whose curving, closed shapes, unmodulated surfaces, and sharp outlines his painting recalls. But Stout's image is not suggestively biomorphic; it has no feeling of a bit of the organic world reduced to a symbol. It also lacks Arp's particularly elegant wit and play. Instead, there is an almost severe seriousness, a single-minded concentration focused upon *one shape*. Rarely does Stout employ more, and just as rarely does this one have more than two parts to it, or two colors: black and white. Stout's shape tends to be centralized and aligned axially with the field, initially in stasis; Arp's several forms exfoliate, use more colors, contain varying diagonals, and are displaced with respect to the canvas and each other (this gives them their skittishness). Though some observers find in Stout's work a remote sensuality, it is one that refuses to yield up its origins or its objective, and thus it remains abstract. It is an imagery that, for all its curving, refers us to a quality of feeling that is potential in emblems but in these is not often raised to the intensity of preoccupation.

Stout's output is comparatively small. A painting may take years to complete. Day by day the surface is built up, and areas are shaped by accumulations of almost imperceptibly minute adjustments, niceties that not only "realize" the image but confer upon the finished work precisely that sense of preoccupation just mentioned. By comparison, many of his contemporaries, who work more rapidly, reveal a palpable thinness in their forms and are unable to hold our attention. Their works are almost enlarged ornament or inflated silhouettes of partial and unidentifiable things that call upon our attention but do not reward it.

I suspect that this style does not allow a painter to make use of swift decision, nor does it permit spontaneity of execution, which finds its meaning in time (or in cheating time). Purist painting arrests time; we may draw the rule of thumb that the less we can feel time as part of such a work, the more time it must take to paint it. Stout shares

Fig. 7 Myron S. Stout, *Untitled (No. 3)*, 1956. Oil on canvas, 26″ × 18″.
The Carnegie Museum of Art, Pittsburgh.

this quality—a cardinal one—with Mondrian, who also devoted years to a canvas. Artists cannot simply say to themselves, "Slow down," and hope to achieve more than a semblance of the aristocracy and calm of this high language. Nor can they convey its special mortality. The prolonged deliberation required here must be a *necessity of the image*. Like Mondrian's basic image, Stout's is frontal and absolute. It commands, by its character, a contemplative effort both in its execution and in its appreciation. And in contemplation, there is little room for gesture.

If Mondrian's image vanishes upon close study, Stout's only succeeds in becoming more irreducibly present, like some cipher held up to our face. Its subtle changes serve to clarify it rather than eliminate it; deviations from true symmetry are seen to be paramount, for they force us to be mindful of centrality in a way that simple balance does not. The image pulsates as our eyes assess and reassess the measurements from image to side, from part to corresponding part. The planar movement is slow and awesome, with the legs of the inverted U alternately advancing and receding in walking motion, but blankly, without further reference to anything nameable. The whole reverses just as slowly into its negative state, its white now a yawning opening beyond a totemic finger of black erected in its midst. In either instance a clear and mysterious figure remains, provoking thought and wonder in a context where we are forever outside its meaning.

I am suggesting that we are intended to wonder, that the painting on some level is made to be wondered at. What is pure and perfected in it is not present in us, or else we should understand. Painted by a man who perhaps wonders as deeply at his own creation, it hints at the separation between us and art.

With Stout, the data of vision are confirmed a fortiori the longer we look, but their significance eludes us. With Mondrian, the data of vision cumulatively annihilate themselves, but it takes our eyes to accomplish this, and we become increasingly sensible of their role in bringing about exaltation. Mondrian has answers, difficult as they may be, whereas Stout poses questions. But both precipitate a crisis of consciousness and identity.

In contrast, Jackson Pollock is thought to be a "classic" example of the impure painter. In the view generally taken of him and his work (particularly that of 1948–51) all the qualities of romanticism spread out large: a sprawling, measureless form, an unadulterated technique

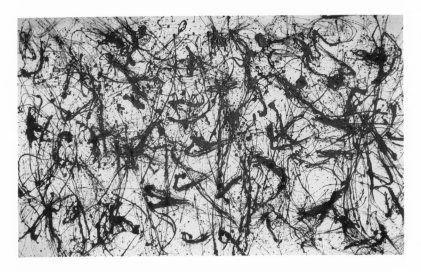

Fig. 8 Jackson Pollock, *Composition 32*, 1950. Kunstsammlung Nordrhein-Westfalen.

flung on in half-trance, a torrential imagination, and a demonism at the apparent mercy of inspiration. I do not consider this view wrong, but, taken simplistically by foes and blindly by partisans, it obscures the same necessary dichotomy at work in impurity that, from the opposite direction, makes purity human—that is to say, moral. That Pollock is opposed to purity in the obvious sense is something with which no one need quarrel; but it cannot be understood without grasping how large a part purity in fact plays in his art.

It is my conviction that the very large overall canvases of Pollock are his most important. Not that the others are unimportant—the same talent is evident in them—but the dripped paintings most clearly crystallize the *issue* of the artist's impurity.

It is hard to fix the image from which these works are expanded, partly because it moves so rapidly, lodging briefly in a multitude of places. Instead of a shape as such, it might be termed a track left by a concatenation of sheer energy. The trouble is also due to the vivid fact that this energy is human, made by a weaving body, with arms swinging in fierce delirium. (It would be almost impossible, once we are even slightly familiar with these canvases, to mistake their "feel" for that of some textured surface in nature; although we may now find

nature itself interesting because it is like Pollock.) The Pollock image, therefore, is at some point an immediate reference to the action that created it, and this, in the mind's eye, amplifies what is on the canvas into a far more complex theme, amounting, for the sensitive observer, to a re-creation of the whole circumstance of the making of the picture.

Despite the elusive physiognomy in such a painting as *One* (1950), there is, nevertheless, an actually discernible theme consisting of two parts: a splatter and a trailing streamer. The first attacks, and the second leaves its tracery after it. One advances, hard and aggressive, and the other retreats swiftly and more softly. Their reciprocal action, like breathing in and out, is the "easy give and take" the painter very likely referred to. The two themes do not usually exist side by side but intermix, exchanging qualities in the action that leaves its record upon the canvas. A splatter will become a spurt and fail in its trajectory, and a streamer will clot and explode while negotiating a turn or colliding with another mark.

Only a basic imagery containing this natural rhythm could permit Pollock the liberty of alternately enflaming and drenching the entire canvas by only varying it slightly. Not all themes are expressive when continued endlessly. There is the theory in the arts that any subject matter, if repeated enough in this way, acquires a value by dinning itself into our brains. We have lately gotten used to the application of this theory in countless quasi-hypnotic paintings, poems, dances, and musical compositions; only those that convince us of the authenticity of the subject matter itself convince us of the value of the din made from it. This value cannot be prescribed, but we can recognize it when it happens, and Pollock's image-gesture is as universal as it is instantaneous.

There is surely a violence present in this tremendous outpouring. But just as the painter's image was twofold in its rhythm, the conflagration suddenly freezes over, and motion stops. In a gesture, as every dancer knows, if an outward move is exactly balanced by a withdrawal, a neutrality results that contains the opposing energies in an intensified form. Mondrian used this principle, and Pollock, by multiplying close variations of this theme almost indefinitely, both electrified it and transcended it, through excess. The result is related to what the ancients called harmony.

Pollock was interested in harmony and wrote about these works:

"The painting has a life of its own. I try to let it come through. It is only when I lose contact with the painting that the result is a mess. Otherwise there is pure harmony, an easy give and take, and the painting comes out well." Pollock was admitting the difficulty of his approach and the precariousness of his contact with the painting's rhythm. When it was maintained, when the balances were perfect, the repetition over an enormous field sustained the same original pulsation: attack/withdrawal, expansion/contraction, tangle/structure, hot/cold, passion/enlightenment. Then the painter achieved the "pure harmony" he was looking for, and it is not unlike the Nirvana that Mondrian suffered for and Stout so deeply questions. Yet each painter had to retrace his steps again every time the plateau was reached. The resolution on Pollock's surface shimmers and dissolves before our eyes, and we are cast once more into the maelstrom. Among writers, Thomas Hess seems to have been alone in recognizing this alternation in the artist, when he wrote in 1951: "After short observation . . . violence is consummated. The image reverts to its enigmatic space on the wall, acquires a cool, almost fragile independence . . . [but the] impulse to movement returns; the vertiginous ride always starts again."

The paintings of Barnett Newman have remained controversial for more than a decade. Among the nine or ten major artists of an acknowledged period of creative power in contemporary art, he appears to have been the most difficult to pigeonhole and thus to write about. There is something at once familiar and grand yet aloof in his work.

Taken at face value, such a well-known work as *Vir Heroicus Sublimis* (Fig. 9) has the idiomatic precision of the Purist: it is architectonic, simple, clear, detached. Because of the presence of vertical stripes, one used to think of Mondrian, and since these stripes did not do what Mondrian's stripes do, it was customary to dismiss Newman. But now that his paintings have borne many children (his influence is considerable), the comparison has become diffused, and we are left to contend with their opaque mystery, a mystery that continues to perplex persons of historical and analytic bent while attracting others whose reasoning is more intuitive. I believe it is to the latter that we can go for understanding.

It will serve no purpose to turn our attention from the classical elements in Newman's work, as a few critics advise. The large rectangular format is there to see; the almost unmodulated expanse of bright

Fig. 9 Barnett Newman, *Vir Heroicus Sublimis*, 1950–51. Oil on canvas,
7′11⅜″ × 17′9¼″. The Museum of Modern Art, New York.

red; the irregularly spaced verticals in dull flesh color, white, brownish
purple, flesh, and tan, from left to right, are all there. The stately
phrasing and the stability of the divisions, their measurability, the
perfection of execution are there, quite evidently. They establish an
impersonal mood in keeping with the taste in our time for the strict
and balanced.

The question to be asked is whether in Newman's work classic
and purist appearance functions as we would expect. When we say
that form follows purpose, we are speaking much as the Greeks did;
we still vaguely accept their tradition of modes but do not practice it
as freely as they did. In the past, techniques were categorized to convey
particular affective as well as philosophical results: a heroic form, for
example, was indicated for an epic subject. This specification, however,
says only that certain forms are appropriate for certain types of expres-
sion; van Gogh's streaming troweled strokes are necessary to the fe-
verish pitch in his work, we believe. But such strokes can also be
applied so endlessly on a picture that they eventually become nearly a
blank surface with little perceivable motion, and I have pointed to this
kind of transformation in Pollock.

I think something like it happens in Newman's work, in which
apparent balance and purity are a necessary foil for a different vision.
A classical art, whatever its ultimate meaning, proceeds from the es-
tablishment of an equilibrium of clearly opposed elements (in some

human scale) within a defined field. Mondrian's point of departure and the means that serve his end are, without question, in accord with this. Whether Newman's are is uncertain.

If we approach *Vir Heroicus* very simply and ask what and where its "objects" are, what relationships they have to each other, and what their "ground" is, we have to grant a few distinctions.

Allowing a stripe to be called an object poses a greater problem in Newman's paintings than in Mondrian's, where the vertical stripe was at least clearly opposed to its perpendicular—which was enough to call marked attention to such elements before they were gradually lost from sight in their interactions with one another and the field. Because Newman's painting has no horizontals, a stripe is far less a "thing," since it is not engaged in a physical contest. In Newman's paintings of seventeen years ago the stripe theme was surrounded by "distractions," gestured markings that spurted around it without touching it, as though it were some favored and special moment of silence. Even then it never felt like a material element but like an emptiness, caused perhaps by Newman's painting over and around a piece of masking tape, which was pulled off the surface at the end, leaving a void. The vertical was, therefore, *arrived at* (as Clement Greenberg has observed), but arrived at in *Vir Heroicus* through the gradual elimination of gesture, until only its residue resounds in the full strength of unvaried color encompassing it. (This residue of gesture is what distinguishes these large areas from a flat coat of paint on a wall, or from the work of lesser artists, whose paintings are turned out quickly.)

But gestures are not entirely forsworn in *Vir Heroicus Sublimis*. We see a vestige of the handmade in the tiny "imperfections" along the second and third stripes from the left, where the gesture spilled over once, as though forgotten in the brief respite of these chosen places. In the context of Purism, these imperfections are "foreign," extraneous. Observed thus, they have the explosive force of self-recognition, for here, palpably, is the human being. And in their near-eclipse, these visible leftovers of the brush further remove the verticals from any association with things.

One might suggest that the five stripes add up in the mind to a unity of verticals, in which each gives the other a quasi-substance through mutual emphasis. But they are spaced too far apart for this; we tend to lose each in isolation as we move along to the next. The time lapse here is purposely lengthened to prevent such a phenomenon;

the rhythm is forgotten. Rather, as in some of Newman's paintings where there is only one vertical, we are compelled to sense such lines as a momentary indication of change of pace, an "inflection" (as Greenberg puts it) in the slow march of our eyes and body before the canvas. The accent is really on our sensations.

But these sensations are important, and as they change against an unchanging field of red, we are led to understand that their occurrence at the verticals was arrived at by the artist with exquisite sensitivity. The task was to keep the verticals alone but at the same time touch the memory of viewers enough so that they recall the *flavor* of their sensation of a past vertical. The simple appearance of the verticals, especially in reproduction, belies the difficulty.

As we scan the painting from one side to the other, the verticals (which I shall henceforth call stops) occur asymmetrically (other paintings of Newman's are symmetrical and many are almost so), with the two lightest spread away from the center—under great tension if looked at as a pair; one thin and crisp, and the other wider, less brilliant, almost at the right edge of the field. Next, the flesh and tan ones are equally separated, but quiet, like whispers. These two pairs play against the unmarked center, a place the eye traverses without rest. But now the dark stop has no relative (or near-relative); it is felt to be the proper counterpart of the light one on the left, yet it belongs to the right side of the work as well. As one of a group of three, it stands apart from the white-dominated group of two. These groups balance nearly exactly, for the mass of the three is equivalent to the intensity of the two.

The zone between, consequently, is given special value; that is, by implication, a kind of symmetry obtains. This delicate weighing and placing gives the stops an internal order, which, added to their suggestion of an unstressed symmetry, also weakens our grasp of this order. Their extreme separation ensures such half-cognizance, permitting each stop to exist only as an emotion that feels appropriately different from the others.

In this respect, again, Barnett Newman is starting out, in his own way, with the classical principle of unity composed of unequal but equivalent forces. Abstracted, the stops acquire such an intelligible pattern; but in actual experience we neither see nor feel it. Newman's paintings, unlike Mondrian's, do not require us to perform continuously the mechanics of counterpoise to grasp the meaning of the work.

Vir Heroicus strikes us as a whole, rather than a part-to-part-to-whole, conception. But it could not do so, paradoxically, without the contrast of a departure from something like purity.

How strongly the whole works upon us can be deduced from the relation of the stops to the field. We look at the field, either from the right side or the left, along the dominant horizontal axis of the canvas. Although nearly all Newman's paintings have vertical stops, it is the total shape of the format that tells us whether to move *with* the direction of the stops (up and down) or *across* their flow. Since they possess no substance per se, we cannot feel that they function singly, or as an aggregate, in contradistinction to the whole. There is, therefore, no real object-ground exchange. And the ground, as large as it is, is almost impossible to measure easily: phenomenally, it exists as aura, not format.

Thus, without the clarity of "structure" we normally perceive in that object-ground exchange, which we at first believed we saw in Newman, the last vestige of tradition slips away as we find no advantage in reading the canvas three-dimensionally. (It can be done to a degree in the reduced photograph, but the elements are few and lack the richness we expect from such play.) The stops, then, submerge and drown in the vast sea of intense red, neither voids nor solids. We may guess that it is we the viewers who are assigned the role of "objects," and the painting is the still "ground" in relation to which we move and feel. In both a metaphorical and literal sense, we are the imagery of an art that deeply involves the human being. How far from being detached and contained this painting is!

As with Pollock, Newman's great scale engulfs us. The red, being impenetrable, returns our penetrating stare, fills the space in front of the canvas, surrounding the viewer, almost "dyeing" him with the relentless hue.

Both Mondrian's and Stout's paintings are smaller than a person; Pollock's and Newman's dwarf us. A modern purism perhaps can be most intense when all that is beyond the human in it is kept tied to the human by a tenuous thread of physically comfortable size. The terms of pictorial purity, if not their familiarity, must always remain measurable. One of the means of contemporary impure art is to overwhelm us, to make us both psychically and physically exposed to everything from within and without. Purity is selective and exclusive, as I have said, while impurity leaves us aghast and imperiled.

44

Thus scale, for Barnett Newman, is overwhelming. We are to the painting as the stops are to their surroundings, as are the small marks of the hand (in the two stops) to the stops themselves: minimum to maximum, without transition. The wide span between creates an intolerable tension, and it must finally break. The flood of utter chaos, of sheer color inundating us, of lines crashing into splinters and vanishing into the vibrating deluge, is the "terror" Barnett Newman refers to when he speaks of his work, and the "abstract-sublime" that Robert Rosenblum perceived. This terror and this passion are as close to our marrow, as unsettling to us emotionally, as anything of Pollock's: they are the other side of his clarity, and they meet, both of them, at the middle. Pollock erupts with frenzy, only to burn into thin air. Newman begins with the premise of a perfect vision in a calm, unruffled world and ends with a cataclysm.

The Artist as a Man of the World

(1964)

Voltaire concluded his book *Candide* with the bitter advice that since this is the best of all possible worlds, we had better cultivate our gardens. We agree with Voltaire but call ours the worst of all worlds. Yet the art world, at least, has never been in better flower. There are probably more novelties today, more esthetic theories, more sheer energy than at any time in history.

We read our papers, attend to our work, and go to sleep at night, having been inundated (we are told daily) by a torrent of the impossible, all of it leading to confusion. As artists, we know more about the history of our field, the infinity of its alternatives, than artists ever knew before. And all this is reflected in the array of styles with which we beckon others' attention. For the first time, blissful ignorance hasn't a chance.

Something for Everybody

Once two drinkers sat contemplating a bottle; the whiskey was at the halfway mark. One said it was half-empty, and the other said it was half-full.

Updating the story, imagine the bottle as a Cubist painter might—from inside and out, above and below, front to back, near and far, in angles and curves—the data concerning the whiskey level are intensified as the vantage points are increased. Suppose, further, that the drinkers themselves are Cubist beings whose many discrete observations are perfectly normal and that the judgment of each is not a simple statement but a "Cubist" one: "The bottle is half-full; *half-full* makes two syllables; *half-full* begins with *h*; *h* is a crooked letter . . ." Now set all these components into Futurist motion, add Dada cynicism,

Surrealist psychology, and Abstract Expressionist crisis, and we may approximate the situation today. Everyone, the artist and perhaps even the nonartist, is "right."

There is another story: a donkey starved to death between two bales of hay because it could not make up its mind which to eat. We resemble the donkey but are surrounded by countless bales of hay. We race in a circle and go mad trying to choose the best. The defiant fall, sooner or later, exhausted from the effort; the sensitive stand shaking in the middle of the arena, nibbling on a straw from a past season. Pursuing the idea of "best" becomes then (insidiously) avoiding the idea of "worst," and value is defeated by paradox. Its most poignant expressions have been the blank canvas, the motionless dance, the silent music, the empty page of poetry. On the edge of such an abyss, all that is left to do is *act* (to echo Harold Rosenberg).

A few have acted, and what they have done has altered the way we think about art. What art has begun to mean now can best be described by its new circumstances and by the self-image artists have had to adopt as a result. Although the change is incomplete, other artists are measuring their stance and goals by what has happened; and those opposed to the change pay it tribute by contrasting their preferences to its alleged inadequacies.

The picture that follows is a synthetic one. It describes no particular artist, nor does it add up specific facts about many artists (though some may be recognizable). It is based upon observation of the painters and sculptors who make up the present vanguard, as well as upon the activities of agents and the public. The picture is as much an interpretation of these observations as a characterization, simplified and purposely dramatized.

Neither Church, nor State, nor Individual

For Leonardo da Vinci, the artist was an intellectual; for Baudelaire, a genius; for the 1930s (as the scene shifts to the United States), a worker; and for the 1950s, a Beat. What a fall from grace! It is said that when we hit bottom there is only one direction to go, and that is up. In one way, it has happened, for if artists were in hell in 1946, now they are in business. But society is becoming so fluid that the way from here is not so much up as out. Not simply "far out," but out of that

inner being who has been bled to death or reduced to impotence from overindulgence. There is a chance that modern "visionaries" are even more of a cliché than their counterpart, "conformists," and that neither truly exists. We look around, and what do we see?

The natural aristocrats are gone, and those still playing the part are like carnival Pagliaccis, pathetic in their self-mockery. The geniuses, too, have vanished, with the beret and velvet jacket. A union label can mean Jimmy Hoffa, instead of humanity. There is no more Beat generation; it found suffering pays off. And the new young hollow-eyed in tattered jeans come freshly showered from the best families and folksing the virtues of Courbet and Cézanne.

The men and women of today's generation matured during and directly after World War II rather than during the Depression. They are almost all college educated and are frequently married, with children. Many of them teach or have taught. On the street they are indistinguishable from the middle class from which they come and toward whose mores—practicality, security, and self-advancement—they tend to gravitate.

They do not live very differently from anyone else. Like anyone else, they are concerned with keeping the rooms warm in winter, with the children's education, with the rising cost of life insurance. But they are apt to keep quietly to themselves no matter where they live—in the suburbs or in the city—rather than enter into the neighborhood coffee break or meetings of the P.T.A. This is not unfriendliness so much as it is a lack of commitment to the standard forms of camaraderie, a detachment born partly of lingering vestiges of romantic alienation and partly of the habit of reflectiveness. Their actual social life is usually elsewhere, with clients, fellow artists, and agents, an increasingly expedient social life for the sake of career rather than just for pleasure. And in this they resemble the personnel in other specialized disciplines and industries in America.

They differ from their middle-class neighbors, not in beliefs, but in consciousness of what is implied by their unexpected position. It shows up in their relations to the art world, in their connection as artists to society, in their sense of themselves and the role they are playing.

According to the myth, modern artists are archetypal victims who are "suicided by society" (Artaud). In the present sequel, they are

entirely responsible for their own life and death; there are no clear villains anymore. There are only cultured reactionaries, sensitive and respected older radicals, rising up in indignation to remind us that Rembrandt, van Gogh, and Pollock died on the cross (while we've "sold out"). As may be expected, then, the artists' involvement with one another is primarily professional. If it is sometimes friendly, the old idea of an artists' clan or group no longer exists.

Society nowadays—at least a rapidly growing part of it—pursues artists instead of exiling them. Unconsciously, it sees them as societal representatives; consciously, it is looking for diversion and status. Of this I shall have more to say shortly, but it is enough to point out that Aunt May and Uncle Jim do not always fit the philistine costumes history has assigned them. Attracted to art by its promotion in mass media, they come to an artist enthusiastically but with little grasp of what that artist is doing. Disconcertingly, they pose as hippies-ready-for-anything and want to be shocked over and over by the very self-analyses, sexual preoccupations, and raw techniques that once repelled them. (Which brings up the problem whether art should not be shocking now to the artist instead of the public . . .)

It is disturbing to be appreciated for naive or wrong reasons. But is it so much better to be vilified for reasons equally invalid? In any case, this uncertain relationship is hardly grounds for war. If society is not entirely bad, if we are a little doubtful of its intent, can we be so sure of our own? If intellectuals cannot come up with fresh insights into the "bourgeois evil" other than its parvenu love for the arts (which they are guilty of themselves), then the main question becomes not, Who is against us? but, What can be done exactly where we are? Unfortunately, there is nowhere else to go.

Unfortunately, also, in the new myth of modern art artists can no longer succeed by failing. Deprived of their classic enemy, society, they cannot comfort themselves in their lack of recognition with the refrain "They'll discover me later," for now their only opponent, if they have any, is the competition. They must put up or shut up, succeed in conveying their own vision in reasonably good time or consider giving up the attempt. Deprived, also, of imaginary ideals, they must work toward an art that they see functioning neither for church nor state nor individual but in a subtle social complex whose terms they are only beginning to understand. Art becomes harder to make than ever.

* * *

The modern artist is usually apolitical (N.B., this was 1964), like some predecessors, but does not have the anxiety about ideological betrayals so typical of artists of the 1940s. International affairs lack essential issues; in practice communism and capitalism look alike: both are simply ambitious, and there is dissension within the ranks of each. National issues, such as civil rights, seem far more real. Yet the newspapers are too full of detailed accounts of the maneuvers and professional tactics of this struggle to leave artists unaware of the consequences of naïveté in the game. Political responsibility is more than mere reaction to injustice and feeling for a cause; it is action planned for results. Political awareness may be everyone's duty, but political expertise belongs to the politician. As with art, only the full-time career can yield results, for results are all that count. The well-meaning amateur in either field is pathetic, and the criterion for involvement in fields that are manifestly no longer easy is, who is best qualified?

Things That Can Be Touched

Harold Rosenberg has pointed out that after World War II artists did not know quite who they were, how they were to function, or what, if anything, there was to value: "The refusal of Value did not take the form of condemnation or defiance of society, as it did after World War I. It was diffident. The lone artist did not want the world to be different, he wanted his canvas to be a world. . . . The American vanguard artist took to the white expanse of canvas as Melville's Ishmael took to the sea. . . . On the one hand, a desperate recognition of moral and intellectual exhaustion; on the other, the exhilaration of an adventure over depths in which he might find reflected the true image of his identity."

Since 1952, when Rosenberg wrote this, artists have found their identities over and over in that white expanse of canvas, and many of the resulting works look remarkably alike. When the plunge into depths brings togetherness up to the surface, the adventure must be

shifted to the pursuit of identities. If things without are truer than the soul within, artists face the same agony of choice as Aesop's donkey. Those who escape the dilemma grasp at the few things personal contact gives them to understand as if these were life jackets, knowing they are not exclusive yet fighting for their recognition because they are true experience.

Value, then, however relative, is taken for granted as the real goal. It is valuable just to make something. It is valuable just to point to something. It is valuable to depict an electric light in a commercial technique (even if it is both an affirmation of the act of depicting and an irony). It is right to attach a pair of pants to a canvas. It is true to life to compose a work that perishes with the occasion. It is better to weld junk metal than to carve wood; and what this means is better than another meaning for the sculptor, and so forth.

Where once artists disclaimed value in favor of the search for it, now artists admit to the blur of values in general and are compelled to establish one or two of them in particular. But if value is the result of artists' crucial decision to act on their own tangible experience, the problem is to transmit that experience effectively in the contemporary department-store milieu. If politics on a national or global scale is presumptuous for amateurs (as "serious" Sunday painting is presumptuous), art politics is not only possible but necessary. It is the new means of persuasion. And persuasion leads to a verification of artists' contact with the world.

Positions of Leadership

The best of the vanguard artists today are famous, usually prolific, financially comfortable. Those who are not yet can be; and those few who will not be must agree that they have rejected the opportunity out of a preference for the tradition of artistic martyrdom or out of fear of temptation.

Among those who have helped the vanguard become well known and successful are schoolmates from the forties and the new curators, gallery dealers, and critics risen to prominence since the war. Nearly all the curators write criticism and monographs (as some of the artists do), thus connecting with the editorial policies of art journals and art

publishers. That these segments of the profession should have a common interest is natural.

Through their colleagues' efforts, artists are called upon to lecture and participate in panel discussions and to appear on radio and TV, where what they say is increasingly attended to as their work is admired. They judge national exhibitions and exert influence on international ones, directly promoting the idea of the new and their own reputations, in addition to recruiting younger artist allies to the big leagues.

They are invited to colleges as part-time "distinguished visiting critics." As heads of art departments or as faculty members with tenure, they personally influence the course of the next vanguard as much as the look of its work: because artist-teacher X's good name has made teaching respectable, students decide upon a similar career, and a generation of creator-professors is born to continue the pattern.

Socially, in turn, vanguard artists are sought after by the wealthy; are seen at fashionable parties and resorts; are honored at the White House. They find, in most instances, that their audience is not the condescending one of the past, because it is not "old money" that seeks them out, but the nouveaux riches, who have been trained like the artists themselves to respond to what is timely.

In such a society, artist Y donates a high-priced work to a useful charity, and others, also reaching uncomfortable tax brackets, find a way to keep their work in circulation while legitimizing the remunerative side of success. At the same time, if artists can perform a charitable act with their own work in the way the executive-collector who buys from them does, by giving it to a museum for a tax break, then these artists not only prove they are on a par with the collector in business matters but best the collector socially by acting independently.

Under such circumstances, painters who may work in a loft cannot in any sense feel themselves part of the "loft generation" of the forties and fifties. Their circumstances are, rather, the conditions of a certain power. The methodology of power is what we normally call politics, and although politics has a bad name, especially in connection with art, implying conniving and dishonesty, it can also be the method of vitality. To assume that standing off from the politics of culture ensures goodness of intent and purity of heart is convincing to no one, least of all to artists who do so; for they will never know whether they have

proved themselves "in the presence of temptation" or have simply run away.

The Responsibility of Power

Power in art is not like that in a nation or in big business. A picture never changed the price of eggs. But a picture can change our dreams; and pictures may in time clarify our values. The power of artists is precisely the influence they wield over the fantasies of their public. The measure of this power lies not only in the magnitude of this influence but in its quality as well. Picasso competes with Walt Disney, who in turn competes with TV soap operas. As it is involved in quality, art is a moral act. Artists usually set out only to be good at their work, but once they recognize the nature of their acts, their obligation is to serve that nature well, and perhaps in ways that can be confused with the practices of hustlers and fakes. When the new is hard to separate from the pseudo-new, motives and results are obscured; but in the absence of standards beyond "each to his own," the best must contend on the same field with the worst. The effectiveness of any artist's vision becomes largely a matter of how that artist balances insights with responsibility to them as value. Practically, this means defending them against other values that may be more immediately compelling; it also means attending to their future. An artist's work, as Rothko and Still have warned, may be misused, perverted, and watered down when it is taken up by the community that is asked to buy it.

Artists cannot assure their success any more than they can control the public's reception of their vision. But this is not the same as saying that it is all a matter of luck. Artists today cannot leave their entire careers to chance, because they will find that others, attending to their own careers, will close them out. A picture remaining in a studio neither exists as value nor exists at all for an art-hungry public that no longer dreams of the romance of bohemia. Similarly, the production of "idle" (i.e., useless) art by artists unconcerned with eternity is a philosophical contradiction as much as it is an unacceptable way of life. The composer John Cage once said that for him a piece was simply incomplete until it was performed. A picture, in this view, is unfinished until it enters the world. But once in the world, that picture cannot be

indifferently released, to exist as best it can. It cannot, for instance, be sold to a recluse in Idaho and to the Time-Life Building in New York on the assumption that either sale will have the same effect—on the work and on the world. It cannot be given for reproduction to a tabloid and to an art journal without its value and its meaning becoming confused. If painters decide that these alternatives are important, however, they must also decide *how*, according to each context, and must be prepared to handle the different consequences. For such consequences polarize the real connections artists have with those around them, who, in turn, have their own interests at stake.

The People Out There

What has been called the art public is no longer a select, small group upon whom artists can depend for a stock response, favorable or otherwise. It is now a large diffused mass, soon to be called the public-in-general. Comprising readers of the weeklies, viewers of TV, visitors to world's fairs here and abroad, members of "culture" clubs, subscribers to mail-order art lessons, charitable organizations, civic improvement committees, political campaigners, schools, and universities—not to mention the boom of new galleries and museums that serve the private collector, the corporation, and the average person—this growing public is involved in art for reasons that are as complicated as they are varied.

A community club may want a stimulating show and lecture. Some members may simply want contact with the artist; but others may want to *learn*. A university art department may want to galvanize its students with the challenge of modernism at its most virulent as well as to prove a point to a lethargic faculty. A politician, seeing an advantage in enlisting the aid of the intelligentsia, may sponsor municipal exhibitions, incidentally becoming so intrigued by the exhibits that he or she starts a collection. A business wants not only the latest art around its factories but also a good investment and, with the tax advantages accompanying large-scale buying, a pleasant sort of philanthropy.

Collectors, the most committed part of this public, are themselves a compound of motives. Newly rich and newly privileged, they are basically intelligent but without excessive training to encumber their enthusiasms. Often crude, compulsive, and unsure of their responses,

they nonetheless grasp the vanguard's work quickly and straightfor-wardly. They support and buy art with a terrifying mixture of awk-ward avidity ("Wow, does that swing!"), suspicion ("Is he nice to me for my money?"), cheap bargaining tactics ("I'll take six paintings at half-price!"), and a deep sense of inherited guilt for their parents' philistinism. (Giotto's Arena Chapel, we are told, was an atonement for its donor's sins; art lovers today may spend cash to redeem their country's art-less past). But such contrasts of intention are not appre-ciably different from what artists themselves experience, so the point need not be pressed.

On the whole, this widening interest in art stimulates the practice of art, as statistics amply confirm. Not only does it echo a pluralistic esthetics, but it also suggests that the range of reasons people now have for being interested in contemporary art is sufficient for art to be admitted to the public domain. Not all artists can benefit from all these reasons, but artists are in a position to turn the welcome signs to their advantage; for, in any case, people are taking advantage of artists.

Essentially, the task is an educational one. Artists are faced with an involved public, willy-nilly. It is not bent on hating them, and it is better to be loved well than loved to death. The duties of instruction in love fall primarily to artists themselves. Their job is to place at the disposal of a receptive audience those new thoughts, new words, new stances even, that will enable their work to be better understood. If they do not, the public's alternative is its old thoughts and attitudes, loaded with stereotyped hostilities and misunderstanding.

Traditionally such responsibility has belonged to critics and, to some extent, dealers. A division of labor was considered appropriate when art was assumed to be an entirely private matter. Intermediaries emerged to tell audiences in words what the artist was doing in images. But, as I pointed out earlier, today's artists are sharing this job at the urging of their own representatives. Indeed, they have done so well at it that the public, still afraid of being foolish in its new-found culture, will have its doubts allayed only by a reassuring word from the horse's mouth. Such artists no longer merely represent authority-as-creator; they are going to be urged more and more to become creator-as-authority.

It seems evident that the days when dealers and critics launched

artists into orbit, while they played the uncontaminated genius, are drawing to a close.

The End of the Temple

The trends I have discussed have affected art's highest office: the museum. This setting has been considered the ultimate glory and sometimes the beatification of art (the Mona Lisa is *enshrined* in the Louvre). Artists still look up to it.

But we might remember that the public museum (along with art shops) developed principally as a substitute for the patronage of the palace and the church. Physically, the museum is a direct parallel in mood, appearance, and function to the cloistered, unattainably grand surrounding art once had. In Europe, the unused monastery and former palace became museums; then in America the style of such structures was imitated. Therefore, we have the "aristocratic" manner of curators, the hushed atmosphere, the reverence with which one is supposed to glide from work to work. Reverent manners became (and still are) confused with reverence for art.

Until recently, far from supporting the art of its time in the manner of a pope or prince, the museum was a conservatoire. To modern artists, it connoted something worse than a repository of objets d'art; it connoted a repository for dead artists, and they were not yet dead.

The curators of today's up-to-date palaces and churches (faced with a scarcity of older art and genuinely sensitive to the new work being produced) try to avoid this dusty stigma by enticing the public in droves with traveling shows, educational programs, rapidly changing exhibits of new work, concerts, lectures, and forums presented by famous names—and even an occasional "scandal." Jean Tinguely's *Homage to New York*, a marvelous contraption of junk that partially and intentionally destroyed itself in performance, was, besides being a work of art by a known innovator, a publicity gesture on the part of the Museum of Modern Art that benefited both parties.

The enterprising commercial gallery functions like a museum in miniature, distinguished from it only by its more open financial motives. Both, attempting to be engagé, enact their rites of life in the isolation of the sanctum sanctorum. A house of art, however, is like a

jewel case for a jewel with no proper place in life; thus museums (and galleries) are rapidly losing contact with the very art they are so eager to promote. As artists become more worldly, their work is less precious, less likely to profit from a setting whose silence and privacy suggest a chapel for the disembodied soul.

At one time, modern art, on its way from the gallery to the museum, stopped off at a collector's home, looking out of place there because it was *lived* with. Now it is the reverse. Kitchen-Sink art, Pop art, Common-Object art, Assemblage, Junk-Culture, Rearrangeables, Multiples, and Environments, united in their appeal to, and often literal involvement in, the themes and space of daily existence, appear absurd and out of kilter in museums where they *cannot* be lived with. (Even the current Hard Edge or Retinal painting and sculpture, whose forms are more retardataire, reveal their precarious purity in contact with active life rather than deprived of it.)

The museum is thus a comparatively recent development that we have assumed always belonged to the nature of art—though in fact most of the past did without it. And it is already obsolete. But even as art is becoming part of the world, more museums are being built to entomb it. It is tragic that painters and sculptors who have reviled the edifice as a tomb willingly consign their life's work to an early burial there. The only hope is that this process will soon stop and that modern museums will be converted into swimming pools or nightclubs.

Middle-class money, both public and private, should be spent on middle-class art, not on fantasies of good taste and noble sentiment. We are as capable of telling a painting's social registration as a building's. Images, techniques, or styles and less obvious appeals to the superior state of beauty, mind, and spirit all display their pedigree and their intentions (or lack of them), along with whatever else the work is about. Middle-class art can wistfully seek "class," but it can never claim it, any more than can its authors, for "class" doesn't exist here. The United States is a country of sophisticated mongrels, and anyone pretending to be highfalutin is marked as a nostalgic. Phony class is always repulsive, but even the sweet dream of yesteryear is getting harder to evoke as time separates us from our European origins. Historical awareness is a necessary part of education, but contemporary action is quite another. The spirit and body of our work today is on our TV screens and in our vitamin pills.

Epilogue

Some theologians and ministers have been hinting that if artists once went to the church for spiritual instruction, it might be time for the church to go to artists. In the two centuries since they left the church, they have stormed barricades or gone to the mountains, become tourists and dandies, felt their pulses, examined their heads, heard their guts growling, picked rags with beggars, lived in cellars with rats, hit the road, or worked in cigar stores. And now they are hurrying along Madison Avenue and jetting around the world, alternately clinking glasses at receptions and conducting seminars in places of higher learning. In between, they work soberly and steadily, for there is not a moment to lose. The best have dared to gamble on the world as it is, for good or for bad. Andy Warhol has said he wants to be a machine: a deus *in* machina! This may be what the church must learn.

Whatever new name we give to our identity remains for the future. But I suspect that it will have more to do with the aisles in supermarkets than with the aisles in houses of God; more with U.S. Highway 1 in a Ford Mustang than the True Path; more with social psychology that Judeo-Christianity. The astronaut John Glenn may have caught a glimpse of heavenly blue from the porthole of his spaceship, but I have watched the lights of a computer in operation. And they looked like the stars.

The Happenings Are Dead:
Long Live the Happenings!

(1966)

Happenings are today's only underground avant-garde. The end of the Happenings has been announced regularly since 1958—always by those who have never come near one—and just as regularly since then Happenings have been spreading around the globe like some chronic virus, cunningly avoiding the familiar places and occurring where they are least expected. "Where Not To Be Seen: At a Happening," advised *Esquire* magazine a year ago, in its annual two-page scoreboard of what's in and out of high Culture. Exactly! One goes to the Museum of Modern Art to be seen. The Happenings are the one art activity that can escape the inevitable death-by-publicity to which all other art is condemned, because, designed for a brief life, they can never be overexposed; they are dead, quite literally, every time they happen. At first unconsciously, then deliberately, they played the game of planned obsolescence, just before the mass media began to force the condition down the throat of the standard arts (which can little afford the challenge). For these the great question has become, "How long can it last?" For the Happenings it always was, "How to keep on going?" Thus *underground* took on a different meaning. Where once the artist's enemy was the smug bourgeois, it was now the hippie journalist.

In 1961 I wrote in an article,

> To the extent that a Happening is not a commodity but a brief event, from the standpoint of any publicity it may receive, it may become a state of mind. Who will have been there at that event? It may become like the sea monsters of the past or the flying saucers of yesterday. I shouldn't really mind, for as the new myth grows on its own, without reference to anything in particular, the artist may achieve a beautiful

Fig. 10 Allan Kaprow, *Household*, 1964, near Ithaca, New York. *Photograph by Sol Goldberg*.

privacy, famed for something purely imaginary while free to explore something nobody will notice.

The Happeners, jealous of their freedom, deflect public attention from what they actually do to a myth about it instead. The Happening? It was somewhere, some time ago; and besides, nobody does those things anymore . . .

There are presently more than forty men and women "doing" some kind of Happening. They live in Japan, Holland, Czechoslovakia, Denmark, France, Argentina, Sweden, Germany, Spain, Austria, and Iceland—as well as in the United States. Probably ten of them are first-rate talents. Moreover, at least a dozen volumes on or related to the subject are currently available: Wolf Vostell, *Décollage 4* (Cologne, 1964), published by the author; *An Anthology*, edited and published by Jackson MacLow and La Monte Young (New York, 1963); George Brecht, *Water Yam* (New York: Fluxus Publications, 1963); *Fluxus 1*, an anthology edited by George Maciunas (New York: Fluxus Publications, 1964); Richard Higgins, *Postface and Jefferson's Birthday* (New York: Something Else Press, 1964); Michael Kirby, *Happenings* (New York: Dutton, 1964); Yoko Ono, *Grapefruit* (Long Island, N.Y.: Wunternaum Press, 1964); Jürgen Becker and Wolf Vostell, *Happenings, Fluxus, Pop Art, Nouveau Réalisme* (Hamburg: Rowohlt Verlag, 1965); Galerie Parnass, Wuppertal, *24 Stunden* (Verlag Hansen & Hansen, 1965); Al Hansen, *Primer of Happenings and Time Space Art* (New York: Something Else Press, 1965); *Four Suits*, works by Philip Corner, Alison Knowles, Ben Patterson, and Tomas Schmit (New York: Something Else Press, 1966); and the Winter 1965 issue of the *Tulane Drama Review*, a special Happenings issue, edited by Michael Kirby, Tulane University, New Orleans. Jean-Jacques Lebel is about to publish his book in Paris, and my book, *Assemblages, Environments, and Happenings* (New York: Harry N. Abrams), will be out this spring. Besides this growing literature, there is an increasing bibliography of serious articles. These publications—and the forty-odd Happeners—are extending the myth of an art that is nearly unknown and, for all practical purposes, unknowable.

Hence, it is in the spirit of things to introduce into this myth certain principles of action, which would have the advantage of helping to maintain the present good health of the Happenings while—and I say this with a grin but without irony—discouraging direct evaluation of

their effectiveness. Instead, they would be measured by the stories that multiply, by the printed scenarios and occasional photographs of works that have passed on forever—and altogether would evoke an aura of something breathing just beyond our immediate grasp rather than a documentary record to be judged. In effect, this is calculated rumor, the purpose of which is to stimulate as much fantasy as possible, so long as it leads primarily away from the artists and their affairs. On this plane, the whole process tends to become analogous to art. And on this plane, so do the rules of the game:

1. *The line between the Happening and daily life should be kept as fluid and perhaps indistinct as possible.* The reciprocation between the handmade and the readymade will be at its maximum power this way. Two cars collide on a highway. Violet liquid pours out of the broken radiator of one of them, and in the back seat of the other there is a huge load of dead chickens. The cops check into the incident, plausible answers are given, tow truck drivers remove the wrecks, costs are paid, the drivers go home to dinner . . .

2. *Themes, materials, actions, and the associations they evoke are to be gotten from anywhere except from the arts, their derivatives, and their milieu.* Eliminate the arts, and anything that even remotely suggests them, as well as steer clear of art galleries, theaters, concert halls, and other cultural emporia (such as nightclubs and coffee houses), and a separate art can develop. And this is the goal. Happenings are not a composite or "total" art, as Wagnerian opera wished to be; nor are they even a synthesis of the arts. Unlike most of the standard arts, their source of energy is not art, and the quasi-art that results always contains something of this uncertain identity. A U.S. Marines' manual on jungle fighting tactics, a tour of a laboratory where polyethylene kidneys are made, a traffic jam on the Long Island Expressway are more useful than Beethoven, Racine, or Michelangelo.

3. *The Happening should be dispersed over several widely spaced, sometimes moving and changing, locales.* A single performance space tends to be static and limiting (like painting only the center of a canvas). It is also the convention of stage theater, preventing the use of a thousand possibilities that, for example, the movies take pictures of but, in the final film, can only be watched, not physically experienced. One can experiment by gradually widening the distance between the events in a Happening. First, at a number of points along a heavily trafficked avenue; then in several rooms and on several floors of an

apartment house where some of the activities are out of touch with one another; then on more than one street; then in different but proximate cities; finally, all around the globe. Some of this may take place en route from one area to another, using public transportation and the mails. This will increase the tension between the parts and will also permit them to exist more on their own without intensive coordination.

4. *Time, closely bound up with things and spaces, should be variable and independent of the convention of continuity*. Whatever is to happen should do so in its natural time, in contrast to the practice in music of arbitrarily slowing down or accelerating occurrences in keeping with a structural scheme or expressive purpose. Consider the time it takes to buy a fishing pole in a busy department store just before Christmas, or the time it takes to lay the footings for a building. If the same people are engaged in both, then one action will have to wait for the other to be completed. If different people perform them, then the events may overlap. The point is that all occurrences have their own time. These may or may not concur according to the fairly normative needs of the situation. They may concur, for instance, if people coming from different areas must meet in time to take a train somewhere.

5. *The composition of all materials, actions, images, and their times and spaces should be undertaken in as artless and, again, practical a way as possible*. This rule does not refer to formlessness, for that is impossible; it means the avoidance of form theories associated with the arts that have to do with arrangement per se, such as serial technique, dynamic symmetry, sonnet form, etc. If I and others have linked a Happening to a collage of events, then Times Square can also be seen that way. Just as some collages are arranged to look like classical paintings, others remind one of Times Square. It depends on where the emphasis lies. A Happening perhaps alludes more to the form of games and sports than to the forms of art; in this connection it is useful to observe how children invent the games they play. Their arrangement is often strict, but their substance is unencumbered by esthetics. Children's play is also social, the contribution of more than one child's idea. Thus a Happening can be composed by several persons to include, as well, the participation of the weather, animals, and insects.

6. *Happenings should be unrehearsed and performed by nonprofessionals, once only*. A crowd is to eat its way through a roomful of food; a house is burned down; love letters are strewn over a field and beaten to pulp by a future rain; twenty rented cars are driven away in different

directions until they run out of gas . . . Not only is it often impossible and impractical to rehearse and repeat situations like these, but it is also unnecessary. Unlike the repertory arts, the Happenings have a freedom that lies in their use of realms of action that cannot be repeated. Furthermore, since no skill is required to enact the events of a Happening, there is nothing for a professional athlete or actor to demonstrate (and no one to applaud either); thus there is no reason to rehearse and repeat because there is nothing to improve. All that may be left is the value to oneself.

7. *It follows that there should not be (and usually cannot be) an audience or audiences to watch a Happening.* By willingly participating in a work, knowing the scenario and their own particular duties beforehand, people become a real and necessary part of the work. It cannot exist without them, as it cannot exist without the rain or the rush-hour subway, if either is called for. Although participants are unable to do everything and be in all places at once, they know the overall pattern, if not the details. And like agents in an international spy ring, they know, too, that what they do devotedly will echo and give character to what others do elsewhere. A Happening with only an empathic response on the part of a seated audience is not a Happening at all; it is simply stage theater.

The fine arts traditionally demand for their appreciation physically passive observers, working with their minds to get at what their senses register. But the Happenings are an active art, requiring that creation and realization, artwork and appreciator, artwork and life be inseparable. Like Action painting, from which they have derived inspiration, they will probably appeal to those who find the contemplative life by itself inadequate.

But the importance given to purposive action also suggests the Happenings' affinities with practices marginal to the fine arts, such as parades, carnivals, games, expeditions, guided tours, orgies, religious ceremonies, and such secular rituals as the elaborate operations of the Mafia; civil rights demonstrations; national election campaigns; Thursday nights at the shopping centers of America; the hot-rod, dragster, and motorcycle scene; and, not least, the whole fantastic explosion of the advertising and communications industry. Each of these plays with the materials of the tangible world, and the results are partly conscious ceremonies acted out from day to day. Happenings, freed from the restrictions of conventional art materials, have discovered the

world at their fingertips, and the intentional results are quasi-rituals, never to be repeated. Unlike the "cooler" styles of Pop, Op, and Kinetics, in which imagination is filtered through a specialized medium and a privileged showplace, the Happenings do not merely allude to what is going on in our bedrooms, in the drugstores, and at the airports; they are right there. How poignant that as far as the arts are concerned, this life above ground is underground!

Experimental Art
(1966)

The world is full of artistic artists, some of them quite good. But there are very few experimenters. The leading vanguard styles of today are engaged in something else.

Hard Edge is the most obviously conservative mode. Its shapes, applied to the standard canvas or the "shaped" canvas or the "object," are a summary of neoclassical abstractions of 1920–45, with a recent boost from Matisse cutouts, which enabled it to parallel the large-scale effect of Abstract Expressionism while avoiding the romantic method. Its composition, however, is more contemporary: it favors the juxtaposition rather than the relationship. Derivatives of the circle, square, triangle, and wave form are abutted, rather than joined by echoes and permutations as in older art. But this device is shared by Assemblage, Pop, some reworked phases of Action painting, and even Environments and Happenings. Though the last two are more genres than styles, and are not "leading" in any case, they are mentioned to show how standard the currency of juxtaposition is. And the use of any currency is antithetical to experimentation.

Op Art intensifies the color theories of Pointillism via Albers and the retinal-fatigue game of Duchamp's Roto Reliefs. Its motifs and their arrangements remain in the Futurist-Constructivist-Purist tradition, whose conventions, echoing the moiré patterns of the fabric industry and the diagrams of psychology and engineering textbooks, have been reabsorbed by Op artists. Although there are subtle differences from the past in this style (and in Hard Edge as well), the sustained impression of Op is not its new look, but its familiarity. Its interest lies in its creation of a new, more palpable, disparity between the illusion of a chromatic movement and the usually static stimuli

that cause it, but the stimuli themselves are well-worn. The same may be said for the kinetic manifestations.

Abstract Symbolism or *Colorfield* painting is in a line that passes back from Newman and Rothko through Purism to the Symbolist circle around Mallarmé. Characterized by a reduction of means so extreme that it approaches vacancy, and attracting the viewer to the subtlest changes of hue and tone, its special appeal comes from the psychic tension caused by prolonged and obsessive use of a single idea minutely varied—within a painting and from painting to painting. But this is the theme-and-variation principle in a state of fixation, and in its very continuousness it cannot be called experimental.

Ob (or object) *Art* has two aspects. One is a contemporary version of the Ready-made and found-object traditions: instead of bottle racks and driftwood, there are electronic devices and cigarette lighters. No further comment is necessary. The other is the physical counterpart in real space to Hard Edge and the crisper kinds of Colorfield painting. It shares a taste for large hypersimple structures, usually geometric, whose blank monochrome surfaces and impersonal treatment at first suggest the reduction of architecture, furniture, or industrial casings to mute essences. It thus invokes the same Purist and Constructivist history as the paintings. Yet most of the works in this vein have no such purpose (metaphysics is unpopular today). Either they frankly exist for themselves without further reference, or they betray a "cool," deadpan wit directed at their "hot" predecessors' search for profound experience. The freedom of this sort of Ob lies in its ambiguous connections to culture and life. But just as it needs art history to define its point of departure and scope, it needs a group of artists all practicing a quasi-repetitive activity to underline its intention; that is, its intention of nonintention. It plays this idea like a popular recording, its insistence increasing with its recurrence. And although this may be a devotional act, it is not an experimental one.

Pop Art continues to affirm a taste for stylization as it narrows its imagery to the nostalgic, chic, or outré and its methods to refinements and parodies of mass-reproduction techniques. Compositionally, it takes off from photomontage, layout design and display, or comic-book and movie-frame sequences, used singly or in repeats, which are them-

selves derived from earlier forms of modern art. Pop is par excellence an art of deliberate cliché, but in its preoccupation with virtuosity it precludes experimentation. Stylists cannot experiment because *what* they style must always be explicit.

Assemblage is potentially the most unbound of the present isms: it eschews consistency on all counts, favoring juxtapositions of not just the shapes of a whole, as in Hard Edge, but also materials and objects differing from one another. Yet Assemblage is an outgrowth of Cubist collage. And in practice it is not appreciably different from territory made familiar by Dada and Surrealism: the urban wastebasket and the oedipal dream. Its subject matter has been updated to include shower fixtures, tires, television sets, rusted motor parts, and neon signs (at which point Assemblage joins Pop). But usually these are fragmented, or the whole group of parts is a fragment of a bit of common reality, in the manner of late Cubism; and so we are continuously playing our present responses against the first quarter of this century.

The avant-garde functions as Art art; its genealogy is spelled out in columns of cultural events: so-and-so begat so-and-so, who begat . . . It is developmental rather than experimental. Yet if it is a truism that art, like everything else, has its past, modern art until recently has acted as if it were an exception. It was new, brand-new, without antecedents. It wiped away the past in a marvelous gesture of self-sufficiency. History was bunk, and influences were usually denied in spite of evidence to the contrary. An era was being born. For the public, urged on by talk in vanguard circles of the early twentieth century, contemporary art as a whole became known as experimental.

Now we know better. We admit with a shrug that there is nothing new under the sun and devote ourselves to magnifying marginal differences. Like popular soaps, the same lather comes out in shades of blue, greeny blue, turquoise, and lilac, each dramatically novel . . . Still, if the characterization of modern art as experimental was incorrect, it remains intriguing to speculate on what an experimental art might be. The idea has the inescapable flavor of daredeviltry. It smells of wildness, trouble, a good fight . . .

To Experiment: schoolboy memories of oddballs puttering in their garages with twisted wires, sparks flying, bubbling test tubes, clanking

gadgets, sudden explosions . . . Tom Swift, Frankenstein, Jules Verne, and now the astronauts (I have often wondered what it would be like to have the first hot-dog stand on the moon). Imagine something never before done, by a method never before used, whose outcome is unforeseen. Modern art is not like this; it is always Art.

This is the adventurer's side. Couple it with the professional view that nowadays young artists are schooled historically to an extraordinary degree, and their knowledge of what is going on is staggering. It is nearly impossible to make the slightest gesture without calling up references that are instantly recognized as history. Among the cognoscenti, whose number is steadily growing, innovations are met with nods of expectation as though they were foregone conclusions. Predictions of things to come are not the business of prophets and quacks; they approach computability on the basis of the abundance of data made available at every minute to the communications systems.

But if something occurred in which the historical references were missing, even for a short time, that situation would be experimental. Certain lines of thought would be cut or shorted out, and normally sophisticated minds would find themselves aghast.

Such a position must be willed, worked at. It shares with the tradition of militant modernity the one essential ingredient of newness that has been confused with experimentation: extremism. For the experimenter, like the extremist or radical, being at the outer limits is an important condition for jarring into focus attention to urgent issues, but the experimenter's issues are philosophical rather than esthetic. They speak to questions of being rather than to matters of art. In contrast, extremist painting—Cubism, for instance—need not be experimental at all; to the public it may be no more than an uncomfortably rapid evolution of a prior mode. The leaps taken by the painter are simply too large for the public to follow quickly.

Developmental artists know what art is. At least they have faith in it as a discipline whose horizons can be extended. Experimentalists have no such faith. What they know of the arts and the variety of esthetic theories confirms their suspicion that art is a free-for-all meaning nothing and everything. The one thing that keeps them from becoming barbers or ranchers is their persistent curiosity about what art might be in addition to what everybody else has made it.

It can be argued that we are not really dealing with alternatives. If almost all modern art is developmental, consciously or not, with a

family tree of commentaries, quotations, and extensions, then the very notions of experimentation and risk are themselves a heritage of the last hundred years. But the critical difference here involves a separation of cultural *attitudes* from cultural *acts*: attitudes that are to be applied to a zone, still unmarked, between what has been called art and ordinary life. Metaphorically, the displacement is almost a manufactured schizophrenia, and in the shift a unique mentality may take over.

Once over the line, experimental artists are those whom the public and their own colleagues consider "far out," but who also believe this about themselves. They feel cast adrift. They are the opposite of naïfs, but the past as a measure has become useless to them; there are no traditions to draw on, no allusions to the work of contemporaries, no esthetic problems, and no apparent solutions. Such circumstances are rare, as extremist artists must admit; *they* at least have a fair idea of what they are doing (in spite of their statements, after the fact, that while working they did not know). The detachment of cultural experimenters from the body of culture must be so great that their state is not so much lonely as metaphysically nameless.

Such an alienation has nothing to do with the social plight of the artist; if there are causes in society, they reflect the general existential crisis, rather than the waning conflict between the arts and the middle class. Nor has it to do with the personal doubts and despair all artists have known in the course of their work. They suffer when the magic is not going well; they feel powerless to serve certain principles they believe in, and everything seems chaotic. But an artist's work goes poorly because of a loss of confidence and self-esteem, not because of experimentation. Uncertainty for painters and sculptors may be no asset, but for the experimentalist it is the sine qua non.

In 1953, Robert Rauschenberg exhibited a number of large all-black and all-white paintings (done in 1951) on which the paint was applied flat and without modulation. Nothing more was done to them. They were taken as a joke by most of the committed artists of the New York school. Yet they are the pivotal works of the artist, for in the context of Abstract Expressionist noise and gesture, they suddenly brought us face to face with a numbing, devastating silence. Even granting the salvational overtones in the pairing of black and white, an implication that no work had been done, no expected artistry demonstrated, left

viewers with themselves and the void in front of them. Their shadows moved across the blanked screen, which mirrored the stammering images of their unwilling minds, because such "nothing" was intolerable. They may have caught a glimmer of the point that now much, if not everything, having to do with art, life, and insight was thrown back at them as their responsibility, not the picture's. And that was shocking. But Rauschenberg for his part did not want to shock; he "wanted to make a painting."

About the same time, Rauschenberg asked Willem de Kooning, whom he admired, for a drawing, in order to erase it. De Kooning agreed and Rauschenberg erased the drawing. The request, often recounted, has also been interpreted as witty one-upmanship. But I find it more in keeping with the equivalent, though psychological, erasure of sensuous paint and personal content from the surface of the black and white canvases. It was a similar kind of esthetic denial. Symbolically, the erasure functioned like, say, the renunciation of worldly life by a hermit-saint, but now exercised within the profession of painting and drawing.

It probably felt as uncomfortable to Rauschenberg, in view of his sensitivity to art, as it felt aggressive to de Kooning. But when Rauschenberg asked for a drawing to erase, the two artists became involved in a drama that transcended them and neutralized personal feelings. The younger man felt that de Kooning understood this because in de Kooning's own work a parallel process of scraping off and interminable repainting often made his canvases seem unfinishable and implied the impossibility of art. Rauschenberg's negation tacitly acknowledged de Kooning's bout with the deeper predicament of modern art, which could not provide the utopian solutions to the world's ills that it had once promised. At best it could be just the effort of the artist to make something that felt honest, as Harold Rosenberg has often pointed out. Here, too, Rauschenberg simply "wanted to make a drawing." By erasing art, he might make art possible.

Renunciations are not new. When they have been purposive, as Rauschenberg's was, they have been a means to achieve freshly and honestly what could not be achieved by going on as before. St. Francis, an urban gentleman, found honesty by "erasing" his secular life and communing with nature. In doing this he became innocent (and thereafter dealt with humans very well). The dream of the return to innocence has been part of history for a long time and has been the

plaintive cry of the modern artist since Impressionism. But the inno-
cence of an adult is always the product of a struggle. Today, among a
generation that no longer trusts in the purity of childhood, innocence
is not something we are born with—something once had, then lost,
then regainable. It is an intellectual invention, which we are forever in
danger of losing as soon as we seem to attain it.

Pissarro and later the Futurists considered the idea of burning
down museums, not out of perversity, but to express a longing to be
unencumbered by a seductive past that blinded them to the present;
that is, to a modern life whose instantaneity made it the available
counterpart in the everyday world to the apparent innocence of the
child or saint. In a less romantic way, Mondrian's art was a methodical
pursuit of the same thing. Its effect on the eye and mind is that of a
fullness of visual action and counteraction whose paradoxical conse-
quence is emptiness, a blank canvas, a tabula rasa. I have described
elsewhere ["Impurity"] how this was brought about by a continuous
process of optical and plastic cancellations and quoted Mondrian as
saying: "The destructive element is too much neglected in art."

But the Impressionist's and Futurist's search for the clean slate was
more or less intuitive, whereas Mondrian made it the endless means
of his work. Rauschenberg's erasures were total and decisive and left
no room for further action in that arena. The black and white paintings
could not be repeated.

In retrospect, as much as these deeds were an effacement, they
were also an experiment. The word *experiment* suggests, among its
meanings, "the testing or trial of a principle," and the principle at stake
in 1953 was explicitly (Rauschenberg's) creativity and implicitly all art.
It is conventional to assume that the human being is creative and
expresses this creativity in works called art. To question this assump-
tion in the activity of painting or sculpture (that is, nonverbally) re-
quires a means that at once accepts creative art and challenges it on its
own grounds. This is what Rauschenberg did. It was unclear then if
the experiment with art was itself art—although in 1966 it has become
art. The interested few at the time seemed not to care. What mattered
was that an artist did something unambiguous, under a burden of
what I recall as great doubt about everything esthetic and, perhaps,
personal.

The move was irrevocable (like suicide) and allowed neither re-
duction nor amplification. It thus had nothing to do with pure essences,

symbolic states, or mystic onenesses, but it had much to do with being utterly deprived of the most elementary means for achieving something productive. This was the price of the experiment, posing as it did the alternatives of jumping blind or facing spiritual impotence. Rauschenberg never doubted the value of art as a cultural dream; he challenged its existence as fact. Facing such choices made it easy to jump; there was nothing else to do. For him and for us who saw the black and white paintings, these works were an end to art and a beginning. Once a human shadow gets into a painting for a moment, everything becomes possible and the conditions for experimentation enter the scene. Possibility, artists know, is the most frightening idea of all.

It is no accident that the lines dividing the arts are rapidly falling out of place and everything is becoming confused. There are no clear distinctions between drawing and painting, painting and collage, collage and Assemblage, Assemblage and sculpture, sculpture and environmental sculpture; between environmental sculpture, displays, and stage sets; between these and Environments; between Environments, architectural design, and architecture per se; between the fine and the commercial arts; and, finally, between art of any kind (Happenings) and life. This is the way the world goes because this, apparently, is the way it wants to go. (Is the line between the North and South the lower border of Pennsylvania or racial prejudice . . . and where is that?) Conventional distinctions are not merely inadequate; they are tiring, and fatigue sits well with no artist.

Conventional distinctions, moreover, insofar as they are maintained by a few men and women of considerable gifts, are not so much accepted as the natural order of things as they are pronounced as articles of faith or the requirements of an ideology: *"Good painting will always be good painting"*; or *"The mainstream of modern art leads inevitably to abstraction; therefore . . ."* Everyone knows what is occurring, though no one knows to what extent or purpose. It may be that the only safe conclusion to draw is that traditions find their place today alongside nontraditions precisely *because* no distinctions can be made. The American melting pot has become a global stew, and the American mind is an Assemblage.

"Safe conclusions" may help us keep our footing in a precarious

art situation, governed as it is by historical awareness. They are useless, however, for experimental artists except as points of departure. Neither experimental artists nor "art" artists can avoid history and esthetic pluralism; but experimentalists are temperamentally less likely to be able to take a stand in their cultural kaleidoscope. To find somewhere to stand, they have to renounce everything. For them all existing values are equally good and equally unconvincing. To affirm any one of them requires discovering it anew by some as yet unknown method; or some other value must be discovered by the same path. If this decision to deny everything is not made early, a consequence close to catatonia can be expected.

Granted, this is artificial, and psychologically it may be dangerous, for we do not lose anything we try to give up. But as in the example of Rauschenberg thirteen years ago, the artist may have no real choice. He or she jumps, or else.

The thing to do is to take the bull by the tail and try to swing him. Instead of beginning with styles and techniques, artists must violate their beliefs regarding the very idea of art; they must destroy as many distinctions as still exist in the idea and let loose with confusion and insecurity (matching by deliberation what already goes on mindlessly in the world). The day after, the week or year after, much will be clear again. It is then time to start all over. We stir up confusion for the sake of clarity and strive for order to lose our wits. We've heard this yell before, but its purpose has always been to keep the action going. The action slows down when we are sure there are answers and when we are sure there are no answers.

A somewhat fuller characterization of experimental artists can now be proposed. They usually say they are making art, whatever anyone thinks. But they will not be sure until sometime in the future, whereas Art artists know they are always making art, good or bad. If experimental artists occasionally say what they do is not art, or both is and isn't, this statement is to be understood as irony to underline the nature of doubt; for they are speaking as artists to other artists and critics. Their action is problematical only to those involved in the profession, who tell the public, via the news media, that it is a problem for them, too. They know that, as contradictory as it is, any nonart action undertaken in the context of the art world may become art by association.

Therefore they keep pushing what they do toward areas in which greater and greater uncertainty lies. Their moves become more decisive as the value of their means eludes them. Their goal of discovery is the more compelling as the outcome of these means is less and less predictable.

Such conditions will obtain probably only once in each artist's life. If artists discover something of value in the process, the chances are that they will cease experimenting and devote the rest of their career to mining what they have found—at which point they join the larger community of artists. But if they wish to continue experimenting, even if only from time to time, their method must be applied as rigorously as in the beginning.

It means erasing their profession as a value and accepting only what is phenomenally doubtless: life. They do not need to refer to Cartesian argument to verify their existence. To artists, if existence is doubtable—that is, if life is a dream—then it is all art, in which case it has been senseless to have restricted it to such a narrow range of dream language as painting or sculpture. If life is not a dream, then what has been called art is different and can easily be denied. Besides, vanguardists seem intent on confusing the two anyway, for everything they touch has a way of turning into dreams. If each succeeding dream is called art and is summarily denied value, then statistically an endless range of discoveries is available. Innocence is possible, after all.

To reject art and being an artist as values, however, does not automatically make them nonvalues. Nor, in contrast, does life or the dream of life automatically become value and thus art. Painters or sculptors cannot put out their past as they would a light. Michelangelo, Bach, Ictinus, Shakespeare, de Kooning, Rauschenberg, and their occupations may be devalued by edict, written off, but only by a deliberate discipline of eradication.

Each day former Art artists, their backs up against the weight of memory and training, insistently turn away from books, exhibitions, and the shoptalk of friends until the seduction of art has ceased. They act like monks, or criminals going straight. The withdrawal symptoms of breaking the art habit are no less agonizing than those of the heroin addict. Similarly, turning back to art during this time will prove as fatal to experimenters as worldliness, crime, and dope prove to those of related callings.

* * *

Abstinence of this sort functions only in a context of knowledgeability. Novices or flip types with an axe to grind can renounce nothing, for they possess nothing except inexperience and/or disrespect. Under the banner of Denial, they would merely substitute naïveté and license, which if pursued to any degree would approach the pathological. The man—or woman—of the world, for whom the test of art is an ethical imperative, cannot do this either casually or intuitively. Obeying feelings as they come and go, wandering around as if in search of pebbles at the beach, will almost certainly lead to clichés. Sensibility and the haphazard are no longer sources of enlightenment for the best minds, because lesser minds have played them out of service. Insight (if indeed it is to be had at all) is now to be gotten through methodical thought and operations. The university training that most artists receive today gives them reasons to doubt art and the means to both destroy it and re-create it. Experimentation is a philosophical affair, but its outcome may be explosive.

Experimental artists always deny art within the circle of art, submitting their alternative actions for acceptance as the preferable form of what they have rejected. Even if they occasionally refuse the accreditation when it is given, they do so to prolong the experimental atmosphere, since the experiment could not be performed elsewhere without losing its identity and the issues it proposes to tackle. This acceptance as art, no matter how late it comes, is in my view the goal. The temporary ambiguity of experimental action is appropriate, for to leave art is to escape from nothing; what is suppressed emerges in disguise. A residue of esthetics and masterpieces lies on the inside of our eyelids as patterns of semiconscious recall. The task is to build up sufficient psychological pressure to release from the transformations of this material the *energy* of art without its earmarks.

Put differently, if any action of an artist meant as a renunciation of art can itself be considered art, then in those circumstances nonart is impossible. Shredding newspaper in a shop window need not merely be making litter for puppies; the shop window could become an Environment in which the dogs might play roles. The thudding of rain-

drops in the dust could become a fabulous sound-painting; ant hills could become great architecture in motion; the screeching of a thousand starlings blotched against the treetops could turn into an unbelievable opera; the monkey building at the zoo could emit a powerful orchestration of odors, revolting, strange, and even pleasant. Art terms like *painting*, *architecture*, and *opera* are used advisedly to point up the ease by which displacement can occur between one mode of reference and another.

Once it is understood that the objective is to raise that inner tension to such a pitch that the conversion of nonart to art will be electrifying, it should be further understandable why experimenters must ruthlessly rip out the last shred of artistry in their every thought and enthusiasm. It is not enough to refuse contact with museums, concert halls, book shops, and galleries. Nor is it enough to put out of mind actual paintings, poems, architecture, musical pieces, dances, and movies. Artists must also reject the facility for metaphor making whenever it becomes apparent, and it will become apparent often. They must put aside all conscious echoes of art media, subject matter, and methods of formation.

Paint, for example, has other uses than in pictures. Experimenters might find it worthwhile to watch the way painters, hanging from ropes, daub red lead on the peeling girders of the George Washington Bridge. Regarding subject matter, if still lifes of apples, gestures of supplication, vertical lines on a rectangular field, bottle racks, Dick Tracy, young men contemplating skulls, or Ronzoni macaroni have been identified with art, they are to be bypassed by the experimenter. (So far as I know, nobody has ever put a functioning Roto-Rooter into a work of art.) Similarly with compositional practices: all the habits of thematic elaboration, countervariation, inversion, rhyme, spatial tension, transition, and balance so important in an artist's training are to be given the heave. Carrying them over to act upon nonart materials would automatically make the result a development of recent art history. The only form a thing has is what it looks like or does. That is, if a chicken runs, eats chicken feed, and roosts, that is all the composition required and all the composition the experimenter needs to think about. This is not nonform, for the brain can only function in patterned ways. It is simply an avoidance of the familiar artistic distinction between matter (the medium) and its malleability (the form). The experimenter's focus may fix on recurrences and relationships, but they

will be more like the recurrence of the pulse and the seasons than inspirations to artifice and skill.

At this juncture we are not just drawing up battle lines; we are also implying active responses. The question is, What do experimental artists *do*? They might sit quietly with friends in a tree, all of them painted black, and when the starlings alight, screech with them. Microphones amplify the noise across hidden public-address systems. Ear-splitting. Probably silence soon. They might rent a bulldozer and throw up a man hill near an ant hill. People slowly crawl like ants up and then down the mound, and on and away, in a file. They might dynamite fifty patches of meadow during a thunderstorm, throwing two hundred big metal drums end over end, booming, bonging.

And so on. In an automat lunches are being eaten. Usual business. Suddenly the eaters smash their dishes to the floor and leave at once. Meanwhile, in a rush-hour subway, a bunch of passengers start to shout as loud as they can and bang on pots and pans for a few seconds. At the next stop they get off and confront the cops. An empty 3 A.M. in the Whitehall Street subway station. A bewildering maze of ramps, stairways, and passages connecting several train lines. Sweepers descend from the street, sweeping dust and bodies while from below, tarpaper is unrolled toward them. As the two groups meet, the bodies are covered with the paper. The sweepers and rollers go home. Still, black clumps remain in the corridors. After a while the covered people get up and stuff their tarpaper into wastebaskets and go home, too . . . Watchers stand around Times Square waiting for a signal from a window. It doesn't come for a long time. When it does, it tells them to walk to a place on the sidewalk and fall down. A truck comes along and they are loaded up and driven away . . .

In a stroke the esthetic problems over which generations have argued go by the board. Classic questions regarding "the discrete art object," "psychic distance," "pure form," "significant form," "the transformation of nature through a medium of expression," "the unity of time and speed," "permanence," and so on do not apply or apply so generally that nothing is gained by dwelling on them. The real issue is that until these actions were written here or, if not written, until they are pointed out by those calling themselves artists, they would hardly have been classifiable as part of fine art.

This uninhabited area is experimentation's proper place. And the longer artists can keep the art world's judgment of it hung in the balance between acceptance as Art and dismissal as something beyond the pale, the more they can trust in the validity of what they do. For they gamble against its being art too soon. Judgment may be difficult—often artists and public are enmeshed in a situation that will vanish after its enactment—but the context demands criticism in retrospect. If something of value must remain for our tomorrows, it will have to be a myth. A myth may compel even more than a picture, and someone may decide to act it out, however altered it may be in its new form. At that moment it becomes art.

Let us imagine the suicide of an obscure painter. It is around 1950. He lives in a railroad flat in New York and is painting large all-black canvases. He covers most of the walls with them, and it is quite dark in his place. Shortly thereafter, he changes to all-white pictures. But he does a curious thing: he proceeds to seal off each of his rooms with four paintings constructed to just fit their space, edging the final one into position as he moves to the next room. He starts in the bedroom and ends in the kitchen (which lets out to the hallway). There he paints the same four white panels but doesn't leave. He builds a series of such cubicles, each within the other, each smaller. He is found dead, sitting in the innermost one.

His act is tragic because the man could not forget art.

Let us imagine the suicide of an obscure painter. It is around 1950. He lives in a railroad flat in New York and is painting large all-black canvases. He covers most of the walls with them, and it is quite dark in his place. Shortly thereafter, he changes to all-white pictures. But he does a curious thing: he proceeds to seal off each of his rooms with four paintings constructed to just fit their space, edging the final one into position as he moves to the next room. He starts in the bedroom and ends in the kitchen (which lets out to the hallway). There he paints the same four white panels but doesn't leave. He builds a series of such cubicles, each within the other, each smaller. He plans to be found dead, sitting in the innermost one.

But the thought of committing suicide becomes less compelling than the thought of how beautifully he is going about it. He breaks open the cubicles, leaves the apartment, makes a lifelike image of

himself, returns to put it on his death chair, replaces all the panels, and then invites his friends to see what he has done.

This act is tragic because the man could not forget art.

Let us imagine the suicide of an obscure painter. It is around 1950. He lives in a railroad flat in New York and is painting large all-black canvases. He covers most of the walls with them, and it is quite dark in his place. Shortly thereafter, he changes to all-white pictures. But he does a curious thing: he proceeds to seal off each of his rooms with four paintings constructed to just fit their space, edging the final one into position as he moves into the next room. He starts in the bedroom and ends in the kitchen (which lets out to the hallway). There he paints the same four white panels but doesn't leave. He builds a series of such cubicles, each within the other, each smaller. He is found dead, sitting in the innermost one.

Actually, the painter is telling this story to his friends as a project he has in mind. He sees how attentively they listen to him, and he is satisfied.

This act is tragic because the man could not forget art.

Experimental art is never tragic. It is a prelude.

Manifesto

(1966)

Once, the task of the artist was to make good art; now it is to avoid making art of any kind. Once, the public and critics had to be shown; now they are full of authority and the artists are full of doubts.

The history of art and esthetics is all on bookshelves. To its pluralism of values, add the current blurring of boundaries dividing the arts, and dividing art from life, and it is clear that the old questions of definition and standards of excellence are not only futile but naive. Even yesterday's distinctions between art, antiart, and nonart are pseudo-distinctions that simply waste our time: the side of an old building recalls Clyfford Still's canvases, the guts of a dishwashing machine double as Duchamp's *Bottle Rack*, the voices in a train station are Jackson MacLow's poems, the sounds of eating in a luncheonette are by John Cage, and all may be part of a Happening. Moreover, as the "found object" implies the found word, noise, or action, it also demands the found environment. Not only does art become life, but life refuses to be itself.

The decision to be an artist thus assumes both the existence of a unique activity and an endless series of deeds that deny it. The decision immediately establishes the context within which all the artist's acts may be judged by others as art and also conditions the artist's perception of all experience as probably (not possibly) artistic. Anything I say, do, notice, or think is art—whether or not I intend it—because everyone else aware of what is occurring today will probably say, do, notice, and think of it as art at some time or another.

This makes identifying oneself as an artist ironic, an attestation not to talent for a specialized skill, but to a philosophical stance before elusive alternatives of not-quite-art and not-quite-life. *Artist* refers to a person willfully enmeshed in the dilemma of categories who performs as if none of them existed. If there is no clear difference between

an Assemblage with sound and a "noise" concert with sights, then there is no clear difference between an artist and a junkyard dealer.

Although it is commonplace to bring such acts and thoughts to the gallery, museum, concert hall, stage, or serious bookshop, to do so blunts the power inherent in an arena of paradoxes. It restores the sense of esthetic certainty these milieux once proclaimed in a philistine society, just as much as it evokes a history of cultural expectations that run counter to the poignant and absurd nature of art today. Conflict with the past automatically ensues.

But this is not the issue. Contemporary artists are not out to supplant recent modern art with a better kind; they wonder what art might be. Art and life are not simply commingled; the identity of each is uncertain. To pose these questions in the form of acts that are neither artlike nor lifelike while locating them in the framed context of the conventional showplace is to suggest that there really are no uncertainties at all: the name on the gallery or stage door assures us that whatever is contained within is art, and everything else is life.

Speculation: Professional philosophy in the twentieth century, having generally removed itself from problems of human conduct and purpose, plays instead art's late role as professionalistic activity; it could aptly be called philosophy for philosophy's sake. Existentialism for this reason is assigned a place closer to social psychology than to philosophy per se by a majority of academicians, for whom ethics and metaphysics are a definitional and logical inquiry at best. Paul Valéry, acknowledging the self-analytic tendency of philosophy, and wishing to salvage from it something of value, suggests that even if Plato and Spinoza can be refuted, their thoughts remain astonishing works of art. Now, as art becomes less art, it takes on philosophy's early role as critique of life. Even if its beauty can be refuted, it remains astonishingly thoughtful. Precisely because art can be confused with life, it forces attention upon the aim of its ambiguities, to "reveal" experience.

Philosophy will become steadily more impotent in its search for verbal knowledge so long as it fails to recognize its own findings: that only a small fraction of the words we use are precise in meaning; and only a smaller proportion of these contain meanings in which we are vitally interested. When words alone are no true index of thought, and when sense and nonsense rapidly become allusive and layered with implication rather than description, the use of words as tools to precisely delimit sense and nonsense may be a worthless endeavor. LSD

and LBJ invoke different meaning clusters, but both partake of a need for code; and code performs the same condensing function as symbol in poetry. TV "snow" and Muzak in restaurants are accompaniments to conscious activity whose sudden withdrawal produces a feeling of void in the human situation. Contemporary art, which tends to "think" in multimedia, intermedia, overlays, fusions, and hybridizations, more closely parallels modern mental life than we have realized. Its judgments, therefore, may be accurate. *Art* may soon become a meaningless word. In its place, "communications programming" would be a more imaginative label, attesting to our new jargon, our technological and managerial fantasies, and our pervasive electronic contact with one another.

Pinpointing Happenings

(1967)

From now on, those who would write or speak intelligently about Happenings must declare what sort of phenomenon they are referring to. *Happening* is a household word, yet it means almost anything to the households that hear it and use it. Consider the following:

A few seasons ago, an issue of the *New Republic* with a lead article on the political campaign of Bobby Kennedy, announced on the cover: "Bobby Kennedy Is a Happening."

Howard Moody, a minister at New York's Judson Church, sent me a reprint of an excellent sermon called "Christmas Is a Happening."

Disc jockey Murray The K once punctuated his hyped-up delivery with "It's what's *happening*, baby!" In his new job, with his now carefully modulated voice, he grooms the call-letters of WOR-FM, "The Happening Station."

A cosmetics commercial, composed of a swirl of gimmicky, suggestive noises leading to the name of the product, ends sexily, "That was a Happening—by Revlon."

Manhattan's former parks commissioner, inaugurating the Great Year of the Spiritual Thaw, sponsored paint-ins, reserved the park for cyclists on Sundays, flew kites in Sheep Meadow, had a water splash on the lake, demonstrated some fancy ice skating, made snowball throwing official, invited the public to a stargazing, and throughout gave the city a phrase to explain it all: "Hoving's Happenings."

Hippie groups, discotheques, PTA meetings, Rotary Club outings, a popular rock-and-roll band, a hit record by the Supremes, a party game kit, and at least two regular-run movies—all are called Happenings.

The *Saturday Review* asked recently in a feature article if American history was not a Happening; there was even a news analyst last winter who cynically judged our war in Vietnam as "a Happening gone out of control."

But everything came together one Sunday in January. In the *New York Times Magazine*, a piece on furniture design was titled "1966 Was a Happening." It summed up an entire year of our lives. The clear implication was that *life itself* is a Happening. And in a special sense perhaps it is, although what this sense is will have to come later.

What do the fifty or so Happeners around the world think a Happening is? With them, too, the variety of opinion is disconcerting. Most, including myself, have tried to get rid of the word *Happening*, but this seems futile by now. Granting a certain amount of oversimplification, roughly six directions appear prevalent. Among them there is a fair amount of overlapping and a continuous recombination. As difficult as it may be to find a pure Happening of each sort, however, future critics will find it useful to identify as nearly as possible the kind of work they are talking about. (There is as much difference between some Happenings as there is between Beethoven and Hershey's chocolate bars.)

First there is the *Night Club* or *Cock Fight* or *Pocket Drama* style, in which small audiences meet in cellars, rooms, or studios. They press close around the performers and are occasionally drawn into the action in some simple way. Jazz may be played, a couple may make love, food may be cooked, a film may be projected, furniture may be battered to bits or paper torn to shreds, dancelike movements may occur, lights may change color, poetry or words of all kinds may pour forth from loudspeakers, perhaps superimposed or in unusual order. Throughout, a mood of intense intimacy prevails.

An extension of this type of Happening is the *Extravaganza*. Presented on stages and in arenas to large audiences, it takes the form of a fairly lavish compendium of the modern arts—with dancers, actors, poets, painters, musicians, and so forth all contributing talents. In basic concept (probably unconsciously) the Extravaganza is an updated Wagnerian opera, a *Gesamtkunstwerk*. Its character and methods, however, are usually more lighthearted, resembling three-ring circuses and vaudeville reviews in the way that these were developed by Dada and Surrealist antecedents. This Happening is the only kind with which

Fig. 11 A participant in Allan Kaprow's *Record*, 1967, near Austin, Texas. *Photograph by Howard Smagula.*

the public has any familiarity and, incidentally, with which it feels some degree of comfort. Watered down, it has emerged as the stock-in-trade of the discotheque and psychedelic scene.

Then there is the *Event*, in which an audience, again usually seated in a theater, watches a brief occurrence such as a single light going on and off or a trumpet sounding while a balloon emerges from its bell until it bursts. Or there is a prolongation of a unitary action such as a man walking back and forth across the stage for two hours. Most frequently, deadpan wit joins, or alternates with, disciplined attentiveness to small or normally unimportant phenomena.

Next is the *Guided Tour* or *Pied Piper* kind of Happening. A selected group of people is led through the countryside or around a city, through buildings, backyards, parks, and shops. They observe things, are given instructions, are lectured to, discover things happen-

ing to them. In this mode, the intended focus upon a mixture of the commonplace and the fantastic makes the journey a modern equivalent to Dante's spiritual one. The creator of this Happening, more than a mere cicerone, is in effect a Virgil with a message.

The fifth is almost entirely mental. It is *Idea* art or literary *Suggestion* when it is written down in its usual form of short notes. "It's raining in Tokyo"; "Fill a glass of water for two days"; "Over there"; and "Red light on the Brooklyn Bridge" are examples. They may be enacted but need not be (and often are not). They follow the Duchampian implication that art is what is in the mind of the beholder, who can make art or nonart at will; a thought is as valuable as an action. The mere notion that the world is full of ready-made activities permits one quite seriously to "sign" the whole earth, or any part of it, without actually doing a thing. The responsibility for such quasi-art is thus thrown entirely upon the shoulders of any individual who cares to accept it. The rest is primarily contemplative but may lead in time to meaningful action.

The sixth and last kind of Happening is the *Activity* type. It is directly involved in the everyday world, ignores theaters and audiences, is more active than meditative, and is close in spirit to physical sports, ceremonies, fairs, mountain climbing, war games, and political demonstrations. It also partakes of the unconscious daily rituals of the supermarket, subway ride at rush hour, and toothbrushing every morning. The Activity Happening selects and combines situations to be participated in, rather than watched or just thought about.

Of the six categories of Happening, the last appears to me most compelling, if indeed most risky. It is the least encumbered by artistic precedents and the least professionalistic; it is free, therefore, to confront the question raised earlier, whether life is a Happening or a Happening is an art of life. Asking the question seems preferable to defending the Happening from the very start *as* an art form. The Activity type is risky because it easily loses the clarity of its paradoxical position of being art-life or life-art. Habit may lead Happeners to depend on certain favored situations and to perfect them in the manner of conventional artists. Or their choices may become so indistinguishable from daily events that participation degenerates into routine and

indifference. Either way, they will have lost the handshake between themselves, their co-participants, and the environment.

It is possible now to consider the difference between the Happening and an advertising campaign, a commuter train ride, the stock exchange. Or if these seem too prosaic—notwithstanding the deliberately prosaic quality of some Happenings—there is the recent Alaska earthquake, the Candy Mossler murder trial, the Buddhist monk who burned himself in Saigon, and, for piquant relief, the Mad Litterbug who periodically covers several city blocks in New York with paper cutouts.

Clearly none of these examples was initially a Happening. Yet any of them *could* be if some Happener wished to include them. The distinction is simply that of assigning a new or multiple set of functions to a situation normally bound by convention; at the very least, it is the consciousness of this possibility. We might imagine that Candy Mossler was a female impersonator whose every appearance in the newspapers caused those in the Happening to dress as she did and privately tape-record their thoughts. These were later sent to "Mrs." Mossler, signed with her name and address.

A Happening is always a purposive activity, whether it is gamelike, ritualistic, or purely contemplative. (It may even have as its purpose no purpose.) Having a purpose may be a way of paying attention to what is commonly not noticed. Purpose implies a selective operation for every Happening, limiting it to certain situations out of countless options. The selections individual Happeners make are as personal as their influence upon lesser figures is obvious. The expressive character of the selection of image-situations may be assertive or passive, but the choice itself suggests value: what is presented is worthwhile in some way. What is left out, by virtue of its very exclusion, is less worthwhile for the time being: it is withheld from our attention. If life can be a Happening, it is only a small portion of life that can be apprehended as one; and only a Happener will make the decision to so apprehend it. If we were speaking of painting or music, what I am saying would seem truistic. But the vast and giddy nonsense about what Happenings are makes it necessary to point to some of their actual characteristics.

Like much social endeavor, and like all creative endeavor, Happenings are moral activity, if only by implication. Moral intelligence, in contrast to moralism or sermonizing, comes alive in a field of press-

ing alternatives. Moral certainty tends to be at best pious and senti-mental, and at worst pietistic. The Happenings in their various modes resemble the best efforts of contemporary inquiry into identity and meaning, for they take their stand amid the modern information del-uge. In the face of such a plethora of choices, they may be among the most responsible acts of our time.

The Shape of the Art Environment
(1968)

Robert Morris's article "Anti Form" (*Artforum* 6, no. 8 [1968], 33–35) identifies some formal problems that remain unresolved. The first is suggested by the title itself. Despite its dramatic promise, there is nothing militant in Morris's words or in his works, nothing that could be construed as taking a stand *against* form. So it is not clear what is meant by *antiform*, unless it means "nonform," and if that quieter term is what is implied, it should be obvious that although someone might be against form from an ideological standpoint, the nonformal alternative is no less formal than the formal enemy. Literal nonform, like chaos, is impossible. In fact it is inconceivable. The structure of the cerebral cortex and all our biological functions permit us only patterned responses and thoughts of one kind or another. For cultural and personal reasons, we may prefer this pattern to that one—say a pile of shit to a series of cubes—but they are equally formal, equally analyzable.

Thus Morris's pile of felt batting (which I hasten to say I like very much) is an arrangement of uniformly colored, uniformly toned pieces of similar material (Fig. 12). In its loops and folds the distribution of gentle curves and hairpin turns is about the same throughout. The extent to which Morris caused the felt to assume these forms or simply let the felt arrange itself out of its own physical nature does not alter its evident form. What matters here is that there is an observable theme and variation at work, occurring, however, in the absence of strict hierarchies as developed by the all-over tradition of the last twenty years. Furthermore, the whole configuration, viewed in the photograph, is an approximately symmetrical bat-like shape with an A-B-A division at the top, or wall, zone. It appears, also, that the length of this upper zone closely echoes that of the zone on the floor. Consistency

Fig. 12 Robert Morris, *Untitled*, 1967–68. Felt pieces. *Photograph courtesy Leo Castelli Gallery, New York.*

prevails, and prevails, and prevails; there is neither pretense to antiform nor nonform.

It can be argued that this analysis is not holistic enough for our new sensibilities, that it is a relational analysis superimposed on the sculpture. But the answer to that argument must be that no one can see this sculpture in any other way than through its formal relationships because of how it was originally made, and how it is now shown in a magazine reproduction. The reasons for this constraint follow.

They point directly to the second, major, formal problem: how to get free of the rectangle.

Morris's new work, and that of the other artists illustrating his article, was made in a rectangular studio, to be shown in a rectangular gallery, reproduced in a rectangular magazine, in rectangular photographs, all aligned according to rectangular axes, for rectangular reading movements and rectangular thought patterns. (It is for good and sufficient reason that we are all "squares.") Morris's works, Pollock's, Oldenburg's, and so forth, function strictly in contrast to, or now and then in conflict with, their enframing spaces. Ruled lines and measurable corners in such spaces tell us how far, how big, how soft, how atmospheric, indeed how "amorphous" an artwork is within these lines and corners. Rectilinearity, by definition, is relational; and so long as we live in a world dominated by this and other part-to-whole geometrical figures, we cannot talk about antiform or nonform *except* as one type of form in relation to another (rectilinear) type.

Morris may not have been in New York during the mid-fifties and early sixties to see the Environments and environmental settings for Happenings made by Dine, Oldenburg, Whitman, and me. These were akin to his present interests, except that they employed a great variety of media. Following shortly on the sprawling, limitless impulses of Abstract Expressionism, they were composed of a preponderance of fragile, soft, and irregular materials such as wire mesh, plastic film, cardboard, straw, rags, newspapers, rubber sheets, tin foil, and a good amount of plain debris. Such materials immediately led to casual, loose arrangements. Oldenburg's current sculpture has its roots in his floppy cartonboard, papier-mâché, and gunnysack figures of those days.

Unlike sculpture, however, which has a relieving space around it, these Environments tended to fill, and often actually did fill, their entire containing areas, nearly obliterating the ruled definition of the rooms. And although the artists may have had concerns more pressing than that of keeping their activities from being subordinated to an architectural enclosure, the thought was in the air and the treatment of room surfaces was pretty carefree. The important fact was that almost everything was built into the space it was shown in, not transported from studio to showcase. This allowed a far more thorough transformation of a particular loft or storefront, and it doubtless encouraged a greater familiarity with the effects of materials and environment upon each other. Nevertheless, it was apparent from conversations at the time that

no matter how casual and organic the arrangement of materials might be, a house, a wall, a floor, a ceiling, a pavement, a city block was there first and last.

Most humans, it seems, still put up fences around their acts and thoughts—even when these are piles of shit—for they have no other way of delimiting them. Contrast Paleolithic cave paintings, in which animals and magical markings are overlaid with no differentiation or sense of framing. But when some of us have worked in natural settings, say in a meadow, woods, or mountain range, our cultural training has been so deeply ingrained that we have simply carried a mental rectangle with us to drop around whatever we were doing. This made us feel at home. (Even aerial navigation is plotted geometrically, thus giving the air a "shape.")

It will be a while before anyone will be able to work equally with or without geometry as a defining mechanism. That is, I see no necessity to give up one in favor of the other; amplification of different possibilities would seem more desirable. The notion of antiform now may mean only antigeometry, a rephrasing of the formlessness that preoccupied the ancients from the Egyptians onward. As such, Morris's interest is part of a long tradition. That his new work is first-rate should not obscure the implications this tradition holds out for contemporary art. Artists really pursuing the palpable experience of the measureless, the indeterminate, the use of nonrigid materials, process, the deemphasis of formal esthetics, would find it very difficult to do so in gallery and museum boxes or their equivalents. For these would only maintain the conventional dualism of the stable versus the unstable, the closed versus the open, the regular versus the organic, the ideal versus the real, and so on.

Finally, besides the structure of the room, there is one other important physical component of the art environment: the spectator(s). Their particular shape, color, number, proximity to the painting(s) or sculpture(s), and relation to each other when there is more than one person will markedly affect the appearance and "feel" of the work(s) in question. This is not just a matter of shifting amounts of reflected colored light and cast shadows; it is that people, like anything else in a room of artworks, are additional elements within the field of anyone's vision. At best, they are censored out imperfectly. Yet far from being independent of the art and gallery, the movements and responses of the spectator(s) are subject to the shape and scale of that gallery. They

can walk only so far from a sculpture and no farther; and they will govern their walking by a nearly conscious alignment with the art object's axial ties to the gallery. This can be readily verified by observation. Any casual meanderings on their part will thus be the formal equivalent within the exhibition floor area of, say, Pollock's drips within the canvas area. The rectangle maintains its primacy in all cases.

If we commonly understand that environmental factors affect personality formation as well as society as a whole, we should also expect them to have an impact on the form of an artwork. As a patch of given color changes its identity, or "form," on different grounds, an artwork changes according to the shape, scale, and contents of its envelope. Additional considerations of psychological and sociological factors, namely the thoughts and attitudes viewers bring with them to the work of art, although outside the immediate scope of this essay, are extremely important because they, too, contribute to the formal structure of the smallest statue.

It may be proposed that the social context and surroundings of art are more potent, more meaningful, more demanding of an artist's attention than the art itself! Put differently, it's not what artists touch that counts most. It's what they don't touch.

PART THREE

THE SEVENTIES

The Education of the Un-Artist, Part I
(1971)

Sophistication of consciousness in the arts today (1969) is so great that it is hard not to assert as matters of fact

that the LM mooncraft is patently superior to all contemporary sculptural efforts;

that the broadcast verbal exchange between Houston's Manned Spacecraft Center and the Apollo 11 astronauts was better than contemporary poetry;

that with their sound distortions, beeps, static, and communication breaks, such exchanges also surpassed the electronic music of the concert halls;

that certain remote-control videotapes of the lives of ghetto families recorded (with their permission) by anthropologists are more fascinating than the celebrated slice-of-life underground films;

that not a few of those brightly lit plastic and stainless-steel gas stations of, say, Las Vegas, are the most extraordinary architecture to date;

that the random trancelike movements of shoppers in a supermarket are richer than anything done in modern dance;

that lint under beds and the debris of industrial dumps are more engaging than the recent rash of exhibitions of scattered waste matter;

that the vapor trails left by rocket tests—motionless,
rainbow-colored, sky-filling scribbles—are unequaled by
artists exploring gaseous media;

that the Southeast Asian theater of war in Vietnam, or
the trial of the "Chicago Eight," while indefensible, is
better theater than any play;

that . . . etc., etc., . . . nonart is more art than Art art.

Members of the Club (Passwords In and Out)

Nonart is whatever has not yet been accepted as art but has caught an artist's attention with that possibility in mind. For those concerned, nonart (password one) exists only fleetingly, like some subatomic particle, or perhaps only as a postulate. Indeed, the moment any such example is offered publicly, it automatically becomes a type of art. Let's say I am impressed by the mechanical clothes conveyors commonly used in dry-cleaning shops. Flash! While they continue to perform their normal work of roller-coastering me my suit in twenty seconds flat, they double as Kinetic Environments, simply because I had the thought and have written it here. By the same process all the examples listed above are conscripts of art. Art is very easy nowadays.

Because art is so easy, there is a growing number of artists who are interested in this paradox and wish to prolong its resolution, if only for a week or two, for the life of nonart is precisely its fluid identity. Art's former "difficulty" in the actual making stages may be transposed in this case to an arena of collective uncertainty over just what to call the critter: sociology, hoax, therapy? A Cubist portrait in 1910, before it was labeled a mental aberration, was self-evidently a *painting*. Blowing up successively closer views of an aerial map (a fairly typical example of 1960s Site art) might more obviously suggest an aerial bombing plan.

Nonart's advocates, according to this description, are those who consistently, or at one time or other, have chosen to operate outside the pale of art establishments—that is, in their heads or in the daily or natural domain. At all times, however, they have informed the art establishment of their activities, to set into motion the uncertainties without which their acts would have no meaning. The art–not-art

dialectic is essential—one of the nice ironies I shall return to several times hereafter.

Among this group, some of whom do not know each other, or if they do, do not like each other, are concept makers such as George Brecht, Ben Vautier, and Joseph Kosuth; found-sound guides such as Max Neuhaus; Earthworkers such as Dennis Oppenheim and Michael Heizer; some of the 1950s Environment builders; and such Happeners as Milan Knížák, Marta Minujín, Kazuo Shiraga, Wolf Vostell, and me.

But sooner or later most of them and their colleagues throughout the world have seen their work absorbed into the cultural institutions against which they initially measured their liberation. Some have wished it this way; it was, to use Paul Brach's expression, like paying their dues to join the union. Others have shrugged it off, continuing the game in new ways. But all have found that password one won't work.

Nonart is often confused with antiart (password two), which in Dada time and even earlier was nonart aggressively (and wittily) intruded into the arts world to jar conventional values and provoke positive esthetic and/or ethical responses. Alfred Jarry's *Ubu Roi*, Erik Satie's *Furniture Music*, and Marcel Duchamp's *Fountain* are familiar examples. The late Sam Goodman's New York exhibition some years ago of varieties of sculpted dung piles was still another. Nonart has no such intent; and intent is part of both function and feeling in any situation that deliberately blurs its operational context.

Apart from the question whether the historical arts have ever demonstrably caused anybody to become "better," or "worse," and granting that all art has presumed to edify in *some* way (perhaps only to prove that nothing can be proven), such avowedly moralistic programs appear naive today in light of the far greater and more effective value changes brought about by political, military, economic, technological, educational, and advertising pressures. The arts, at least up to the present, have been poor lessons, except possibly to artists and their tiny publics. Only these vested interests have ever made any high claims for the arts. The rest of the world couldn't care less. Antiart, nonart, or other such cultural designations share, after all, the word *art* or its implicit presence and so point to a family argument at best, if they do not reduce utterly to tempests in teapots. And that is true for the bulk of this discussion.

When Steve Reich suspends a number of microphones above corresponding loudspeakers, sets them swinging like pendulums, and amplifies their sound pickup so that feedback noise is produced—that's art.

When Andy Warhol publishes the unedited transcript of twenty-four hours of taped conversation—that's art.

When Walter De Maria fills a room full of dirt—that's art.

We know they are art because a concert announcement, a title on a book jacket, and an art gallery say so.

If nonart is almost impossible, antiart is virtually inconceivable. Among the knowledgeable (and practically every graduate student should qualify) all gestures, thoughts, and deeds may become art at the whim of the arts world. Even murder, rejected in practice, could be an admissible artistic proposition. Antiart in 1969 is embraced in every case as proart, and therefore, from the standpoint of one of its chief functions, it is nullified. You cannot be against art when art invites its own "destruction" as a Punch-and-Judy act among the repertory of poses art may take. So in losing the last shred of pretense to moral leadership through moral confrontation, antiart, like all other art philosophies, is simply obliged to answer to ordinary human conduct and also, sadly enough, to the refined life-style dictated by the cultivated and rich who accept it with open arms.

When Richard Artschwager discreetly pastes little black oblongs on parts of buildings across California and has a few photos to show and stories to tell—that's art.

When George Brecht prints on small cards sent to friends the word "DIRECTION"—that's art.

When Ben Vautier signs his name (or God's) to any airport—that's art.

These acts are obviously art because they are made by persons associated with the arts.

It's to be expected that in spite of the paradoxical awareness referred to at the beginning of this essay, Art art (password three) is the

condition, both in the mind and literally, in which every novelty comes to rest. Art art takes art seriously. It presumes, however covertly, a certain spiritual rarity, a superior office. It has faith. It is recognizable by its initiates. It is innovative, of course, but largely in terms of a tradition of professionalistic moves and references: art begets art. Most of all, Art art maintains for its exclusive use certain sacred settings and formats handed down by this tradition: exhibitions, books, recordings, concerts, arenas, shrines, civic monuments, stages, film screenings, and the "culture" columns of the mass media. These grant accreditation the way universities grant degrees.

So long as Art art holds on to these contexts, it can and often does costume itself in nostalgic echoes of antiart, a reference that critics correctly observed in Robert Rauschenberg's earlier shows. It is self-evident in later Pop painting and writing, which make deliberate use of common clichés in content and method. Art art can also assert the features, though not the milieu, of nonart, as in much of the music of John Cage. In fact, Art art in the guise of nonart quickly became high style during the 1968–69 season at the Castelli Gallery warehouse shows of informal dispersions of felt, metal, rope, and other raw matter. Shortly afterward, this quasi-nonart received its virtual apotheosis at the Whitney Museum's presentation of similar stuff, called Anti-Illusion: Procedures/Materials. A hint of antiart greeted the viewer in the title, followed by the reassurance of scholarly analysis; but far from fomenting controversy, the temple of muses certified that all was Cultural. There was no illusion about that.

If commitment to the political and ideological framework of the contemporary arts is implicit in these seemingly raunchy examples, and in those cited at the beginning of this account, it is explicit in the bulk of straightforward productions of Art art: the films of Godard, the concerts of Stockhausen, the dances of Cunningham, the buildings of Louis Kahn, the sculpture of Judd, the paintings of Frank Stella, the novels of William Burroughs, the plays of Grotowski, the mixed-media performances of E.A.T.—to mention a few well-known contemporaries and events of achievement. It is not that some of them are "abstract" and this is their Art or that others have appropriate styles or subjects. It is that they rarely, if ever, play renegade with the profession of art itself. Their achievement, much of it in the recent past, is perhaps due to a conscious and poignant stance taken against an erosion of their respective fields by emerging nonartists. Perhaps it was

mere innocence, or the narrow-mindedness of their professionalism. In any event, they upheld the silent rule that as a password *in*, Art is the best word of all.

It is questionable, however, whether it is worthwhile being *in*. As a human goal and as an idea, Art is dying—not just because it operates within conventions that have ceased to be fertile. It is dying because it has preserved its conventions and created a growing weariness toward them, out of indifference to what I suspect has become the fine arts' most important, though mostly unconscious, subject matter: the ritual escape from Culture. Nonart as it changes into Art art is at least interesting in the process. But Art art that starts out as such shortcuts the ritual and feels from the very beginning merely cosmetic, a superfluous luxury, even though such qualities do not in fact concern its makers at all.

Art art's greatest challenge, in other words, has come from within its own heritage, from a hyperconsciousness about itself and its everyday surroundings. Art art has served as an instructional transition to its own elimination by life. Such an acute awareness among artists enables the whole world and its humanity to be experienced as a work of art. With ordinary reality so brightly lit, those who choose to engage in showcase creativity invite (from this view) hopeless comparisons between what they do and supervivid counterparts in the environment.

Exemption from this larger ballpark is impossible. Art artists, in spite of declarations that their work is not to be compared with life, will invariably be compared with nonartists. And, since nonart derives its fragile inspiration from everything except art, i.e., from "life," the comparison between Art art and life will be made anyway. It then could be shown that, willingly or not, there has been an active exchange between Art art and nonart, and in some cases between Art art and the big wide world (in more than the translational way all art has utilized "real" experience). Relocated by our minds in a global setting rather than in a museum or library or onstage, Art, no matter how it is arrived at, fares very badly indeed.

For example, La Monte Young, whose performances of complex drone sounds interest me as Art art, tells of his boyhood in the Northwest when he used to lean his ear against the high-tension electric towers that stretched across the fields; he would enjoy feeling the hum of the wires through his body. I did that as a boy, too, and prefer it to the concerts of Young's music. It was more impressive visually and less

hackneyed in the vastness of its environment than it is in a loft space or a performance hall.

Dennis Oppenheim describes another example of nonart: in Canada he ran across a muddy lot, made plaster casts of his footprints (in the manner of a crime investigator), and then exhibited stacks of the casts at a gallery. The activity was great; the exhibition part of it was corny. The casts could have been left at the local police station without identification. Or thrown away.

Those wishing to be called artists, in order to have some or all of their acts and ideas considered art, only have to drop an artistic thought around them, announce the fact and persuade others to believe it. That's advertising. As Marshall McLuhan once wrote, "Art is what you can get away with."

Art. There's the catch. At this stage of consciousness, the sociology of Culture emerges as an in-group "dumb-show." Its sole audience is a roster of the creative and performing professions watching itself, as if in a mirror, enact a struggle between self-appointed priests and a cadre of self-appointed commandos, jokers, guttersnipes, and triple agents who seem to be attempting to destroy the priests' church. But everybody knows how it all ends: in church, of course, with the whole club bowing their heads and muttering prayers. They pray for themselves and for their religion.

Artists cannot profitably worship what is moribund; nor can they war against such bowing and scraping when only moments later they enshrine their destructions and acts as cult objects in the same institution they were bent on destroying. This is a patent sham. A plain case of management takeover.

But if artists are reminded that nobody but themselves gives a damn about this, or about whether all agree with the judgment here, then the entropy of the whole scene may begin to appear very funny.

Seeing the situation as low comedy is a way out of the bind. I would propose that the first practical step toward laughter is to *un-art* ourselves, avoid all esthetic roles, give up all references to being artists of any kind whatever. In becoming un-artists (password four) we may exist only as fleetingly as the nonartist, for when the profession of art

is discarded, the art category is meaningless, or at least antique. An un-artist is one who is engaged in changing jobs, in modernizing.

The new job does not entail becoming a naïf by beating a quick retreat back to childhood and yesterday. On the contrary, it requires even more sophistication than the un-artist already has. Instead of the serious tone that has usually accompanied the search for innocence and truth, un-arting will probably emerge as humor. This is where the old-fashioned saint in the desert and the newfangled player of the jetways part company. The job implies fun, never gravity or tragedy.

Of course, starting from the arts means that the *idea* of art cannot easily be gotten rid of (even if one wisely never utters the word). But it is possible to slyly shift the whole un-artistic operation away from where the arts customarily congregate, to become, for instance, an account executive, an ecologist, a stunt rider, a politician, a beach bum. In these different capacities, the several kinds of art discussed would operate indirectly as a stored code that, instead of programming a specific course of behavior, would facilitate an attitude of deliberate playfulness toward all professionalizing activities well beyond art. Signal scrambling, perhaps. Something like those venerable baseball aficionados in the vaudeville act that began, "Who's on first?" "No, Watt's on first; Hugh's on second . . ."

When someone anonymous called our attention recently to his or her slight transformation of a tenement stairway, and someone else directed us to examine an unaltered part of New York's Park Avenue, these were art, too. Whoever the persons were, they got the message to us (artists). We did the rest in our heads.

Safe Bets for Your Money

It can be pretty well predicted that the various forms of mixed media or assemblage arts will increase, both in the highbrow sense and in mass-audience applications such as light shows, space-age demonstrations at world's fairs, teaching aids, sales displays, toys, and political campaigns. And these may be the means by which all the arts are phased out.

Although public opinion accepts mixed media as additions to the

pantheon, or as new occupants around the outer edges of
ing universe of each traditional medium, they are more
of escape from the traditions. Given the historical trend c
arts toward specialism or "purity"—pure painting, pure poetry, ͏-
music, pure dance—any admixtures have had to be viewed as contam-
inants. And in this context, deliberate contamination can now be in-
terpreted as a rite of passage. (It is noteworthy in this context that even
at this late date there are no journals devoted to mixed media.)

Among the artists involved in mixed means during the past decade,
a few became interested in taking advantage of the arts' blurry bound-
aries by going the next step toward blurring art as a whole into a
number of nonarts. Dick Higgins, in his book *foew&ombwhnw*, gives
instructive examples of vanguardists' taking positions between theater
and painting, poetry and sculpture, music and philosophy and between
various intermedia (his term) and game theory, sports, and politics.

Abbie Hoffman applied the intermedium of Happenings (via the
Provos) to a philosophical and political goal two or three summers ago.
With a group of friends, he went to the observation balcony of the
New York Stock Exchange. At a signal he and his friends tossed hand-
fuls of dollar bills onto the floor below, where trading was at its height.
According to his report, brokers cheered, diving for the bills; the tick-
ertape stopped; the market was probably affected; and the press re-
ported the arrival of the cops. Later that night the event appeared
nationally on televised news coverage: a medium sermon "for the hell
of it," as Hoffman might say.

It makes no difference whether what Hoffman did is called activ-
ism, criticism, pranksterism, self-advertisement, or art. The term *in-
termedia* implies fluidity and simultaneity of roles. When art is only
one of several possible functions a situation may have, it loses its priv-
ileged status and becomes, so to speak, a lowercase attribute. The
intermedial response can be applied to anything—say, an old glass.
The glass can serve the geometrist to explain ellipses; for the historian
it can be an index of the technology of a past age; for a painter it can
become part of a still life, and the gourmet can use it to drink his
Château Latour 1953. We are not used to thinking like this, all at once,
or nonhierarchically, but the intermedialist does it naturally. Context
rather than category. Flow rather than work of art.

It follows that the conventions of painting, music, architecture,
dance, poetry, theater, and so on may survive in a marginal capacity as

academic researches, like the study of Latin. Aside from these analytic and curatorial uses, every sign points to their obsolescence. By the same token, galleries and museums, bookshops and libraries, concert halls, stages, arenas, and places of worship will be limited to the conservation of antiquities; that is, to what was done in the name of art up to about 1960.

Agencies for the spread of information via the mass media and for the instigation of social activities will become the new channels of insight and communication, not substituting for the classic "art experience" (however many things that may have been) but offering former artists compelling ways of participating in structured processes that can reveal new values, including the value of fun.

In this respect, the technological pursuits of today's nonartists and un-artists will multiply as industry, government, and education provide their resources. "Systems" technology involving the interfacing of personal and group experiences, instead of "product" technology, will dominate the trend. Software, in other words. But it will be a systems approach that favors an openness toward outcome, in contrast to the literal and goal-oriented uses now employed by most systems specialists. As in the childhood pastime "Telephone" (in which friends in a circle whisper a few words into one ear after the other only to hear them come out delightfully different when the last person says them aloud), the feedback loop is the model. Playfulness and the playful use of technology suggest a positive interest in acts of continuous discovery. Playfulness can become in the near future a social and psychological benefit.

A global network of simultaneously transmitting and receiving "TV Arcades." Open to the public twenty-four hours a day, like any washerette. An arcade in every big city of the world. Each equipped with a hundred or more monitors of different sizes from a few inches to wallscale, in planar and irregular surfaces. A dozen automatically moving cameras (like those secreted in banks and airports, but now prominently displayed) will pan and fix anyone or anything that happens to come along or be in view. Including cameras or monitors if no one is present. People will be free to do whatever they want and will see themselves on the monitors in different ways. A crowd of people may multiply their images into a throng.

**But the cameras will send the same images to all *other*
arcades, at the same time or after a programmed delay.
Thus what happens in one arcade may be happening in
a thousand, generated a thousand times. But the built-in
program for distributing the signals, visible and audible,
random and fixed, could also be manually altered at any
arcade. A woman might want to make electronic love to
a particular man she saw on a monitor. Controls would
permit her to localize (freeze) the communication within
a few TV tubes. Other visitors to the same arcade may
feel free to enjoy and even enhance the mad and sur-
prising scramble by turning their dials accordingly. The
world could make up its own social relations as it went
along. Everybody in and out of touch all at once!**

**P.S. This is obviously not art, since by the time it was real-
ized, nobody would remember that I wrote it here, thank
goodness.**

And what about art criticism? What happens to those keen inter-
preters who are even rarer than good artists? The answer is that in the
light of the preceding, critics will be as irrelevant as the artists. Loss
of one's vocation, however, may be only partial, since there is much to
be done in connoisseurship and related scholarly endeavors in the uni-
versities and archives. And nearly all critics hold teaching posts anyway.
Their work may simply shift more toward historical investigation and
away from the ongoing scene.

But some critics may be willing to un-art themselves along with
their artist colleagues (who just as often are professors and double as
writers themselves). In this case, all their esthetic assumptions will have
to be systematically uncovered and dumped, together with all the his-
torically loaded art terminology. Practitioners and commentators—the
two occupations will probably merge, one person performing inter-
changeably—will need an updated language to refer to what is going
on. And the best source of this, as usual, is street talk, news shorthand,
and technical jargon.

For example, Al Brunelle, a few years back, wrote of the halluci-
nogenic surfaces of certain contemporary paintings as "skin freak."

Even though the pop drug scene has changed since, and new words are necessary, and even though this essay is not concerned with paintings, Brunelle's phrase is much more informative than such older words as *tâche* or *track*, which also refer to a painting's surface. Skin freaking brought to picture making an intensely vibrating eroticism that was particularly revealing for the time. That the experience is fading into the past simply suggests that good commentary can be as disposable as artifacts in our culture. Immortal words are appropriate only to immortal dreams.

Jack Burnham, in his *Beyond Modern Sculpture* [New York: Braziller, 1968] is conscious of this need for accurate terms and attempts to replace vitalist, formalist, and mechanistic metaphors with labels from science and technology like *cybernetics*, "responsive systems," *field*, *automata*, and so forth. Yet these are compromised because the reference is still sculpture and art. To be thorough, such pietistic categories would have to be rejected totally.

In the long run, criticism and commentary as we know them may be unnecessary. During the recent "age of analysis" when human activity was seen as a symbolic smoke screen that had to be dispelled, explanations and interpretations were in order. But nowadays the modern arts themselves have become commentaries and may forecast the postartistic age. They comment on their respective pasts, in which, for instance, the medium of television comments on the film; a live sound played alongside its taped version comments on which is "real"; one artist comments on another's latest moves; some artists comment on the state of their health or of the world; others comment on not commenting (while critics comment on all commentaries as I'm commenting here). This may be sufficient.

The most important short-range prediction that can be made has been implied over and over again in the foregoing; that the actual, probably global, environment will engage us in an increasingly participational way. The environment will not be the Environments we are familiar with already: the constructed fun house, spook show, window display, store front, and obstacle course. These have been sponsored by art galleries and discotheques. Instead, we'll act in response to the given natural and urban environments such as the sky, the ocean floor, winter resorts, motels, the movements of cars, public services, and the communications media . . .

Preview of a 2001-Visual-of-the-USA-Landscape-Via-Supersonic-Jet. Every seat on the jet is equipped with monitors showing the earth below as the plane speeds over it. Choice of pictures in infrared, straight color, black-and-white; singly or in combination on various parts of the screen. Plus zoom lens and stop-action controls.

Scenes from other trips are retrievable for flashback cuts and contrasts. Past comments on present. Selector lists: Hawaiian Volcanos, The Pentagon, A Harvard Riot Seen When Approaching Boston, Sunbathing on a Skyscraper.

Audio hookup offers nine channels of prerecorded criticism of the American scene: two channels of light criticism, one of pop criticism, and six channels of heavy criticism. There is also a channel for recording one's own criticism on a take-home video cassette documenting the entire trip.

P.S. This, also, is not art, because it will be available to too many people.

Artists of the world, drop out! You have nothing to lose but your professions!

The Education of the Un-Artist, Part II (1972)

Catbirds Mew, Copycats Fly

What can the un-artist do when art is left behind? Imitate life as before. Jump right in. Show others how.

The nonart mentioned in part 1 is an art of resemblance. It is *lifelike*, and "like" points to similarities. Conceptual Art reflects the forms of language and epistemological method; Earthworks duplicate ploughing and excavating techniques or patterns of wind on the sand; Activities replay the operations of organized labor—say, how a highway is made; noise music electronically reproduces the sound of radio static; videotaped examples of Bodyworks look like close-ups of underarm-deodorant commercials.

Ready-made versions of the same genre, identified and usually claimed by artists as their own, are imitations in the sense that the condition "art," assigned to what has not been art, creates a new something that closely fits the old something. More accurately, it has been *re*-created in thought without performing or making a physical duplicate. For instance, washing a car.

The entire thing or situation is then transported to the gallery, stage, or hall; or documents and accounts of it are published; or we are taken to it by the artist acting as guide. The conservative practitioner extends Duchamp's gesture of displacing the object or action to the art context, which brackets it as art, whereas the sophisticate needs only art-conscious allies who carry the art bracket ready-made in their heads for instant application anywhere. These moves identify the transaction between model and replica.

Afterward, whatever resembles the Readymade is automatically

another Readymade. The circle closes: as art is bent on imitating life, life imitates art. All snow shovels in hardware stores imitate Duchamp's in a museum.

This re-creation in art of philosophical and personal inquiry, the forces of nature, our transformation of the environment, and the tactile and auditory experience of the "electric age" does not arise, as could be supposed, out of renewed interest in the theory of art as mimesis. Whether we are talking about close copies, approximations, or analogues, such imitating has no basis in esthetics at all—and that must be its point. But neither is it based on an apprenticeship to fields unfamiliar to art, after which it will be indistinct from politics, manufacturing, or biology. Because nonartists may be attracted intuitively to mimetic behavior already present in these fields and in nature as well, their activity parallels aspects of culture and reality as a whole.

For instance, a small town, like a nation, is an amplified nuclear family. God and the pope (papa) are adult projections of a child's feelings about the divinity of its father. The governance of the church and of heaven and hell in the Middle Ages echoed the workings of secular governments of the time.

The plan of a city is like the human circulatory system, with a heart and major roads called arteries. A computer alludes to a rudimentary brain. A Victorian armchair was shaped like a woman with a bustle, and it actually wore a dress.

Not everything is anthropomorphic. Machines imitate animal and insect forms: airplanes are birds, submarines are fish, Volkswagens are beetles. They also imitate each other. Auto design, in the streamlining of the thirties and the tailfins of the fifties, had the airplane in mind. Kitchen appliances have control panels that look like those in a recording studio. Lipstick containers resemble bullets. Staplers that shoot nails and movie cameras that shoot people and scenes have triggers and are shaped like guns.

Then the rhythms of life and death: we speak of a stock market or a civilization growing and declining, as if each were a living organism. We imagine family history as a tree and trace our ancestors on its limbs. By extension, the grandfather theory of Western history proposes that each generation reacts to its immediate past as a son reacts to his father. Since the past reacted to *its* past, too, every other generation is alike (Meyer Schapiro, "Nature of Abstract Art," *Marxist Quarterly*, January–March 1937).

The nonhuman world also seems to imitate: fetuses of different species look similar at early stages of development, whereas some butterflies of different species are dissimilar when young but look the same in maturity. Certain fish, insects, and animals are camouflaged to blend with their surroundings. The mockingbird mimics the voices of other birds. The roots of a plant reflect its branches. An atom is a tiny planetary system. Such matchings continue without apparent end, differing only in detail and degree.

The inference that our role may be that of copycat rather than master of nature is no secret to scientists. Quentin Fiore and Marshall McLuhan (in *War and Peace in the Global Village* [New York: Mc-Graw-Hill, 1968], p. 56) quote Ludwig von Bertalanffy on this: "With few exceptions . . . nature's technology surpasses that of man—to the extent that the traditional relationship between biology and technology was recently reversed: while mechanistic biology tried to explain organic functions in terms of man-made machines, the young science of bionics tries to imitate natural inventions."

Imitation of this sort in science or art is a thoughtful affair. Even its frequent wit is profound, sometimes approaching existential trials and proofs. But when it is clear that the most modern of the arts are engaged in imitations of a world continuously imitating itself, art can be taken as no more than an instance of the greater scheme, not as a primary source. The obsolescence of that instance doesn't discredit the mimetic impulse but spotlights art's historic role as an isolating discipline at a moment when participation is called for. Leaving the arts is not enough to overcome this obstacle; the task, for oneself and for others, is to restore participation in the natural design through conscious emulation of its nonartistic features. The feeling that one is part of the world would be quite an accomplishment in itself, but there's an added payoff: the feedback loop is never exact. As I have said, something new comes out in the process—knowledge, well-being, surprise, or, as in the case of bionics, useful technology.

Everywhere as Playground

When the un-artist copies what's going on outside of art, or copies a less visible "nature in her manner of operation" (Coomaraswamy), it

doesn't have to be a somber business. That would be too much like work. It's to be done with gusto, wit, fun; it's to be play.

Play is a dirty word. Used in the common sense of frolic, make-believe, and an attitude free of care for moral or practical utility, it connotes for Americans and many Europeans idleness, immaturity, and the absence of seriousness and substance. It is perhaps even harder to swallow than *imitation*, with its challenge to our tradition of the new and original. But (as if to compound the indiscretion) scholars since the time of Plato have noted a vital link between the idea of play and that of imitation. Besides its sophisticated role in ritual, instinctive imitation in young animals and humans takes the form of play. Among themselves, the young mimic their parents' movements, sounds, and social patterns. We know with some certainty that they do this to grow and survive. But they play without that conscious intention, apparently, and their only evident reason is the pleasure it gives them. Thus they feel close to, and become part of, the grown-up community.

For adults in the past, imitative ceremony was play that brought them closer to reality in its more felt or transcendent aspect. Johan Huizinga writes in the first chapter of his valuable book *Homo Ludens* [Boston: Beacon, 1955] that the

> "ritual act" represents a cosmic happening, an event in the natural process. The word "represents," however, does not cover the exact meaning of the act, at least not in its looser, modern connotation; for here "representation" is really *identification* of the event. The rite produces the effect which is then not so much *shown figuratively* as actually *reproduced* in the action. The function of the rite, therefore, is far from being merely imitative; it causes the worshippers to participate in the sacred happening itself.

In the same chapter he says:

> As Leo Frobenius puts it, archaic man *plays* the order of nature as imprinted on his consciousness. In the remote past, so Frobenius thinks, man first assimilated the phenomena of vegetation and animal life and then conceived an idea of time and space, of months and seasons, of the course of the sun and the moon. And now he plays this great processional order of existence in a sacred play, in and through which he actualizes anew, or "recreates" the events represented and thus helps maintain the cosmic order. Frobenius draws

even more far-reaching conclusions from this "playing at nature." He deems it the starting point of all social order and social institutions, too.

Representational play is thus as instrumental, or ecological, as it is sacred. Huizinga, shortly after commenting on Frobenius, quotes Plato's *Laws*:

"God alone is worthy of supreme seriousness, but man is God's plaything and that is the best part of him. Therefore, every man and woman should live life accordingly, and play the noblest games and be of another mind from what they are at present." [Plato condemns war and continues] "Life must be lived at play, playing certain games, making certain sacrifices, singing and dancing, and then a man will be able to propitiate the gods and defend himself against his enemies and win the contest."

Huizinga goes on to ask: "How far [do] such sacred activities as proceed within the forms of play [i.e., mimetic forms] also proceed in the attitudes and mood of play?"

He answers: "Genuine and spontaneous play can also be profoundly serious. . . . The joy inextricably bound up with playing can turn not only into tension, but into elation. Frivolity and ecstasy are the twin poles between which play moves."

Sports, feasts, and parties on holidays (holy days) are no less sacred for being enjoyable.

It's been observed often enough that nowadays we have no sacred rituals left that have even the remotest representational, and therefore propitiative, function that anyone can observe, much less feel. Only in such sports as surfing, motorcycle racing, and sky diving; in social protests such as sit-ins; and in gambles against the unknown such as moon landings do we approximate them unofficially. And for most of us these experiences are acquired indirectly, through television. We participate alone, immobilized.

The imitative activity of modern adults outlined earlier is probably instinctive, like children's. Like children's, it also ranges from being unconscious, as I would guess the feminizing of furniture was in the Victorian era, to being deliberate and conscious in the case of certain artists and scientists today. But in general it is haphazard and occa-

sional, a specialized function of professions concerned with other matters. The designer of an atomic submarine doesn't think he's Jonah making a whale for himself, even though he may know that predecessors studied whales and fish and their aquadynamics. The maker of an Apollo rocket may be familiar with popular Freudian symbolism, but he isn't mainly out to create an erect penis. Neither is he out mainly to have fun.

"Serious" practicalities, competition, money, and other sobering considerations get in the way. Such discontinuity and specialization produce a sense of separation from the whole of life and also veil the imitative activity along with the enjoyment that might be had from it. The result is not play; it is work.

Work, Work, Work

Epworth, England (UPI)—Minutes after a gang of workmen had placed a new layer of tar on the main street of this small Midlands town, another gang of workmen appeared and began digging it up. "It's just a coincidence that both gangs were working at the same time," a local official said. "Both jobs had to be done."

—New York Times, *circa December 1970*

Runner

St. Louis, Missouri, Washington University—(1st day) A mile of tar-paper is unrolled along the shoulder of a road. Concrete blocks are placed on the paper every twenty feet.

(2nd day) Procedure is repeated in reverse, second layer of tarpaper laid over first. Again repeated in opposition direction.

(3rd day) Tarpaper and concrete blocks removed.

—*Activity, A.K., February 9–11, 1968*

Imitation as practiced by nonart artists may be a way of approaching play on a modern yet transcendent plane, which, because it is intellectual—or better, *intelligent*—can be enjoyed by adults afraid of being childish. Just as children's imitative play may be a survival ritual, this could be a stratagem for the survival of society. In the passage from art to un-art the artist's talent for revealing the interchangeability

of things could be made available to "civilization and its discontents"—in other words, could be used for bringing together what has been taken apart.

But if all the secular world's a potential playground, the one taboo against playing in it is our addiction to the idea of work. Work cannot be banished by fiat; it must be replaced by something better. To guess at how that may be done requires an examination of the meaning of work in our society—even if with minimal expertise. One thing is clear: the concept of work is incompatible with that of play, childlike or holy.

Home Work

Western Europe and the United States, in the course of industrialization, developed a practical life-style of self-sacrifice for the purpose of growing and fattening machines. Perhaps evolved initially as a middle-class "con job" on laborers, it soon conned the con men. Work and pain were internalized as truths on high; they were right for the soul, if not exactly for the body (since that passed into the machine).

But the picture has changed. Industrialization has accomplished its purpose, and we live in the "global village" of communicational contact, with all the new insights and problems this entails. The issue now is not production but distribution; it is not even simple distribution but the quality and organic effects of distribution. And what matters is the quality and distribution, not of goods alone, but also of services.

Farming, mining, and manufacturing in this country, largely mechanized, each year require fewer additional workers to implement steadily rising levels of output. It is probable that the work force will level off and then drop sharply with increasing automation. In contrast, the expanding service industries, consisting mainly of people rather than goods and equipment, now represent about 50 percent of the nation's employed and are expected to increase to 70 percent of the total work force in the next few decades (*Fortune*, March 1970, p. 87).

But services—they include local and federal government, transportation, utilities, and communications as well as trade, finance, insurance, real estate, and the professions—services are themselves changing. Menial and domestic workers and other routine service

workers such as mail carriers, mechanics, maids, clerks, bus drivers, and insurance agents hold jobs with little growth potential; none have significant social status, all pay rather poorly, and there is little or no inherent interest in them as vocations. In a period of large-scale mobility, physical and social, they appear to be dead ends, vaguely implying that those performing such jobs are themselves dead.

All the while billboards, magazines, and television sets beckon everyone to the good life of adventurous travel, sex, and eternal youth; the U.S. president himself dedicates his government to improving the "quality of life." Labor unions strike not only for higher wages but also for better conditions and fringe benefits, shorter hours and longer paid vacations. Enjoyment and renewal for everyone. Given these pressures, it is probable that many of the drudgery occupations will eventually be automated along with industry, while others will simply disappear as workers abandon them.

The more modern services, however, such as corporate management, scientific and technologic research, environmental improvement, communications, planning consultation, social dynamics, the wide field of mass education, and international, outer-space, and undersea law, are growing at an exponential rate. They are vital occupations with seemingly unlimited possibilities for development (therefore for personal development); they offer global travel and fresh experiences; they pay well and their status is considerable.

Whereas routine services are merely necessary, the new services are important. Routine services steadily require less of a worker's total time, thanks to machines and legislation; although the new services actually take up more time, they function in more flexible and, in a sense, "growing" time. Time that is merely filled is debasing, but time that is flexible and personalized is released time. The ability to move, in space, hours, and mind, is a measure of liberation. As more young people demand and receive extensive educations, the ranks of the modern services will swell, the public appetite to consume what they offer will increase, and the world will continue to change—while quite possibly its moral base will remain rooted in the past: work.

Work? For nearly everyone, the workweek has been reduced to five days. Workdays are shortened regularly, holiday periods lengthened. The four-day week is being increasingly tried out, and a three-day week has been predicted. Even if this last prediction is a bit utopian, the psychological expectation is popular and affects performance

on the job. As a result, the meaning of work is becoming unclear since steady pressure is felt to eliminate it or falsify it if it can't be eliminated.

The issue is traditionally fought out by big business (that is, the produce, goods, transportation, and basic service industries) and by labor unions, which still represent the bulk of the country's work force. Let's say business wants to automate and scrap expensive payrolls. That decision may mean a shorter workweek, which in turn may cost thousands their jobs and society more than it can afford in a chain reaction. The results are rarely self-evident. Labor steps in immediately and insists on work crews when one worker or none at all is needed. Management suffers by being prevented from modernizing; labor suffers by doing patently dishonest work. It amounts to this: neither business nor labor is particularly interested in extolling leisure time; they want to make money, and money is a token of work. Labor will accept shorter hours if management pays for them, but when a reduced workweek means forfeiting jobs or hard-won guaranteed overtime pay, labor will oppose the change (as in fact it does; see, e.g., *Newsweek*, August 23, 1971, p. 63). Hence the concept "work," maintained artificially, can only elicit the most cynical responses in society.

The arts are among the last high-status vestiges of the handicraft and cottage industries. It is curious to note how deeply tied they are to the idea of labor. Artists *work* at their paintings and poems; out of this sweat come *works* of art. Following the Russian revolution, artists everywhere began calling themselves *workers*, no different from those in factories. Today, the political reformist Art Workers Coalition, in its name and some of its rhetoric, continues to appeal to the rallying values of "the people" and "an honest day's work." Art, like work, is quaint.

In contrast to this work ethic, our underlying attitudes toward life goals are shifting, and not in work habits alone. The "fun market"— entertainment, recreation, tourism—according to *Look* magazine (July 29, 1970, p. 25), amounts to about $150 billion a year and is forecast to reach $250 billion by 1975, "outrunning all the rest of the economy." But to atone for this indulgence, the American public permitted its government in 1970 to spend more than $73 billion, or 37 percent of its annual budget, on war and armaments (confidently

spurred on by a global outlay, in 1969, of some $200 billion). In fact, according to Senator Vance Hartke in a report to the Senate Finance Committee, our military outlay was about $79 billion in 1968 and has been rising at a yearly rate of 12 percent since 1964; with this rate of increase, military spending in 1971 will be $107.4 billion (*Vista*, March–April 1970, p. 52).

The State is our outspoken conscience. Fun, it seems, is not yet fun; it has hardly diverted us from the common "weekend neurosis," which leaves us anxious to play but unable. More atonement for trying. It's abundantly clear that we don't want to work but feel we should. So we brood and fight.

Playing really is sinning. Every day hundreds of books, films, lectures, seminars, sensitivity sessions, and articles gravely acknowledge our worries over our incapacity to freely enjoy anything. But such commentaries, when they offer help, offer the wrong kind by reciting the standard formula: *work* at sex, *work* at play. To help, they'd have to urge a wholesale revision of our commitment to labor and guilt, which they won't do. We live by a scarcity mentality in a potentially surplus economy. With time on our hands that we cannot infuse into our personal lives, we damn ourselves, as we've been taught, for wasting time.

Basically, our way of life, reflected in our love life as well as in our foreign policy, believes in the way things used to be. As long ago as the writing of the Declaration of Independence, an ambivalence toward pleasure was hinted at in the salute to our right to "life, liberty and the pursuit of happiness." The "pursuit" part of it seems to have occupied most of our time, implying that happiness is only a dream . . . We struggle not to struggle.

Playing and Gaming

The nation's education system must take much of the responsibility for perpetuating and championing what's wrong with us: our values, the goods and bads, the dos and don'ts. Educators in the twentieth century, we all know, operate in loco parentis. Principals and deans like to say the Latin words reassuringly because they know how nearly impossible it is for mothers and fathers to bring up their children, with all their time consumed in motion on the highways, shopping, vaca-

tioning, and working. And, besides, like everyone, parents are specialists at whatever they do. So they depend on other specialists, the educators, to do what they can't and worry that TV is doing a better job than both.

Consider what happens to children after the age of five or six. At first, they enjoy school, often beg to go. The teacher appears to like it too. Both the teacher and the children play. But by the first or second grade, Dick and Jane discover that learning and winning a place in the world are not child's play at all but hard, often dreadfully dull work.

That value underscores nearly all educational programs. "Work hard, and you'll get ahead" is a guide not only for students but for educators. "Ahead" means being head man. Authoritarianism closes out play's inviting role and substitutes the competitive game. The threat of failure and dismissal for not being strong hangs over every individual from college president to school superintendent on down.

Students compete for grades, teachers for the well-behaved class, principals for higher budgets. Each performs the ritual of the game according to strict rules, sometimes artfully, but the fact remains that the many are striving for what only the few may have: power.

Calendar
planting a square of turf
amid grass like it

planting another
amid grass a little less green

planting four more squares
in places progressively drier

planting a square of dry turf
amid grass like it

planting another
amid grass a little less dry

planting four more squares
in places progressively greener

*—Activity, A.K., California
Institute of the Arts,
November 2, 1971*

In spite of, and perhaps because of, the disclosures of Freud and other psychologists, the games people play are played to win. The forms of sports, chess, and other diversions are symbolically akin to the forms of business, love, and battle. Huizinga's classic *Homo Ludens*, quoted before, richly documents the pervasiveness of such transferences. As direct play is denied to adults and gradually discouraged in children, the impulse to play emerges not in true games alone, but in unstated ones of power and deception; people find themselves playing less with each other than on or off each other.

A child plays his mother off against his father, using affection as the game's reward. In the game of international diplomacy, a strong nation plays at helping weaker ones to gain their political subordination and to force the hand of competitors. A young executive on the way up plays off one company's offer of advancement against another's. In the same spirit, a large business stimulates and plays on the public's appetites in its advertising campaigns, gambling against the similar tactics of an entire industry. War itself is the play of generals, whose rehearsals are appropriately called war games. As civilization lives to compete and competes to live, it is no accident that education in most parts of the world is deeply involved in games of aggressive struggle. Education plays at ignoring or denying such struggle (substituting the metaphors of democracy) while perfecting its forms and encouraging participation in it in every classroom exercise (take, for an example, one of its pleasanter diversions, the spelling bee).

Those who plan public instruction programs need first to learn, and then to celebrate, the idea of play—but play as inherently worthwhile, play stripped of game theory, that is, of winners and losers. Huizinga, writing and lecturing in the thirties in an economically depressed and politically unstable Europe, finally publishing his book in Switzerland during World War II, could not easily have imagined the social potentials of play without contest. For Huizinga, play in the form of the agon was a way of discharging and clarifying violence and unreason. Although he and earlier theorists, from Kant and Schiller to Lange and Groos, acknowledged pure play, they did not believe it to be enough by itself; it was "primitive" and needed the "higher" forms of tragic awareness that games (and art seen as a game) provided. Today, the conditions are different, and it is obvious that agonistic games, no matter how ritualized, are testimonials to the forces they would sublimate. Anyone who has seen *Berlin Olympiade*, Leni Rie-

fenstahl's great film on the 1936 Olympic games, needs no persuasion. Through art and sport, it powerfully persuaded viewers that a master race was the prize of perpetual struggle.

Similarly, the real substance and the stimulus of our "fun market," particularly in entertainment and sportive recreation, are superstars, record sales, popularity ratings, prizes, getting someplace first, catching the biggest fish, beating the house at Las Vegas. Some fun!

> *Charity*
> buying piles of old clothes
>
> washing them
> in all-night laundromats
>
> giving them back
> to used-clothing stores
>
> —*Activity, A.K.,*
> *Berkeley Unified School District,*
> *March 7, 1969*

This critical difference between gaming and playing cannot be ignored. Both involve free fantasy and apparent spontaneity, both may have clear structures, both may (but needn't) require special skills that enhance the playing. Play, however, offers satisfaction, not in some stated practical outcome, some immediate accomplishment, but rather in continuous participation as its own end. Taking sides, victory, and defeat, all irrelevant in play, are the chief requisites of game. In play one is carefree; in a game one is anxious about winning.

Making the world carefree, converting a work ethic into one of play, would mean giving up our sense of urgency (time is money) and not approaching play as one more political game, for that would contradict what is done. We can't say we game not to game. This is exactly what we've been doing with our Judeo-Christian virtues and democratic ideals all along.

Gymnastics, surfing, long-distance running, glider flying are among those sports sometimes practiced apart from competition, and almost approach the condition of

play. In each, an ideal is probably internalized and acts in lieu of an opponent; but this motive for developing skills and intense involvement falls considerably short of the combat mentality that most sports, such as football, depend on.

Generally, coaches and gym teachers conduct their professions with military zeal and sometimes murderous discipline. But a new breed, more philosophical and pleasure-oriented, could use noncompetitive sports, and their resemblances to the movements of animals, fish and airborne seedlings, as departures for the invention *by students* of fresh activity devoid of win-lose possibility.

It is not the history of crimes committed in the name of ideas that needs to be noted but the perfectly well meant, sympathetic "good works" of humankind implied by expressions like "good, clean sport," "a clean bomb," "a just war," "fighting spirit," and "free enterprise." It is the connivance, bought votes, and wheeler-dealering necessary to pass every enlightened law on civil rights, abortion reform, or job opportunity. This particular mode of deferred gratification, excused as transcendent competition or a necessary evil, has caused us to practice the exact opposite of what we preach.

A typical example of innovative learning in high school is the simulation game. Students in a class studying international politics assume roles as the leaders of certain nations. They act out local news reports, gather "intelligence" from political journals, and spy on one another; they try to work out deals, exert various forms of pressure, use "public forums" such as their own press or their version of the UN; they figure the mathematical odds on every proposed move, attempt trickery and deception—and in general try to win power for the country they represent. The teacher acts as observer-referee and keeps score. Such lifelike education has proved effective, especially for the sons and daughters of white affluent parents. It closely parallels training programs given by industry and government to their most promising elite in top management, the diplomatic corps, and the military.

The issue is obviously an educational one. Education can help

change the system, given enough time and money. Neither parents nor neighborhoods nor communes that sentimentalize work in simple, controllable forms of sharing can so measurably affect values. In education are included not only schools but also education's most persuasive and timely teachers, the mass media—television, radio, film, magazines, billboards—and the leisure industry. All that's needed is their commitment.

But sadly, the media and the leisure industry are unlikely prospects for help. They are dominated by quick-profit interests, even while their technologies are developed by men and women of uncommon imagination. At present they offer only token "community services," forced on them by government and the tax structure. Asking their representatives to commit expensive facilities and choice exposure to the promotion of playfulness would be futile; they would have to be shown that consumerism is the highest kind of play.

The better bet is still the public schools, hidebound in habit, bureaucracy, and janitors as they are. Principals and teachers are more likely than members of the business community to consider implementing changes in human values. Traditionally, they have viewed their vocation as performing a positive, even innovative, social function. Although eventually schools as we know them may give way to the technology of mass communication and recreation, instruction in play can begin in kindergarten and teachers college.

To foster play as a foundation of society, long-term experimentation would be essential, say twenty-five years minimum, with assessments every five years. The usual, loudly touted, flash-in-the-pan welfare programs, tailored to changing political administrations, would be out of the question. Financing would have to come variously from state education commissions, major public-minded foundations, industry, and private individuals, all utilizing tax programs and allowances as inducements more fully than they presently do.

At the same time, the nonartists now populating the globe, who continue to believe they are part of the Old Church of Art, might think about how unfulfilling their position is and how by un-arting, that is, dropping out of the faith, they might direct their gifts toward those who can use them: everyone. Their example would be a model to younger colleagues, who could then begin to train for constructive roles in elementary and secondary public education. Those under

twenty-five today tend to feel keenly about performing some human-itarian service, but among vanguard artists the desire is frustrated by a profession lacking inherent utility. The proposed alternative not only eliminates this problem but also avoids the disaster of populist solu-tions that watered down and ruined major talents in Soviet Russia and Europe and in the United States in the thirties.

Not enough has been made of the drawbacks in art's celebrated uselessness. Utopian visions of society aided or run by artists have failed because art itself has failed as a social instrument. Since the Renaissance, art has been a discipline of privacy, the testament of the outsider in the midst of expanding urbanization. That the crowd is lonely in its own way does not give the artist an audience or political role, since the crowd does not want to be reminded of the depth of its unhappiness and cannot resolve it, as the artist does, by inventing countless personal cosmologies. Nor does the artist-seer, like William Blake, automatically know how to settle wage disputes and pollution problems. The separation has been complete, like that of the soul from the body.

Only when active artists willingly cease to be artists can they con-vert their abilities, like dollars into yen, into something the world can spend: play. Play as currency. We can best learn to play by example, and un-artists can provide it. In their new job as educators, they need simply play as they once did under the banner of art, but among those who do not care about that. Gradually, the pedigree "art" will recede into irrelevance.

I suspect that static words, particularly names, are greater deter-rents than social customs to the changes brought about by such nonverbal forces as jet transportation. Adjustment to the new state of affairs is slowed down by keeping an old name, as when, until quite recently, one spoke of embarking on and debarking from a jetliner. Memories of the *Queen Mary* were evoked. Consider how the titles *financier*, *psychiatrist*, *impresario*, or *professor* burden those to whom they are applied with the weight of each profession's accumu-lated attributes and meanings; each virtually imposes a performance of its known frames of reference. A professor *acts* like a professor, and sounds like one. An artist obeys certain inherited limits on per-ception, which govern how reality is acted on and construed. But new names may assist social change. Replacing *artist* with *player*,

as if adopting an alias, is a way of altering a fixed identity. And a changed identity is a principle of mobility, of going from one place to another.

Art work, a sort of moral paradigm for an exhausted work ethic, is converting into play. As a four-letter word in a society given to games, *play* does what all dirty words do: it strips bare the myth of culture by its artists, even.

Doctor MD

(1973)

What good is history? Marcel Duchamp's legacy contains a small but influential body of quasi-art, often bordering on philosophy. A carefully styled dialectic is at work, in which linked visual and verbal puns are couched in narrative fictions, operational processes, common objects, and words meant not so much to be seen as read. He was opposed to the taste of his time for optical means in painting; he questioned whether modern art had its own language, doubted that such a "dumb" affair, which addressed itself to the eyes, could be intelligent. Above all, he wanted art to be intelligent. Today, thanks to him, critical discourse is inseparable from whatever other stuff art is made of. Conceptualism, for example, is "inconceivable" without Duchamp.

It followed that his position equally questioned the possibility of purely verbal intelligence. Professional philosophy, bound up as it was with words alone, was as fruitless as pure painting. That's the barb contained in his puns: human aspiration that until recently sought understanding through specialization was both futile and absurdly amusing. Multimedia experiments of the sixties were not caused by Duchamp alone, but he clarified the critical setting for their emergence.

Hence, his verbal-visual play, perhaps born of mixed skepticism and dandyism, confronted a romantic tradition of high, often tragic, seriousness in art making. Humor was superficial. Even humor as arch as his was overcast by the dreamwork of Surrealism and the existential struggles of Abstract Expressionism. But since Pop art (itself indebted to him), artists are quite funny and still avant-garde! The Fluxus movement, many Bodyworkers, Conceptualists, and Happeners are evidence of the permission he gave to wit. Wit, from the Duchampian perspective, is the condition and consequence of keen thought. If you see things clearly, *really* clearly, you've got to laugh because nothing's been accomplished. There's a Zen story about one of the great patri-

archs, who was asked what it felt like to be enlightened. His answer was, "I found out that I was just as miserable as ever." Considering Duchamp's work specifically, the *Large Glass*, though a major piece of art and a summary of his early interests as a painter, is nevertheless not particularly helpful for the present. It is a late Symbolist conceit over which academics hover, seeking linguistic riddles and cabalistic import (both are there, along with the latest racing poop sheet). But it remains a hermetic exercise, a *picture*, in the old sense, of a world contained within itself. The best part of the *Glass* is that it is a window-pane to look through; its actual configurations are forced into accord with the visible environment beyond them, for instance, a chocolate-grinder diagram superimposed on a kid picking his nose.

His Readymades, however, are radically useful contributions to the current scene. If simply calling a snow shovel a work of art makes it that, the same goes for all of New York City, or the Vietnam war, or a pedantic article on Marcel Duchamp. All the environmental pieces, Activities, slice-of-life video works, Information pieces, and Art-Tech shows we've become accustomed to owe their existence to Duchamp's idea about a snow shovel.

Conversely, since any nonart can be art after the appropriate ceremonial announcement, any art, theoretically, can be de-arted ("Use a Rembrandt for an ironing board"—Duchamp). This, it turns out, is a bit difficult. Duchamp's gesture in this direction, his *L.H.O.O.Q.*, didn't alter the Mona Lisa; it simply added one more painting to the museums. Replacing the meaning and function of the history of the arts with some other criteria seems to interest us much less than discovering art where art wasn't.

Beyond these identity games, the implication that life can be beautiful is rather salutary, if overwhelming. In the process, the word *art* ceases to refer to specific things or human events and becomes a device for getting the attention of key people, who, having been gotten to, realize that the world is a work of art. Art as such, as it used to be, is reduced to a vestigial specialization on its way out; only the title remains, like the military epaulets on a doorman's uniform.

As an addition to the history of thought, the Readymade is a paradigm of the way humans make and unmake culture. Better than "straight" philosophy and social science, a good Readymade can "embody" the ironic limits of the traditional theory that says reality is nothing but a projection of a mind or minds. Duchamp, a cool sub-

scriber to that tradition, knew, I suspect, that metaphysics, theology, science, and art were "useful fictions" (Hans Vaihinger's phrase). The intellectual or artist merely needs a persuasive consensus to launch an idea into the world. "All in all, the creative act is not performed by the artist alone," Duchamp said in a speech in 1957. Otherwise, the fiction will be useless, only a fiction and not a reality. The Readymade is thus both exposure meter and confidence game.

According to some of my friends, the freeways of Los Angeles are great theater, modern theater, with no beginning or end, full of chance excitements and plenty of the sort of boredom we all love. I pass that observation on here. Their future as Readymade art depends on the reader. That is, I am engaging in gossip. Duchamp's generous reminder to his posterity is how fragile public relations are.

The Education of the Un-Artist, Part III
(1974)

The models for the experimental arts of this generation have been less the preceding arts than modern society itself, particularly how and what we communicate, what happens to us in the process, and how this may connect us with natural processes beyond society.

The following examples—some dating from the early fifties but most of them recent—have been grouped according to five root types found in everyday life, the nonart professions, and nature: *situational* models (commonplace environments, occurrences, and customs, often ready-made), *operational* models (how things and customs work and what they do), *structural* models (nature cycles, ecologies, and the forms of things, places, and human affairs), *self-referring* or *feedback* models (things or events that "talk" about or reflect themselves), and *learning* models (allegories of philosophical inquiry, sensitivity-training rituals, and educational demonstrations).

A number of the artworks do not fit neatly into their assigned categories but can belong in two or three at once, depending on where we want to put the emphasis. Baldessari's map piece, placed in the self-referring group, could also belong to the operational one; Beuys's sit-in, besides being situational, could be called operational and learning. And the High Red Center's *Cleaning Happening* could be extended from operational to include both learning and situational models.

Within these large groupings, the works derive from more specific sources. Vostell's and Neuhaus's pieces are based on the guided tour; Haacke uses a polling device as the political tool it really is; Ruscha employs the format of a police report; Orgel parodies a domestic routine; Harrison's compact ecology system echoes many made in the science lab.

Fig. 13　Computer keyboard. *Photograph by Jeff Kelley.*

What is essential now, to understand the value of the new activities on any level, is not to pigeonhole exactly but to look regularly for these ties to the "real" world, rather than the art world.

Situational Models

Richard Meltzer occupied a small utility room in the basement of a university. He turned it into Meltzer's Clothing Store, where quantities of old clothes were hung or shelved in fixed proportions according to color, size, subject, and, I believe, use. Anyone could take an article as long as it was replaced with something in a similar category, for instance, a violet tie for a sash of the same hue, or a pink sock and a blue one. That way the store retained its compositional integrity. There were dressing areas for men and women. (1962)

Paul Taylor, dressed in a business suit and standing in one spot, assumed simple poses in succession (hand on hip, foot extended, right turn) for the entire length of a dance, while an amplified recording of a telephone operator was heard telling the time every ten seconds. (1958)

For a Steve Paxton dance a group of people simply walked naturally across a stage, one after the other. (1970)

Joseph Beuys conducted a sit-in for one hundred days in a recent international Documenta show at Kassel. He was available for anyone to discuss with him his current interests in political change and the role the arts might have in this change. He was officially on exhibit and, by implication, so was any future action that might ensue from the talks. (1973)

Merce Cunningham accompanied a tape of Musique Concrète by arranging a group of seventeen persons—mostly nondancers—to simply "do gestures they did normally." Chance procedures were applied to these movements regarding time and positions onstage. They were independent of the sounds coming over the loudspeakers. The gestures consisted of such things as "washing one's hands," "walking and viewing the country," "two people carrying a third," "touching," "eating," "falling asleep," "jitterbug step," and "running." (1953)

Allen Ruppersberg obtained the use of a rooming house in Los Angeles. He advertised it as *Al's Grand Hotel* and offered rooms for rent on six successive weekends. The hotel had a bar, music, continental breakfast, maid service, souvenirs, and price-adjusted rooms with double beds. The rooms contained such things as a large wooden cross (the Jesus Room), a picnic spread on a checkered cloth with *Life* magazine papering the walls (the B Room), and seven framed wedding photos, a three-tier wedding cake, ten wedding presents, plastic

ivy, and flowers (the Bridal Suite). As at a popular resort, a catalog offered mementos of one's stay. (1971)

Sandra Orgel performed a collaborative piece at Woman House in Los Angeles. She appeared washed-out, wore a cheap housedress and floppy slippers, and had her hair in curlers and a cigarette dangling from her mouth. She set up an ironing board and plugged in an iron. When it was hot she spit on it. Its hiss was the only sound. She methodically and silently pressed a bed-sheet for about ten minutes, and when it was finished, she folded it and went out. (1972)

Ed Ruscha compiled a picture book of a drama on a des-ert freeway. An old Royal typewriter was thrown out of a speeding auto. Photo documents with measurements were carefully made of the strewn debris—an "official report" of the scene of the accident. (1967)

Joseph Kosuth arranged three clean-topped tables around the walls of a bare room. Three folding chairs at each table faced the walls. Fixed to the walls were three numbered placards in enlarged type containing extracts from scholarly writings on the subject of models in sci-entific theory. Placed neatly on the tables before each chair was a notebook of related texts, open for perusal. (1972)

In the Museum of Modern Art, Hans Haacke set up two lucite boxes side by side, with counting devices on each. An overhead sign asked the passerby to consider whether New York Governor Rockefeller's silence on Nixon's Vietnam policy would stand in the way of a vote if Rockefeller should run for reelection. A yes ballot was to go in the left box and a no ballot in the right one. (1970)

Operational Models

Michael Heizer got a bulldozer and driver to hollow out of the desert a large crater. In a television interview af-

terward the driver judged that he had dug a good hole. (1971?)

Barbara Smith produced a book with a Xerox copier. Beginning with a photo of her young daughter, she made a copy, copied the copy, copied that copy, and so on through a long series. As in biological generations, things changed. Because the Xerox machine automatically reduced each image by about ¼ inch, the girl's head gradually disappeared into a receding constellation of dots until it seemed a mere point in space. This occurred at the middle of the book. As the pages were turned, the reducing process reversed and soon a face was discernible advancing toward one. But at the end it was a somewhat different photograph of the same little girl! (This second Xerox series was made in the same way as the first, but Smith simply turned around the order when assembling the book.) (1967)

Emmet Williams composed a book called *Sweethearts* that is more scanned than read. Each page is made up of spatially arranged permutations of the eleven letters in the title word. The book starts from the back cover and the pages are meant to be flipped with the left thumb so that a blurred but subliminally clear meaning is registered in the mind. This filmic treatment of a text recalls the flip photo and cartoon stories of our childhood in which a staccato sense of images in motion was achieved. (1966)

La Monte Young's composition *Draw a Straight Line and Follow It* took place in a loft. Young and a friend drew on the floor with a piece of chalk (from two points, as I recall, in the manner of surveyors). The process took some hours and every once in a while quiet comments were exchanged. (1960)

In part of an Yvonne Rainer dance a group of men and women carried and stacked about a dozen mattresses, variously lying, diving, and sitting on them. (1965)

George Brecht arranged a sundown event for cars in a parking lot. Each person had twenty-two rearrangeable cards indicating the equipment on his or her car that was to be activated within certain time-counts: radio, lights, wipers, doors, windows, motor, seatbacks, foot brake, glove compartment, trunk-cover, engine-hood, horn, etc. (1960)

As an agit-prop event, Japan's High Red Center group prepared a *Cleaning Happening*. Dressed in immaculately white lab suits, mouths covered by sanitary hospital masks, they silently and precisely cleaned a busy street in Tokyo. (1968?)

Bernard Cooper devised a metal mouthpiece (a "Regulator") looking something like an orthodontist's lip retractor. It was balanced on the front lower teeth. From this were hung one to six steel disks, each weighing 5 ounces. The user was instructed to say a word or two and notice what happened to the phonemes as the weights were added and the jaw pulled down. Conversations on the telephone, serious discussions, and public lectures were then recommended for users of the device. (1972)

Max Bense spread sixty-two common words at random on a page, words like *fish, nothing, wall, year, salt, way, night*, and *stone*. He saw these as a "set of words," as in mathematical set theory. They could be recombined by the reader in almost endless "sets" as object values rather than verbal ones. (1963)

Structural Models

James Tenney programmed a computer to generate analogues to the structural characteristics of the sounds of cars he heard every day while driving through the Lin-

coln Tunnel in New York City. The tape had the slightly hollow sound of wind around the ears. (1961)

Michael Snow had an apparatus made that automatically swung a continuously running camera around for hours in two variable orbits. The rig was set up in a desolate section of Canada and the camera recorded whatever was in front of its lens: earth and sky. In viewing the film, one heard the sound of the rig's motors and saw the sun go down and come up in what felt like real time; the circling of the camera was like that of the earth around the sun. (1971)

For Tomas Schmit's *Zyklus* the contents of a full Coke bottle were slowly and carefully poured into an empty one, and vice versa, until (because of slight spillage and evaporation) no liquid remained. The process lasted nearly seven hours. (1966?)

Dieter Rot arranged to exhibit twenty-odd old suitcases filled with a variety of international cheese specialties. The suitcases—all different—were placed close together in the middle of the floor, as you might find them at a Greyhound bus terminal. In a few days the cheeses began to ripen, some started oozing out of the suitcases, all of them grew marvelous molds (which you could examine by opening the lids), and maggots were crawling by the thousands. Naturally, the smell was incredible. (1969)

Newton Harrison recently turned to farming. He made a model shrimp farm of four rectangular tanks of sea water of graduated degrees of salinity. Algae and young shrimp were put into the tanks; the algae were nourished by the sun and the shrimp ate the algae. As the sun evaporated the water, the salinity of the tanks increased, making the water change color, from green in the least salty to bright coral in the most salty. The water level was then kept constant and the shrimp were eventually harvested. (1970)

Self-referring Models

Helen Alm made a videotape of herself trying to relax. It was played back on a monitor, and she sat in front of it and carried on a kidding dialogue with her playback self about the same thing: trying to relax. A tape was made of this doubling of Alm and was then played on the monitor for viewing by her and others. (1972)

John Baldessari selected a map of California. He determined where its printed letters C.A.L.I.F.O.R.N.I.A. would fall on the real space of the state. Traveling to each location on the map, he painted or made of rocks, yarn, flower seed, wood, etc. a large corresponding letter on the landscape. Photo documents of these letter sites, mounted in a row, spelled back to the viewer the word California on the map. (1969)

For a Robert Whitman theater piece, two women performed in front of a projected film of themselves. Another woman, in a full white dress, doubled as a second screen, on whom was projected a film of herself removing her clothes. She exactly matched the movements of her film self until she appeared nude, although everyone could also see her dress. (1965)

Michael Kirby put together a construction of aluminum struts and mounted photographs into a number of its spaces. Spectators who moved around it saw that each photo corresponded to the view of the room or window seen from its own vantage point. The piece functioned as a collection of "eyes," and when once it was moved to another site, all the photos were naturally retaken. (1966)

In a different piece, the scaffold was eliminated and a rectangle was conceived to lie both inside and outside Kirby's apartment window. Photographs were taken from the four points on the rectangle, facing in and out, and were then mounted unobtrusively at their sight points as objectified views of their respective surroundings. (1969)

Dieter Rot noted that he was "advertising my type-writer" in the following poem:

o ɸ ɸ ʊ ɵ ɸ ɸ
ɸ l l ʋ ɛ t l
ɸ l i ʋ ɛ t i
ʊ ʋ ʋ v ɵ ʋ ʋ
ɵ ɛ ɛ ʊ ɵ ɛ ɛ
ɸ t t ʋ ɛ t t
ɸ l i ʋ ɛ t i

The typewriter also misspells . . . (1958)

Robert Morris made a small gray box. From inside it came barely audible hammering and sawing sounds. It was called *Box with Sounds of Its Own Making*. (1961)

Learning Models

Robert Rauschenberg made a series of vertically joined blank white canvases. Because there was nothing else on them, viewers became aware of their own shadows on the surface, the bumps in the fabric, and the flashes of colored light produced by the pulsing of their eyes. (1951, 1953)

Shortly after, John Cage presented his *4'33"*. The pianist David Tudor opened the piano keyboard cover and set a stopwatch. Adjusting his stool, he sat there for the prescribed time and played nothing. The sounds of the street, the elevator, air-conditioning, squeaking chairs, coughing, giggling, yawning, etc. became deafening. (1952, 1954)

Wolf Vostell provided a map for a trip on the Petite Ceinture bus line of Paris and advised the traveler to look for torn posters, debris, and ruins and to listen to noises and cries . . . (1962)

Some years later, Max Neuhaus took friends on a

number of tours of municipal electric generating plants, where they were able to listen to the pervasive whine of the enormous motors and feel the building vibrate through their feet. (1966, 1967)

In one of Ann Halprin's dances, a group of men and women slowly and ceremonially undressed and dressed themselves, all the while examining each other's movements. (1964?)

George Brecht sent small cards to friends, like this one (1960):

TWO APPROXIMATIONS

(

obituary

)

Vito Acconci placed himself, blindfolded, on a chair at the bottom of a cellar stair. Armed with a metal pipe, he proceeded to talk himself into a state of intense paranoia about the possibility that someone would attempt to get past him into the cellar. Muttering constantly to build his nerve and slowly swinging his pipe at the imaginary challenger, Acconci punctuated his words with thuds of the pipe on the hard floor. A man in a group watching it all on a remote video monitor upstairs decided to try Acconci out, and a dramatic scuffle ensued. (1971)

These examples mark a turning point in high culture. Although artists have long been more or less consciously concerned with the

nature of the physical universe, with ideas and with human issues—
i.e., with "life"—their primary models were life *in translation*, namely
other artworks. Life itself was the secondary model; an artist went to
art school to study art, not life.

Now the procedure seems to be reversing. Experimenters are by-
passing the defined linguistic modes of poetry, painting, music, and so
forth and are going directly to sources outside their professions. Ac-
conci reads scholarly books on social behavior, and his work resembles
case histories of abnormality presented as quasi-rites; Bernard Coo-
per's piece alludes to the familiar experience of trying to respond to a
dentist's small talk with one's mouth full of braces and tubes; Barbara
Smith discovers a new kind of portraiture by taking advantage of the
mechanical peculiarities of a standard office copier; and Cage applies
to a concert situation Zen teachings and his acoustic perceptions in a
scientifically soundproofed chamber.

None of this is to be found raw in prior artwork. Instead, such
activity calls for comparison with the models indicated (or causes us
to look for them if they aren't immediately apparent in examples not
described here). What follows now is a closer look at these nonart
models and at what it has meant for artists to copy them.

Mirrors of the Mirror

Some imitations are made to deceive. Like the phony dollar bill, they
are counterfeits—more or less well done. High art's prevailing preju-
dice against imitation suggests that even when a work is not intended
to palm off a copy for an original, it is an unconscious forgery anyway
and that at the heart of the matter is an escape into another's identity
and the impossibility of self-realization by such a practice.

It is too easy to get caught. After more than five hundred years of
individualism, society's scrutinizing demand for proofs of uniqueness
quickly exposes the copy as if it were a fake and its artist a criminal.
Faced with this great pressure, only rarely (and perhaps pathologically)
will artist apprentices continue in the role of disciples beyond appren-
ticeship, copying faithfully a master's vision and style. In the past,
devotees may have felt so close to their guide that the efforts of each
seemed almost mystically united. They strove for the impression that
there was no difference between first- and secondhand. But in recent

history imitation, no matter how sincere, has appeared to most intellectuals dishonest in its very doubtlessness, as if, in a pluralistic culture, there were indeed one true way.

Yet a strain of imitation has been allowed and even welcomed in the vanguard arts, in the form of the takeoff or quotation. Presented like a stage whisper between artist and public, the copy was always explicitly different from the source. It was essential to its meanings that everyone know both instantly; therefore what was copied was usually not fine art but the daily world, its customs and artifacts. As an important early example, Alfred Jarry appropriated the style of his play *Ubu Roi* from a schoolboy marionette skit he probably helped write as a youth, a style familiar to anyone who has gone to summer camp or experienced preadolescent entertainments. In his novel *The Exploits and Opinions of Dr. Faustroll, Pataphysician*, the various jargons of popular science, legal and documentary records, "essential reading" lists, and occultism are juxtaposed into an absurd and mock-inflated portrait of the twentieth-century antihero. And in his sci-fi essay "How to Construct a Time Machine," Jarry uses the how-to form of technical manuals and sets the method for Duchamp's *Bride Stripped Bare* and notes to the *Green Box*.

The Cubists, for their part, included in their pasteups bits and pieces of real newspaper, wallpaper, oilcloth, and imitation wood graining. Satie scored a typewriter, revolvers, an airplane motor, and a siren in his music for the ballet *Parade*. The Futurist Luigi Russolo built machines for his concerts that would reproduce the noises of the city: "whispers, thunders, bubblings, screeches, grindings. . . ." Blaise Cendrars reportedly copied every line of his book of poems *Kodak* from a series of contemporary pulp novels. The Russians Vladimir Tatlin and Aleksandr Rodchenko carried over into their constructions and monuments the girdered and strutted look of the industrial scene; and from 1918 to 1922 in Petersburg and Baktu there were those famous citywide performances of ship and factory steam whistles designed for apparently appreciative workers. In the same period, the Dadas sprinkled their broadsides and posters with advertising slogans and reproductions. Picabia's best work was executed in the crypto-diagram manner of hardware catalogs and engineering texts. Most radically, Duchamp's Readymades replaced the artist's labor with a standardized object of ordinary use simply by moving it, largely unchanged, into an art context.

Thus the passé but venerable notion of the artist as master illusionist was wryly hinted at, but deadpan, as though it were a slightly vulgar admission among friends. Mass-production techniques, after all, had taken over this role by the last quarter of the nineteenth century (besides chromos, remember those mechanical music bands and cast-iron classical building facades?), so illusions were more or less lifted from their metropolitan surroundings ready made. They became the artist's cheap imitations of other imitations or multiples, but accomplished by none of the illusionistic skills once expected of a professional!

In our time, such re-presentations, parodies, and quotations have continued in the writings of the Beats and in Pop art; in the noise music of Cage, Neuhaus, and others; in the "task" modes of dancers such as Yvonne Rainer; in the commonplace environments and enactments of Happenings, Bodyworks, and Activities; in the industrial materials, fabrication methods, and shapes of Minimalist sculpture; in schematically conceived paintings; in the electronic apparatus and scientism of Art Tech; in computer-made and Concrete poetry; in the propositional forms of Conceptualism, and so on. (I've commented on this kind of copying in parts 1 and 2 of this essay.) The irony here is that the very act that releases the ordinary object, sound, or event from routine indifference counts as novelty. For the artist is not simply re-creating the world but is commenting on the infinite reproducibility of its illusions.

Harold Rosenberg (in *The Anxious Object* [New York: Horizon, 1964], pp. 61–62) describes how illusionism of this recurrent sort, which appears strident in Pop art and New Realism of the early 1960s, is due in part to urbanization. "The city dweller's 'nature,'" he writes,

> is a human fabrication—he is surrounded by fields of concrete, forests of posts and wires, etc.; while nature itself, in the form of parks, a snowfall, cats and dogs, is a detail in the stone and steel of his habitat. Given the enormous dissemination of simulated nature through window displays, motion picture and television screens, public and private photography, magazine advertisements, art reproductions, car and bus posters, five-and-ten art, it is plain that in no other period has the visible world been to such an extent both duplicated and anticipated by artifice. Surrounded by artistic copies of presidents,

scenes, famous events, we become in the end largely insensitive to the distinction between the natural and the made-up.

What Rosenberg says may also be true of the distinction between originals and copies. Do young people with long hair remember, or care, that it was the Beatles who were responsible for reviving a fashion that had endless echoes back into time? Who would insist that the Japanese have no right to a Western technology that allowed them to become a major economic and political power just because they copied it? Replication, modularity, and serialism, aspects of mass production, have become the norms of daily life; they are part of the way we think.

Only in the fine arts does the quest for originality remain a vestige of individualism and specialization. It is the ideological token of the sufficient self. Yet popular acceptance of psychoanalysis makes everyone today an individual, while the phenomenal growth of leisure time in the economy implies that, potentially, anyone (not just artists or eccentrics) can pursue a personal life-style. And gradually increasing public and corporate support of pure research, arts education, and the performing arts promises more tangible rewards to the intellectual than isolation in the garret. These changing social circumstances have at least blunted, if not done away with, the special poignancy that once moved artists to struggle to be idiosyncratic.

At any rate, originality as an index of integrity may be on the wane, expressing itself sometimes as nostalgic pose, more often as a kind of canned or repeatable individualism that only thinly veils the anonymous sources of the new art's vitality. For in fact, artists are noticeably discarding unique handmade qualities in favor of multiples made by machines or teams, ideas conceived by groups, or processes generated in the lab or environment.

Jill Ciment found that for each of the numbers on a touch-tone telephone there is a different sound heard when a person is called. She then push-buttoned the numbers of 185 telephones that were "important during my life," recording the resulting tones on tape. The faint, thin, drawn-out whistles varied in both pitch and duration because of the stumbling time it took to carry out the process, while the dynamics remained constant. Ci-

ment thus composed an autobiography and group portrait of her past. (1972)

On January 9, 1969, a clear plastic box measuring $1 \times 1 \times \frac{3}{4}''$ was enclosed within a slightly larger cardboard container that was sent by registered mail to an address in Berkeley, California. Upon being returned as 'undeliverable' it was left altogether intact and enclosed within another slightly larger container and sent again as registered mail to Riverton, Utah—and once more returned to the sender as undeliverable.

Similarly another container enclosing all previous containers was sent to Ellsworth, Neb.; similarly to Alpha, Iowa; similarly to Tuscola, Mich.; similarly and finally to Hull, Mass., which accomplished the 'marking' of a line joining the two coasts of the United States (and covering over 10,000 miles of space) during a period of six weeks of time.

That final container, all registered mail receipts, and a map joined with this statement to form the system of documentation that completes this work.

—Douglas Heubler

Of course, original artists can still be applauded. They have the *ideas* and conceive the prototype of their works. But when Andy Warhol's popularity a few years ago was so great that he hired a stand-in to make appearances at universities (until he was fingered by one of the outraged intelligentsia), he left the nagging impression that an artist today might be as easy to replicate as his art. In fact, for some time after the exposé, people wondered at parties if they were talking to the real Andy or another substitute. They seemed to enjoy the uncertainty.

Although some criticism has been leveled at this apparent irreverence, not enough attention has been paid to our current taste for heroes made by, and experienced through, publicity channels. Rosenberg, in the passage quoted from *The Anxious Object* and again recently, has remarked on the way media create realities; as far as the fine arts are concerned, he has some reservations about the shift away from the created art object to the artist as creation but points out that the phenomenon bears on the issue of illusionism.

In the semblance of the artist displayed in magazines and on TV,

something particularly gratifying happens, as if, in support of Mc-Luhan's view, each of us felt a closer contact with the personality than even a formal handshake could provide, if that were possible, yet shared paradoxically with multitudes. It is at once intimate and public. And it is all the more real for its reproducibility. It is obvious that the hero in the flesh cannot be everywhere for everyone. Far better to commune with an immaterial fantasy in print or one served up at the touch of a dial in our living rooms.

Traditionally, the artist-genius, creator of the masterpiece, was the analogue of God the Father, creator of life. One artist, one original; one God, one existence. But today there are countless artists and reproductions, countless gods and cosmologies. When "the one" is replaced by "the many," reality may be perceived as a menu of illusions, transformable and replenishable according to need (as the electric light turns night into day).

Lifelike That

The West's recurrent dreams of returning to rustic nature or exploring the future in outer space are accomplishable by the technology of the present. Besides the technologies of rapid transportation and communication, without which getting to either nature or outer space would be impossible, there are quick medical services along the way in case of illness, guidelines about diverse life-styles and techniques for physical and emotional survival, genetically advanced seedlings developed at major universities for "new primitives" wishing to grow their own food, freeze-dried nourishment for astronauts, and, most critical of all, a cultural upbringing in which options are the birthright of the middle class.

Disney World engineers have on their drawing boards a highly sophisticated planned city to be built in the vicinity of the recreation park. There would be not only completely automated supply and waste systems, underground roads and trainways, and overhead footpath neighborhoods conceived in the expected variety of old-world styles but also a Fuller-type enclosing shell with controlled atmosphere more "naturally" pleasant than the tropical humidity of Florida. As the Disney song goes, "It's a small, small world," and it can be wrapped in cellophane.

Airline pilots have been trained for some time by flight simulators that reproduce in a laboratory all the conditions of flying. Sitting at controls that match those of an airliner, they see outside the cockpit window a projected day or night scene that corresponds in detail and scale to one or another major airfield they'll have to land on or take off from. As they manipulate the controls, the scene recedes, enlarges, banks to left or right, and streams below at greater or lesser speed, just as it would in an actual plane. Complete with earphones and vibrations, the replica is made to be, in effect, real.

In a related example, recent televised moon landings of exceptional clarity were interspersed with previously shot footage of simulations made on earth, so that, half-jokingly, some viewers conjectured that the whole business was a mock-up with changes only in caption.

The anthropologist Edmund Carpenter, in his book *They Became What They Beheld* (New York: Outerbridge and Dienstfrey/Dutton, 1970), quotes an account of Robert Kennedy's body arriving in New York from Los Angeles. The writer, "standing with a group of reporters, . . . noticed that they almost all watched the event on a specially rigged television screen. The actual coffin was passing behind their back scarcely any farther away than the small-screen version." Similarly, Harold Rosenberg—always a keen observer of such occurrences—points out in one of his *New Yorker* articles (March 17, 1973) that "on television, POW's returning from Hanoi were shown passing the time watching POW's returning from Hanoi on television. A man rows across Main Street to buy a newspaper showing his town flooded. . . ."

Such examples, by their wide extent, reveal the implications of staple items like creamless sweet cream, meatless meat, synthetic wool, plastic bricks, and AstroTurf. And *Life* magazine, true to its name, devoted one of its issues (October 1, 1965) to new discoveries in genetic code breaking and led readers to speculate that test-tube babies are right around the corner. In this kind of civilization, dreams of nature's way or life on the moon are only different versions of human nature's artifice. Art, which copies society copying itself, is not simply the mirror of life. Both are made up. Nature is an echo system.

David Antin was asked to give a lecture on art. He talked impromptu and recorded what he said on tape. The tape was transcribed, and all breath stops and phrases were

indicated by spaces left in the lines of print. The transcript was published first as an article in an art magazine and subsequently as a poem in a book of his recent works. But when read silently or aloud, it was just like David Antin speaking normally. (1971)

Terry Atkinson wrote an essay on the nature of Conceptual Art and posed the question, "Are works of art theory part of the kit of Conceptual art, and as such, can such a work, when advanced by a Conceptual artist, come up for the count as a work of art?" The question was answered by Ian Burn and Mel Ramsden in another essay on this subject when they stated that their text "counts as an artwork." But when read silently or aloud, both these essays were just like estheticians writing about their subject. (1969, 1970)

For a Happening of Robert McCarn's, four eight-foot-high gray wooden crates were made, like ordinary shipping containers, and were stamped in yellow with the words "Fragile Works of Art." They were forklifted onto a flatbed truck along with two pallets of sandbags and driven (on prior agreement) some eight hundred miles to two museums and an art school gallery. Bills of lading were specially printed, a trucker's log was kept, and the proper forms and receipts were filled out upon delivery.
 Some crates and sandbags were accepted (it was up to the recipient to accept or reject the shipment) and were then exhibited as art; one was accepted as a packing box for other artwork and was used accordingly; two were unloaded, opened (they were of course empty), closed again, and sent back with the driver, McCarn. He and his friends carried out the process exactly the way any trucker might have done it. (1970)

Video Art: Old Wine, New Bottle
(1974)

The use of television as an art medium is generally considered experimental. In the sense that it was rarely thought of that way by artists before the early sixties, it must be granted a certain novelty. But so far, in my opinion, it is only marginally experimental. The hardware is new, to art at least, but the conceptual framework and esthetic attitudes around most video as an art are quite tame.

The field has customarily been divided into three main areas: taped art performance, environmental closed-circuit video, and documentary or political video. In the first, some artistic event performed by the artist and friends or by electronically generated shapes is condensed, stored, and reproduced on standard-length tapes for replay later on.

In the second, people, machines, nature, and environments interact, communicate, and perhaps modify each other's behavior in real time. Although tapes are sometimes produced to document what has occurred, they are not integral to it. But tapes can be used to alter time and file away prior activities for representation in the carrying out of the process.

In the third area, events deemed socially important are recorded on portable equipment (or, more rarely, are transmitted live over cable) for the enlightenment of a public that normally has no access to this material on network TV or via other news media. I discount this third group as socially important rather than simply artistic, because although it has been made welcome in art when no one else wants it, its legitimate work must be done in the real world and not in the art world. It is a hunch that this use of video could bring about valuable human experiments. But to include it in a discussion of art just because it has made the art world its crash pad is to limit its utility to a small intelligentsia and to defuse its critical intent by a pretense to esthetics.

I'll confine my comments, then, to the first two areas. There are,

of course, overlaps between them and sometimes additions of other means such as radios and telephones, telegrams, films, and slides— but in general this division helps to locate the artists' principal concerns. Now, more than a dozen years after Paik and Vostell used TV sets as props in their Environments and Happenings, a tentative evaluation of the field is possible.

It is clear to everyone that the more popular of the two modes is video art tapes—for all the obvious financial reasons. Taped performances of an artist doing something or of abstract color patterns doing something are, after all, theatrical arts. They evoke comparisons with TV commercials, comedy routines, product demonstrations, promotional and educational TV, and the most dreary abstract animated films of thirty-odd years ago. Thus although only a few performances are unique as theater pieces and fewer still involve experiences with video per se—I'm thinking of tapes by Acconci, Joan Jonas, and Wolfgang Stoerchle—most of them are just more or less adequate recordings of the performances or are compositions of "special effects" that could have been done just as well or better as film. Videotape is simply cheaper and faster.

Moreover, this traditionalism is encouraged by galleries and museums that display and merchandise the tapes as the equivalent of editions of prints. Collectors purchase them as art objects, and audiences view them as chic home movies. The accumulated weight of art history and current gallery-induced preciosity are brought to bear on every tape that's shown. Given these conventional sources, formats, contests, and modes of consumption, the tapes contain only minor "discoveries"; they are not experimental.

I pass over live performances, which continue to incorporate video as a prop, as in the work of Jonas and Stoerchle, or which use it as the equivalent of a performer, as in Ned Bobkoff's substitution of a video tape recorder (VTR) for the audio recorder in Samuel Beckett's *Krapp's Last Tape*. These performances are straightforward theater, retaining the usual physical conditions of the art: an enclosed time/ space with an audience and an actor, animate or otherwise. When these structural elements are constant from one era to another, any internal changes are merely changes in details. This unchanging theatrical structure is worth mentioning in the context of video art tapes, because they are presented to the public as if in a pocket movie theater.

The closed-circuit, environmental videographers, in contrast, are

trying to make use of what in the medium is *not* like film or other art. The most experimental feature of their work, it seems to me, is its emphasis upon situational processes rather than some act canned as a product for later review. Products do, of course, provide new experience and influence thought. Hallucinogenic drugs, water skis, even TV sets are examples. But art products tend to elicit stereotypical responses; very little fresh experience or thought comes about from them.

Among those working in closed-circuit video are Douglas Davis, Juan Downey, Frank Gillette, Bruce Nauman, the Pulsa group, Ira Schneider, and Keith Sonnier. Video for these artists is a system of echoes, communications, reflections, and dialogues linking the self with what is outside the self and back again. This hardware linkage proposes to alter positively the behavior of human and nonhuman participants alike, as if it were some infinitely readjustable ecology. (I am intentionally using hyperbole here to emphasize a certain grandeur, or high seriousness, in these projects.)

Some works include real-time communiqués between the public and TV stations, using telephone and other rapid-message technologies, all of them fed back into the TV output to be, in turn, modified and commented upon by the participating public. Other works involve elaborately constructed displays, with many monitors and cameras, that visitors pass to see their own images in different views and in delayed time. Such mirrors of the individual may also be collaged with pretaped and electronically generated material.

Still other works are assemblages of concentric or serially arranged stacks of monitors and cameras that show simultaneous views of the cosmos, nature, a city, and microcosmic life. And there are room-filling environments achieved solely with video projectors that blow up the small scale of the normal monitor and fill the walls with deserts, subways, and one's own real self.

Arising from the opposite point of view are the spare contemplative environments of a few bare walls (sometimes physically constrictive), one or two fixed cameras, and a monitor showing a motionless section of blank wall or doorway. They resemble those security monitors in expensive apartment houses: one waits for a thief to cross the camera's path—and, of course, that "thief" is the visitor to the exhibit.

Intriguing as these works are, they are also discouraging. The level

of critical thought in them, their built-in assumptions about people, the indifference to the spaces into which the hardware is put, and the constant reliance on the glitter of the machines to carry the fantasy strike me as simpleminded and sentimental. For instance, there is the notion, introduced by the Italians before 1914 and worn threadbare by the sixties, that there is something vital about an all-at-once rapid flow of indiscriminate information, sensations, and activity between people and surroundings—a notion that ignores the selective way people and surroundings receive and exchange messages. There is the science-fiction assumption that electronic communications technology can provide a global and even cosmic consciousness, when nothing in the world's extensive use of that technology to date suggests that that is so or, if it is so, that we apprehend and apply such beatitude. Moreover, it cannot answer to our clear need for privacy. The minimal, meditative environments where extremely subtle body sensations and feelings are stimulated rest on the assumption that meditation and privacy are possible in a gallery situation; but it should be obvious nowadays that everyone entering a gallery is immediately on display as a work of art. One cannot be alone. A gallery is not a retreat. Everything becomes *art*, not self-awareness.

There is the utopian conviction, the last one with its roots in progressive education, that if people are given a privileged place and some sophisticated toys to play with, they will naturally do something enlightening, when in fact they usually don't. For example, Frank Gillette and Ira Schneider designed a collaborative Environment at Antioch College in 1969. It was a room with four persons, seated back-to-back, facing four walls, two mirrors, four remote-control cameras, and a single monitor. As the artists describe it, "after an initial period of self-consciousness, the subjects began to generate their own entertainment. During the session, the subjects played with their mirrors and cameras, read poetry, drew, rapped, did sommersaults" (*Radical Software* 2, no. 5). Playing around? Poetry? Rapping? Sommersaults? All that expensive technology, care, and work for behavior that has been predictable in every so-called experience chamber since the eighteenth century! That is hardly experimental.

But Gillette and Schneider are gifted artists with very good minds, whose work interests me very much. I single out the Antioch piece because it points up the frequent lapses in critical judgment among

those who get seduced by fancy hardware. They become indifferent to the clichés passed on in the name of modernity.

Actually, their environment as described and diagramed seems to me much more ritualistic and hieratic than the human response to it. The problem came about because the artists felt free to program the physical surroundings but held off giving their subjects a program appropriate to those surroundings. This may have been a misplaced fear of manipulating people, even though the room was designed to elicit responses and that can be construed as a manipulation. Whatever the reason, Gillette and Schneider didn't follow through holistically.

In general, when participatory art is shown in an exhibition context, both artist and viewer unconsciously expect it to be, and act like, a picture—discrete and kept at a distance. When viewers are urged to become part of the art without further help or preparation, they feel put upon and become stereotypes.

I might add to the list of stereotypes the video artists' relentless fondness for time-lag devices. These are the exact counterpart to echo effects in earlier Musique Concrète. The idea implied here is that repetitive recall of the immediate past is an effective denial of the future, hence proof of an eternal present. Perhaps, too, there is a popularistic appeal to the same experience from drugs. In any event, this is not exactly a brand new philosophical discovery or one that illuminates a world accustomed to forgetting its yesterdays and ignoring its to-morrows *without* the benefit of video environments. (Ironically, I find tape art, which is relatively conservative, especially the kind that simply records a theatrical performance, much less trivial on a conceptual level. Undistracted by either the mystique or the technical problems of gadgetry, videotape artists may spend more time in thought and fantasy.)

In the last analysis, environmental (tapeless) video, whose only products are heightened consciousness and the enlargement of useful experience, seems to me the only interesting video art. But it is still a lavish form of kitsch. Like so much Art Tech of recent years, video environments resemble world's fair "futurama" displays with their familiar nineteenth-century push-button optimism and didacticism. They are part fun house, part psychology lab. Such associations, and a sponsorship by art museums and galleries that have a tradition of hands-off, silent respect for what they show, practically guarantee a

superficial and cautious participation in what is supposed to be involving.

Participation is a key word here, but in this most experimental branch of video, we succumb to the glow of the cathode-ray tube while our minds go dead. Until video is used as indifferently as the telephone, it will remain a pretentious curiosity.

Formalism: Flogging a Dead Horse
(1974)

There is a medieval definition of God, later quoted by Descartes or Pascal, that says, "God is a circle whose center is everywhere and circumference is nowhere." Center and circumference have often been exchanged in the retelling, but the definition remains a formal one.

Much earlier, Aristotle introduced into Western thought a complex idea of the form of things that even today we have not forgotten. Things, he wrote, have not only an obvious shape, like that of a hand, but also a unity or wholeness of parts. In addition, they possess an essential or conceptual form, which is the ideal state toward which they strive. In this rich notion, as in most other aspects of Aristotle's philosophy, the physical world is analyzable, measurable, and reasonable, but it also seems to contain Platonic, vaguely mystical attributes apprehensible, not by the senses, but by intelligence and intuition.

Together, the two examples evoke a reality that is apparently knowable yet increasingly intangible the more one knows. Hence in the movement from a hand to God, the form becomes more and more regular, yet less and less clear.

At its best, formalist practice in the art of the last hundred years resembles these views. Clarity, essentiality, measurability, control, unity, and often a taste for some kind of geometry prevail; but at the same time there is always a mystery and paradox; there lurks a pervasive faith that such a way of making art is a truer, deeper revelation of reality than other ways that are only apparently true.

Thus a Malevich painting of a whitened square tilted on its axis and set into an off-white field may seem only minimally engaging to the untrained viewer, but that artistic poverty, so to speak, is superficial. Malevich's art intends our thoughts to be directed to a transcendent, superior state of being.

Fig. 14 Bucket and dirt. *Photograph by Robert Cook.*

A Frank Stella painting of parallel stripes in the shape of an angular U, which in turn shapes the canvas as a U, or, reading in reverse, a U-shaped canvas that is echoed throughout by stripes parallel to the border, is not simply repetitious; it can be taken as a bluntly elegant exercise in "thingness." That is to say, if a stripe refers to another stripe next to it, and to another and another, and also refers to the material object on which it is painted, a sort of internally consistent, self-declaring monologue occurs. The eye swings between immaterial stripe and thick support projecting from the wall, each lending the other simultaneous flatness and density. As a metaphor of a difficult idea, the canvas "for and of itself" alludes to age-old questions about the possibility of individuality and free will . . .

At its worst formalism has justified routine and dreary formulas for making tasteful art without any of the blurry but necessary metaphysical considerations. This sort of academicism is what institutions and political ideologists support since it represents the possibility of quick, controllable norms, echoing what is desirable in the society. What is either ignored or despaired of is the one romantic part of formalism, its dream of vibrant perfection. My teacher, Hans Hofmann, an occasionally formalist painter and always a formalist to his classes, knew very well this elusive, arcane part of the life of forms. He said once that you couldn't teach art at all, but you could certainly teach the right direction to it, namely methods and exercises. It was understood that one made one's art at home, "sacredly," while at the school one did basically formal exercises from a model.

Now the formalist's opposite number, the antiformalist, has, on the surface at least, an impatience with the detached, supra-individual, rationally contained features of the esthetics of form. The antiformalist seems to champion the release of energies, rather than the control of them; he or she wants things indeterminate, muddy, or sensually lyric, rather than proportioned and balanced. The true nature of being for this kind of mind trembles somewhere between personal emotion that constantly reaches peaks and valleys and a morbid conviction that the universe has no design.

But on closer examination, one is still dealing with a profound involvement in form. The antiformalist simply replaces the appearance of order with the appearance of chaos. Both order and chaos have a substantial history of images that are still fed into daily life and

thought. By analogy, antiform is the structure of hell as the nether image of heaven. The shape of disorder, like that of order, is easily analyzable into typical part-to-whole relationships. That is to say, stars in the sky, dust on the floor, garbage, people in a riot—any apparently random accumulation of whatever—can be grouped, arranged in sets, classified, graphed, and systemized into both physical properties and expressive ones. Hence the antiformalist's artwork is as much a form as anything we can sense or know, probably because the human organism cannot perceive or think except in patterns. But the *meaning* of the forms of antiformalism is the crucial difference here, for antiformalism is associated with the so-called dark or obscure forces rather than with light and clarity.

Thus, in meanings and attitudes, the formalist's view of reality is more indirect and meditative; or it is passionate on a transcendent plane purged of personal idiosyncracy. It implies a complex, sometimes grand scheme of nature that, once understood, is a source of wisdom. That wisdom may affect daily life yet may be quite sufficient as an end in itself. But the antiformalist, *by definition*, reacts to this stance; it is the point of departure without which the conflict would be senseless. Like the oedipal struggle of the child against the parent, it is a fight within the family, so to speak; and whatever positive change antiformalism may achieve, it is at the same time a profound acknowledgment of laws, orders, and ideas.

For instance, the Dadaist Tristan Tzara's formula for making a poem could be construed for its time as the archetypal antiformalist doctrine. He writes:

> To make a dadaist poem
> Take a newspaper.
> Take a pair of scissors.
> Choose an article as long as you are planning to
> make your poem.
> Cut out the article.
> Then cut out each of the words that make up this
> article and put them in a bag.
> Shake it gently.
> Then take out the scraps one after the other in the
> order in which they left the bag.
> Copy conscientiously.

The poem will be like you.
And here you are a writer, infinitely original and
endowed with a sensibility that is charming though
beyond the understanding of the vulgar.

The program is written out so that it scans like a poem itself, with
seven short lines and four long ones. It can be read in couplets as AA,
AB, AB, AB, AA, and B as coda; or in triplets as AAA, BAB, ABA,
with an AB coda, both patterns neat, almost syllogistic. Considered as
three actions—finding a newspaper article, cutting it up, reassembling
it—it can be a classic Hegelian closure: thesis, antithesis, synthesis.

Even the strategy can be judged a formal problem. In effect, Tzara
proposes the by now classic modernist ploy: when the enemy (i.e., the
conventional artist) zigs, you zag. All zags constitute a special class of
objectives. It is first necessary to have a thorough idea of all the enemy's
moves, which make up the class of zigs. Then its opposite members
will be zags. If the enemy evokes metaphors of sensitivity, parade
crassness. If the enemy embroiders metric niceties in the lines of the
poem, botch up all the rhythms (as it seems Tzara has done in the
present example, at least from the evidence of the English translation).

Thus if Tzara had cut up a chapter from a novel of Proust in the
same way he cut up a newspaper, he would immediately have forfeited
the secular impact of his nonart materials and subject matter; the
manifesto-poem would instead take on a more cultivated, literary tone
and reference. The analyst would have to say in that case that Tzara
didn't quite zag; he zigzagged. In fact, the one zig Tzara was unwilling
to oppose was poetry itself. He shared with formalists and other kinds
of artists a belief in his exclusive access to truth forever denied the
ordinary mortal.

Another case in point is the work of Jackson Pollock. The impact
of Pollock's paintings (now softened by familiarity) at the time they
were made was that of a maelstrom. Even today, particularly in the
case of the large dripped works, one is swept along. The flung skeins
and splatters of running paint, shot out and retracted in clotted tangles,
reduce one to a helplessness Pollock found attractive. He said:

"When I am *in* my painting, I don't know what I am doing."
Conscious volition was given up, or at least consciousness of the dis-
tinction between the "I" and the painting, between the acting self and
the willing self. But discrimination between conception, creation, and

completion, in short between the parts of a whole and the whole itself, is a necessary attribute of formalism. Thus Pollock would seem to be an antiformalist.

Nevertheless, Pollock's canvases are consistent in their recurrent choice of fairly even dispersions of short gestural flurries and trials. These pulsations are set into longer rolling streams of open forms with unstable axes. Throughout there is an absence of marked zones of contrast. As Pollock wrote about them, they have no apparent beginning, middle, or end. We feel they could go on forever. The effect of energies in a state of becoming replaces the formalist's arrangements of poised, completed configurations. That is, in rejecting one set of formal elements and procedures, Pollock established another.

Moreover, there is another sense in which the formalist-antiformalist clash is misleading. I have written elsewhere ("Impurity") that if we look at the overall Pollocks for an extended time—say, a time equivalent to their making—the expressionistic tone of the gestural language tends to reverse itself. The heated jabs, swipes, and flowing body movements that we read from the rich surfaces slowly neutralize one another and cool off. A calm stasis results, balanced and sublime. The frenzy is simply spirit, in psychological terms; optically, this is the effect of nearly equal high-impact forces impinging on one another in every part of the canvases.

In the same essay I suggested that the opposite reversal could be experienced before the very formal works of Mondrian. The ambiguities of figure-ground exchanges cause lines to bend, advance, and recede irrationally. White spaces become warped positives, their black edges are seen as abysses dropping far behind the white planes, and the hues of red, yellow, or blue, when they are used, cause further complications by temperature allusions and expansions and contractions of scale. A Mondrian becomes more and more unstable the longer one looks (or, more properly, *stares*). One experiences vertigo.

The Pollocks thus emerge as an almost classical statement, the Mondrians as an ardent romantic one. What is elegant about this paradoxical aspect of formalism is that it resembles the medieval description of God: it is confusing, but very clearly confusing. The epitome of this difficulty of simply pitting formalism against antiformalism is present in the music of John Cage. A less passionate personality than Pollock, perhaps more ironic, Cage nevertheless has the same vast sense of naturism. His welcome of accident and his taste for blurring

the edges between his art and the world beyond are as great as Pollock's or even greater. Just as Pollock's painting has no definite frame, so the sounds and silences in Cage's music could be continued indefinitely. Musical sound and noise (customarily divided) are really one; so are art and life. If art in the high formal sense is what gives order to life's aimlessness, then Cage's music qualifies as antiformalist.

But Cage does not create his music in a disorganized way. His "chance operations"—already procedural by his choice of the word "operation"—involve careful and lengthy preparations and the use of the *I Ching* or computer, both very formal tools.

Moreover, his pieces, childlike and often gently humorous, lack the antiformalist's virulence. The absence of sharp discontent—the *anti* part of antiformalism—and the presence instead of a fey positivism score the oversimplification of the formalist dialectic from either end of the scale and do not account for the subtle shades of temperament really present in any live artist. They are inadequate, for instance, to explain so-called informalists.

Finally, as in the works of Pollock, Cage's music can be analyzed into equivalences of silence and sound, musical and nonmusical, loud and soft, and so forth. Intelligible patterns emerge, despite the initial sensation of scattered disorder, no focus. But if Cage is not an antiformalist, still he does seem to celebrate informality in the attention he gives to chance occurrences and to listening devotedly to the manifold sounds that fill the air at every moment. What shall we call him if, according to our topic, we must assign him a place? Perhaps in his worldview he is an American Zen Buddhist (or funny monist); in technique he is a formalist; in his pieces he is a formalist in spite of his techniques to make them indeterminate; but in the *effect* of his music upon most listeners at this time, he is an antiformalist.

It could be argued that anytime you use a formal tool (like a grid) to look at the world, whatever you look at will be formal (for instance, it will always be gridded). Conversely, to the antiformalist or informalist seeing through those values, everything will seem antiformal or informal. But this doesn't really happen, as I hope I have explained: the antiformalist recognizes formality but abuses it; the informalist is usually too inspired to spend time squabbling; and we who are not the artist in question are faced with the growing absurdity of trying to divide matters into two distinct parts.

At its root, the problem with a theory of form is its idea of whole-

ness. Before any question of part-to-whole relationships and their sig-nificance can be asked, the whole must be identified. It must be "out there," visible or, if not visible, at least deducible by some rational means. When it turns out that the whole can't be located precisely or, if approximately located, cannot be limited with an outline or kept still, either all hell has broken loose or we're in another ball game.

I think we are indeed in another ball game. When seemingly for-malist artwork becomes antiformal, and antiformal art becomes for-mal; when the artwork includes its vast history, its conceptual origins in the artist's mind, its processes of creation; when it also includes the surroundings and the perceiver, its economics and its future, then we are faced with a contextual problem that old-fashioned formal esthetics simply cannot handle.

But without a theory of form sophisticated enough to account for a physical environment in constant flux, as well as for all the equally changing qualitative features of human civilization, we are left with a form-antiform approach to art that is about as novel as discovering night and day, up and down, laughter and tears. An updated formal-ism, however, even if it could be devised, seems just too unwieldy in practical terms.

Apart from that reason, I suspect that on a metaphoric level, for-malism and its counterpart no longer hold much interest for us. The very idea of form is in the last analysis too external, too remote, to allow for urgent fantasies of integration, participation, and significa-tion brought about by an increasingly crowded and compressed planet.

Consider what is happening in much contemporary art. If a Rem-brandt were to be used for an ironing board (as Duchamp proposed), or if, as is more usually the case, an ironing board or its equivalent were to be placed, like a Rembrandt, in a museum, the issues that arise relate to the motives, not the formalism or antiformalism of the acts. Too many works of art today are made to function as situations, com-mentaries, or processes, rather than as discrete objects, for us to ignore their contextual role. Formalism tends to presume the value of an ideal, permanent standard.

Different questions—emerging in the sciences, the social sciences, and even the arts—may offer several ways out of the bind. For ex-ample, what is the nature of thought? Is it totally verbal or not? What is the relation between mind, speech, and culture? How and what do we communicate? Do we communicate with so-called nonintelligences

like animals, plants, rocks, air? Are there intelligences in outer space? If so, what kind of language would allow us to communicate? Is it mathematical? Is the invention of artificial life systems (say, bionics) a metaphor for a natural biological system? And is human culture such a metaphor? Can we really distinguish between natural and artificial conditions; that is, if the mind is natural and it creates a concept of systems, are the systems artificial, or are systems metaphors of the way the mind naturally works? If they are metaphors, are human beings forever limited to being the model for all our knowledge of the objective universe? How does culture—like science, technology, art—use models? How does culture condition the questions asked about the nature of reality? That is, how does rapid cultural change affect our sense of time and space? How do these changes modify our inherited concerns for permanent human values and permanent artworks? If art today often resembles nonart—insane behavior, road constructions, the yellow pages of the telephone directory—what kind of dialogue is going on with the nonart models? What is the connection between the way people relate to one another, to their natural and artificial environments, and to their cultural artifacts? The questions could go on at length: but even these few may suggest to the artist possibilities for bypassing the confinements of formalism.

Formalism, after all, posits a self-sufficient, closed universe of art and / or mind. It says in effect that the esthetic state is made up of its own resonances and needs only itself. It talks to no one but its own, comes from nowhere but itself, and leads only to the perpetuation of its own species. Formalism, for all its traditional appeals to Apollo, is a synonym for parthenogenesis: pure mentality, born outward to the framed work of art, is its model; the artist, in virginal isolation from society, is its human embodiment.

Nontheatrical Performance

(1976)

Traditional theater: an empty room except for those who've come to watch. The lights dim. End of performance. Audience leaves.

West Berlin, 1973. Wolf Vostell arranged a Happening called *Berlin Fever*. It involved close to a hundred participants. Driving from various parts of the city, they converged on a vast empty field near the wall dividing Berlin's western and eastern sectors. Above the wall in a tower were armed border guards. At one edge of the field were small flower and vegetable gardens tended by local residents. The field itself had been cleared of the ruins of buildings bombed in the last war. It was a warm, sunny September weekend. The plan given to the participants read:

(A) Come with your car to Osdorfer Street in Berlin Lichterfeld (dead end), last stretch of the street on the right side.

(B) Take up a position with your car in rows of ten each, as thickly as possible, with the cars next to and behind one another.

(C) At a signal start all the cars and try to drive as slowly as possible. Try to remain as tightly grouped as you started.

(D) If you have a companion in the car, he should write down how many times you shift gears, clutch and step on the gas. If you're alone, try to be conscious of every smallest action. Add up all these activities in your brain as psycho-esthetic productions.

(E) After 30 minutes of this extremely slow driving, get out of the car (turn off motor) and go to the trunk of your vehicle. There open and close the trunk lid 750 times; and put a white plate inside and take it out 375 times. This ritual should be accomplished as fast as possible, without interruption, and without dramatization.

(F) When this event is completed, lay strips of cloth on the ground in front of the columns of cars; then place the white plate which is in your car trunk onto the cloth.

(G) Take a handful of salt out of a bag beneath the biggest nearby tree. Pour it onto the plate which you've previously placed on the cloth.

(H) After this, the auto columns begin to move again at the slowest possible speed. All cars pass over the cloths, the plates and the salt.

(I) During the whole passage, lick the hand you previously held the salt in.

(J) Now the motors are turned off again. Everyone sews up his over-ridden plate or its remains into the strips of cloth. A derrick arrives along with supplies of wire for hanging purposes.

(K) Everyone now goes with their cloth to the tree where the bag of salt lies. Each one decides where in the tree their cloth (with sewed-up plate) should hang. With the derrick's help the cloths and their contents are fastened to the branches.

(L) The notebook with records of clutching, shifting, stepping on the gas, etc. should be fastened with Scotch tape to the inside of the trunk.

(M) When you next have a fever, take the notebook out of the trunk and tear it up.

(N) 3 days after the Happening, Berlin Fever, meet with Vostell for a talk. Note your dreams for these 3 days and bring the notes to the discussion.

Vostell's Happenings have always been grandly scaled. Their images are consistently charged with impact: border guards, banners in trees, lanes of slow-moving cars . . . Spectacle and apocalypse re-echo in whatever he conceives. Yet they are only for the participants to experience. The guards in the tower watched curiously and strollers in the gardens beyond gazed for a few moments before going their way. Such casual observation is accidental, without information or expectations. The participants, however, were voluntary initiates in a quasi-ritual, for which the ongoing world, undisturbed and hardly caring, was the context. This, for me, was part of the piece's poignancy.

Like any experimental work, the Happening's language was strange. Only gradually, while going through it, did the participants begin to sense its pervasive political references: West Berlin's ideolog-

ical and economic isolation in Communist East Germany; its reduction to an artificial island confined by a wall and three foreign military encampments; the piped-in, superficial affluence in the midst of surrounding austerity and a disadvantaged Turkish working force; an island whose population is dwindling and whose industry is leaving; an island whose artistic culture is imported or pumped up by political machinery, mainly in Bonn and Washington; this island's "fevered" self-consciousness; and saddest of all, its present garrison-town identity compared with the impressive city it once was. The symbolism was personal, but it was based on so many other Vostell works over the years that such a reading could be intuited at the time.

I have spoken of the casual passerby. But not even intentional watchers could have *experienced* this drama or these references without literally opening and closing a car trunk 750 times (hearing the drumming thumps of other cars), without tasting the salt on their own hands, without actually feeling and hearing the plates crushed under their own cars, without sewing up the broken pieces into white shrouds to be lofted by a derrick to hang in a giant tree. The internalization would escape such an observer. But that is what Vostell was seeking, not esthetic detachment.

Vostell built into the Happening an aftermath—a telling of dreams three days later and the task of remembering at a next fever to tear up the account of gear shiftings, starts, and stops, along with all the sensations felt during a particular thirty minutes of *Berlin Fever*. On the one hand, he was curious about its possible effect upon near-future fantasy, and, on the other, he wanted to keep the past alive by binding a person to a symbolic pact: associating a personal fever with Berlin's.

Although Vostell was a participant too, he viewed his piece as a consciousness-raising device, as teaching, as behavior changing. This goal was, I recall, hard to measure, but it is crucial to take into account his hope to see *Berlin Fever* extend into the real lives of all the participants.

By way of contrast, a much cooler effect comes across from the text or "program" of an Activity of mine. Its printed language is sparse, its repeated -*ing* verb endings convey a continuous present, its images are low-key and perhaps a little funny, and its context is the home environment of the participants.

Called *7 Kinds of Sympathy*, it uses a modular participational unit of two persons (A and B), who carry out a given program of moves. The program was discussed beforehand with five other couples, who

then separated to perform the piece and reconvened the next day to exchange experiences. As usual, I was one of the participants. *7 Kinds of Sympathy*, whose text follows, took place this year in Vienna.

<div style="margin-left: 2em;">

A, writing
occasionally blowing nose

B, watching
copying A blowing nose

continuing

(later) B, reading A's writing
occasionally scratching groin, armpit

A, watching
copying B scratching

continuing

(later) A, examining something
occasionally feeling for something in pocket

B, watching
copying A feeling for something

continuing

(later) B, examining A's object
occasionally coughing

A, watching
clearing throat in reply

continuing

(later) A and B, close together

B, holding tissue to A's nose
A, occasionally blowing into it

B, clearing throat in reply

continuing

(later) B and A, close together

B, describing and pointing to itching
in groin and armpit

</div>

> A, scratching where B itches
> occasionally coughing
>
> B, continuing description
> instructing A until relieved
>
> A, occasionally coughing
>
> (later) A, feeding silent B
>
> copying B's mouth movements
> saying: open chew swallow
>
> continuing

The notes accompanying the program intentionally pointed out guidelines to interpretation. It is worthwhile mentioning this aspect of the preparation for participating. An unfamiliar genre like this one does not speak for itself. Explaining, reading, thinking, doing, feeling, reviewing, and thinking again are commingled. Thus the following comments accompanied the main text:

> There is the well-known story of a little boy who was being loudly chastised by his mother for misbehaving. The mother ranted and raved while the boy stared curiously at her, seeming not to listen. Exasperated, she demanded to know if he had heard her. He answered that it was funny the way her mouth moved when she was angry. The boy had ignored one set of messages and focused on another.
>
> In *7 Kinds of Sympathy* primary and secondary messages are similarly contrasted. A person "sympathizes" with a partner by copying secondary, normally unconscious, ones (blowing the nose) while disregarding the primary ones (writing). The observer/observed roles are then reversed and the original primary message is attended to while a secondary message (scratching an itch) is sent out and copied.
>
> The exchange continues, with coughs and throat clearings added, next developing into a virtual repertory of such moves. The partners come much closer together, one helping the other to blow the nose, scratch an itch, and finally to eat. Primary and secondary become thoroughly mixed up, as do observer and observed. And unlike ordinary behavior, both partners are aware from the start of all these factors as they perform the program; hence the socially acceptable and personally private are also mixed up.
>
> But the partners will naturally tell about themselves in other ways,

sending perhaps tertiary messages; these may be picked up quite consciously, thereby provoking quarternary ones, and so on . . .

What occurred in the doing was, on the surface, a vaudeville routine in seven simple parts, requiring neither special skills nor anyone's loss of identity. From a briefing and the notes, the partners expected that there would be more to it than the schematic plan suggested.

They understood, for instance, that since durations were unspecified except by the words *continuing* and *later*, they could stretch on and on or be quite short. They understood that prolongation of mimicry could become caricature and that too much brevity might prevent attentiveness. But since the Activity used mutual scrutiny as the partners' means of finding out about each other, they had a protective formula in the very absurdity of their moves: absurdity allowed them to drop their normal constraints and go with the program as long as it seemed appropriate.

As always, there was a range of responses to a commonly shared plan. There was, to begin, a certain self-conscious indifference and some laughter. Then there were loaded silences, subtle aggressions, artful manipulations, and dodges of the uncontrollable messages going back and forth between individuals. There were also feelings of closeness (perhaps born of the absurdity of what each participant was doing), intimations of ceremonials, sensations of vulnerability (each one wondered what the other "saw"). And of course there was a feigned disregard and simultaneous acknowledgment of the sexual connotations of scratching a partner's itch "until relieved." Finally, at the end there was that vague feeling that "sympathy" implies carrying the burden of another's foolishness. It is important to record here that my own prior knowledge of the concept did nothing to jade me to these experiences; if anything, it sensitized me.

The texts of George Brecht's *Events* of 1959–62 are even more neutral than mine, but unlike mine were not likely to stimulate interpersonal action. If anything, they were finely attenuated thought, rather philosophical in their inclination, though never ponderous. Printed on small cards, they appeared to be a sort of shorthand, or chapter notes without the chapters. Their language, like their scale, was minimal, uninflected, and apparently as small in scope of operation as in implication. The impression was that you couldn't do much with them, but they were very impressive and very elegant.

Some pieces were in fact performed in the United States, Europe, and Japan, in Fluxus festivals and related performance presentations, using conventional theater formats and audiences. Others were carried out privately and were never documented or reported to the art press. Many were performed in the head.

But in any case, most of the cards were ambiguous about how they were to be used. It was clear to some of us then that this was their point: to be applicable to various requirements. Those wishing to conventionalize the brief scores (as Brecht called them) into a neo-Dada theater could and did do so. Those who wanted to project their tiny forms into daily activity, or into contemplation, were also free to follow that route. Here is one example that does specify a site.

TIME-TABLE MUSIC

For performance in a railway station.

The performers enter a railway station and obtain time-tables.

They stand or seat themselves so as to be visible to each other and, when ready, start their stop-watches simultaneously.

Each performer interprets the tabled time indications in terms of minutes and seconds (e.g. 7:16 = 7 minutes and 16 seconds). He selects one time by chance to determine the total duration of his performing. This done, he selects one row or column and makes a sound at all points where tabled times within that row or column fall within the total duration of his performance.

George Brecht
Summer, 1959

Ten or twelve of us went late one afternoon to the station and were quickly lost to our own devices in the rush-hour crowd. Each interpreted freely the bare indications. For instance, sounds of any kind were to be made by chance selection of departure and arrival times listed in a train schedule. We were also to remain visible to each other. But the masses of commuters swallowed us and our sounds, and we became aware of what was, in the final analysis, a group of private performances.

In a version of 1961, that outcome was accounted for as the most logical result, so the group action and specification for making sounds were left out. The participant was given the responsibility of determining or discovering, in some fashion, what would happen.

In the following pieces, however, the absence of instruction leaves no doubt about their appeal to ambiguous use.

TWO ELIMINATION EVENTS

● **empty vessel**
● **empty vessel**

Summer, 1961

If *Two Elimination Events* is judged a performance score, one or more persons in any environment(s) can interpret the repeated word *empty* as a verb or an adjective; the two identical phrases can refer to two empty containers that should be accounted for somehow or can be taken as instructions that two containers be emptied.

As a Conceptual piece, the work invites participants to consider that these possibilities may be simply thought about. The title's key word, *elimination*, suggests a reductive attitude that can be assumed toward them—a getting rid of something undesired or unneeded. This could lead to the physical act of performance as such, and it could allude to the "empty" (but full) state of Zen.

Brecht's indirect call to the reader to share in the making of a piece is playfully revealed in

THREE WINDOW EVENTS

opening a closed window

closing an open window

which prompts one, after a while, to ask where the third window event is. One answer is that the question is the third event; another is looking out the window; another is the thought that there are countless possibilities. Naturally, a performer can actually do what is described on the card and then add the missing component.

Three Aqueous Events, however, does explain itself exactly in three words, the solid, liquid, and vaporous forms of the universal solvent:

THREE AQUEOUS EVENTS

● **ice**

● **water**

● **steam**

Summer, 1961

It tends to rest at that point as a Conceptual piece because the words are most easily read as nouns. But they can be felt as promptings, if

not commands: I once made a delicious iced tea on the stimulation of the piece and thought about it while drinking.

This fifth example, *Two Exercises*, depends on being read more than anything else.

TWO EXERCISES

Consider an object. Call what is not the object "other."

EXERCISE: Add to the object, from the "other," another object, to form a new object and a new "other."
Repeat until there is no more "other."

EXERCISE: Take a part from the object and add it to the "other," to form a new object and a new "other."
Repeat until there is no more object.

Fall, 1961

Nevertheless, if it were put into physical practice, it would quickly become apparent that the piece is written as a verbal smoke screen. Suppose there were two baskets of apples, one called object, and one called other. By substituting for the word *object* in the first exercise the word *basket*, and for the word *other* the same word *basket* and, further, by substituting for the next use of the word *object* the word *apple*—you will have a simple recipe. Rewritten, it would read: EX-ERCISE: Add to the basket of apples, from the other basket, another apple, to form a new (or bigger) basket and a new quantity of apples. Repeat until there are no more apples in the other basket. The second exercise simply reverses the process and you end up where you began.

What Brecht does here, with some wit, is confuse the ear with repetitions and different applications of the words *object*, *other*, and *another*. Consequently, the mind performs and mystifies itself. It is a species of conundrum.

Ordinarily, a performance is some kind of play, dance, or concert presented to an audience—even in the avant-garde. But actually there are two types of performance currently being made by artists: a predominant theatrical one, and a less recognized nontheatrical one. They correspond, interestingly, to the two meanings the word *performance* has in English: one refers to artistry, as in performing on the violin; the other has to do with carrying out a job or function, as in carrying out a task, service, or duty—viz. a "high-performance engine."

Theatrical performance, in the broadest sense, takes not only the form of plays but also marriage ceremonies, stock-car races, football games, aerial stunts, parades, TV shows, classroom teaching, and political rallies. Something occurs in a certain place, someone comes to attend it in an adjacent place, and it begins and ends after a usually conventional time has elapsed. These characteristics have been as unchanging as the seasons.

Thus it would still be theater if spectators gathered to watch an artist on a television monitor watching herself on a different monitor in another room. From time to time she would come into the spectators' space to do the same thing. In this way the piece would build its layers of real and reproduced realities. Such a piece typifies a kind of sophisticated performance seen in galleries and art lofts but is structurally similar to others that might appear more conservative in content. Take away the video, take away what the artist is doing, and she could replace these with Shakespeare or gymnastics.

Nontheatrical performance does not begin with an envelope containing an act (the fantasy) and an audience (those affected by the fantasy). By the early sixties the more experimental Happenings and Fluxus events had eliminated not only actors, roles, plots, rehearsals, and repeats but also audiences, the single staging area, and the customary time block of an hour or so. These are the stock-in-trade of any theater, past or present. (Plays such as Robert Wilson's, along with certain Chinese performances and the operas of Richard Wagner, extend duration but in all other respects hold to theatrical conditions.)

Since those first efforts, Activities, Landworks, Concept pieces, Information pieces, and Bodyworks have added to the idea of a performance that isn't theater. Besides my own work and the examples of Vostell and Brecht, already described, it is not difficult to see the performance aspects of a telephone conversation, digging a trench in the desert, distributing religious tracts on a street corner, gathering and arranging population statistics, and treating one's body to alternating hot and cold immersions. But it *is* difficult not to conventionalize them. What tends to happen is that the performances are referred to by photos and texts presented as art shows in galleries; or whole situations are brought intact into galleries, like Duchamp's urinal; or art audiences are taken to the performances as theater. The transformed "artification" is the focus; the "cooked" version of nonart, set into a cultural framework, is preferred to its "raw" primary state.

For the majority of artists, art agents, and their publics, it probably could not be otherwise. Most could not sustain enough interest and personal motivation to dispense with the historical forms of legitimation. The framework tells you what it is: a cow in a concert hall is a musician; a cow in a barn is a cow. A man watching the musician-cow is an audience; a man in a cow barn is a farmer. Right?

But the experimental minority apparently does not need these settings, though the reason they do not has nothing to do with daring or heroic indifference. Instead (as I've written in "The Happenings Are Dead: Long Live the Happenings!"), it has to do with artists themselves, who today are so trained to accept anything as annexable to art that they have a ready-made "art frame" in their heads that can be set down anywhere, at any time. They do not require the traditional signs, rooms, arrangements, and rites of performance because performance is an attitude about involvement on some plane in something going on. It does not have to be onstage, and it really does not have to be announced.

To understand nontheatrical performance as an idea, it might be worthwhile to consider the current state of the art profession in the West. All artists have at their fingertips a body of information about what has been done and what is being done. There are certain options. Making performances of some sort is one of them. Making nonart into art is another. Nonart art, when applied to performing, means making a performance that doesn't resemble what's been called art performance. Art performance is that range of doing things called

theater. An artist choosing to make nonart performances simply has to know what theatrical performances are and avoid doing them, quite consciously, at least in the beginning. The value in listing one's options is to make things as conscious as possible; experimenters can experiment more when they know what's what. Accordingly, here is the ball game I perceive: an artist can

(1) work within recognizable art modes and present the work in recognizable art contexts

 e.g., paintings in galleries
 poetry in poetry books
 music in concert halls, etc.

(2) work in unrecognizable, i.e., nonart, modes but present the work in recognizable art contexts

 e.g., a pizza parlor in a gallery
 a telephone book sold as poetry, etc.

(3) work in recognizable art modes but present the work in nonart contexts

 e.g., a "Rembrandt as an ironing board"
 a fugue in an air-conditioning duct
 a sonnet as a want ad, etc.

(4) work in nonart modes but present the work as art in nonart contexts

 e.g., perception tests in a psychology lab
 anti-erosion terracing in the hills
 typewriter repairing
 garbage collecting, etc. (with the proviso that the art world knows about it)

(5) work in nonart modes and nonart contexts but cease to call the work art, retaining instead the private consciousness that sometimes it may be art, too

e.g., systems analysis
 social work in a ghetto
 hitchhiking
 thinking, etc.

All artists can locate themselves among these five options. Most belong to the first, very few occupy the fourth, and so far, I know of no one who fits the fifth who hasn't simply dropped out of art entirely. (One runs into such postgraduates from time to time, but their easy testimonials to the good life lack the dense ironies of doublethink that would result from simultaneous daily participation in art and, say, finance.)

Performance in the nontheatrical sense that I am discussing hovers very close to this fifth possibility, yet the intellectual discipline it implies and the indifference to validation by the art world it requires suggest that the person engaged in it would view art less as a profession than as a metaphor. At present such performance is generally nonart activity conducted in nonart contexts but offered as quasi-art to art-minded people. That is, to those not interested in whether it is or isn't art, who may, however, be interested for other reasons, it need not be justified as an artwork. Thus in a performance of 1968 that involved documenting the circumstances of many tire changes at gas stations in New Jersey, curious station attendants were frequently told it was a sociological study (which it was, in a way), while those in the cars knew it was also art.

Suppose, in the spirit of things nonartistic, that having a stance of some sort was important for making experimental performances. A stance includes not just a feeling tone but also a rough idea of the human and professional values you are dealing with. A stance gives a shape and an explanation to an unfamiliar course of action. It may be valuable to bring up this issue here because new art tends to generate new stances, even though while this happens old notions are carried over that are incompatible with the new situation. For instance, an Existentialist stance was helpful to Action painting because it could explain, and therefore justify, personal isolation and crisis better than the Marxism of the thirties. At present, a formalist stance would be

inadequate for a performance genre that intentionally blurs categories and mixes with everyday life.

My own stance has evolved, somewhat pragmatically, in actual working conditions. I describe it here as an example rather than as a prescription for others. With that caveat in mind, suppose that performance artists were to adopt the emphasis of universities and think tanks on basic research. Performance would be conceived as inquiry. It would reflect the word's everyday meaning of performing a job or service and would relieve the artist of inspirational metaphors, such as creativity, that are tacitly associated with making art, and therefore theater art.

The intent of this shift is not to do away with feeling or even inspiration—these belong to scholars and scientists as well as to artists. It is to identify the inquisitive and procedural approach of researchers to their work so that the artist adopting it would be free to feel without being beholden to the look and feeling of prior art. But most of all, the artist as researcher can begin to consider and act upon substantive questions about consciousness, communication, and culture without giving up membership in the profession of art.

When you attempt to interact with animal and plant life, and with wind and stones, you may also be a naturalist or highway engineer, but you and the elements are performers—and this can be basic research.

Basic research is inquiry into whole situations—for example, why humans fight—even if, like art, they are elusive and constantly changing. What is basic research at one moment becomes detail work or something trivial at another; and seeking what is worth researching at a particular moment is where the guesswork comes in. My hunch about art is that a field that has changed in appearance as fast as it has must also have changed in meaning and function, perhaps to the extent that its role is qualitative (offering a way of perceiving things) rather than quantitative (producing physical objects or specific actions).

When you use the postal system to send mail around the globe to persons known or unknown and when you similarly use the telephone, telegraph, or newspaper—these

message carriers are performers and this communication can be basic research.

Who is interested in performance by artists? The art world, obviously. It is an art world that is trained in the visual contemplation of objects made by visual artists. It has next to no experience in theater, yet because of this naïveté it is free to innovate. Its boundless enthusiasm has led to astonishing works one wouldn't find in professional theater, yet it applauds the rankest amateurism along with what is genuine. When faced with nontheatrical performance, the art world cannot recognize what is happening because it responds to art as art. It believes in studios, galleries, collectors, museums, and reverential and meditative ways to look at art. A gallery performance or its equivalent is framed like a painting by its shrinelike setting; an Activity out in the real world, if announced, is beyond the pale.

When you experiment with brain waves and related biofeedback processes in order to communicate with yourself, with others, and with the nonhuman world—these performances can be basic research.

Who sponsors performances by artists? Promotion of both the theatrical and nontheatrical kinds rests mainly with dealers and museum officials (universities, which were once supportive, are now economically crippled; they continue their interest indirectly by hiring performance artists to teach in their art departments). This encouragement is praiseworthy and is acknowledged by the press. But because it is so uninformed, it is almost disastrous.

The first American Happenings, Fluxus events, and parallel works in Japan, Europe, and South America were presented as distinct modes of art. Today their progeny have become part of the public relations of influential galleries and arts institutions, which offer them as front-office attractions to the sale or display of other artists' tangibles in the showrooms.

When you view a normal routine in your life as a performance and carefully chart for a month how you greet someone each day, what you say with your body, your

**pauses, and your clothing; and when you carefully chart
the responses you get—this can be basic research.**

Artists who might prefer to devote all or most of their time to performance are pressured to make documentary prints and objects on the theme of the performance—as a guarantee against financial loss by the sponsor. Among such salables are bits and pieces of paraphernalia left over from the event, signed and numbered, and dressed up as tokens of the live experience. They are offered and sometimes collected like pieces of the True Cross, or a sock worn by a deceased matinee idol. I do not want to ignore the quasi-magical import of relics and tokens; but these are now preferred to the performance. And I am not decrying commerce here; but an artist rarely receives a fee for a performance alone, because it is used as a come-on.

With ignorance of what is at stake so widespread, sponsors tend to have a negative influence on the actual performances. Without intending harm, they urge that they be given conveniently in their own galleries or museums when a laboratory, subway, bedroom, or a combination of these might be better. From habit, they and the public expect the duration of the pieces to be a comfortable hour or so, when ten seconds, ten days, or discontinuous time might make more sense.

**When you attend to how your performance affects your
real life and the real life of your co-performers; and
when you attend to how it may have altered the social
and natural surroundings—this follow-up is also perfor-
mance, and it can be basic research.**

Because strong visual imagery is always suitable for advertising flyers and pamphlets, and because all artists are supposed to be visually oriented, performances with such imagery are most welcomed. Those that might involve darkness, tactility, or Conceptual matters are discouraged with the eager reminder that the media people will have nothing to see.

Similarly, with recording technology, particularly videotape, artists are regularly solicited to gear their performances to what will look good and fit easily on a standard cassette. The performance, via the document, reverts to an object that can be merchandised in replica,

like a print. In many cases the once-only nature of a performance precludes having anything at all left over.

Ironically, some of these objections could be dropped if everyone were clear about the issues. There is nothing wrong with strong visual images being used to promote a work, if the artist is in charge and wants it. There is nothing wrong with making editions of documents and relics, if the artist is in charge and wants it. (A performance could be conceived around the subject of documentation per se.) There is nothing wrong with a performance that only lasts a convenient hour, if the artist is in charge and wants it. And there is nothing wrong with being a front-office attraction to an art gallery, if the artist makes it very clear that she or he is to be paid for public relations work. PR is performance . . . The artist's role is not merely to make performances. It is to guide agents and the public to their appropriate use.

When you collaborate in scholarly, socio-political, and educational work; and when you direct your performance to some definite utility—this can be basic research. Being purposive, it is neither Ready-made art nor just playing at real life, since its value is measured by its practical yield.

Participation Performance

(1977)

Live radio and TV audiences participate by clapping and laughing on cues from the host, until they do so spontaneously. Some members of the audience are invited onstage to carry props around, sing, answer questions, act in skits, and play competitive games. They thus pass (for a time) from watching to doing; they are inside the action, generating it. Yet they know they have a relatively minor role. The show is being directed by someone else. They will return, sooner or later, to their seats in the audience. In fact, in their thoughts they never leave their seats.

Such participants are a sort of mobile audience, acting for everyone's entertainment as if they were real actors. They are "good sports." They form a bridge between the spectators and the showpersons. The MC and his or her staff do not come from a place in the audience. Where you come from tells you what you are.

Audience-participation shows have evolved as popular art genres along with political rallies, demonstrations, holiday celebrations, and social dancing. Parts of the common culture, they are known and accepted; the moves individuals must make are familiar, and their goals or uses are assumed to be clear.

Use to the user, however, can differ markedly from use to the observer (the nonparticipant). Observers who analyze culture in depth might be looking for large abstract purposes in popular art forms: ceremonial, sexual, propitiational, recreational, and the like. For example, in the labor disputes of the 1930s they might see a ritualistic similarity between a picket line and what happened inside a factory. Workers, carrying signs aloft, would pace a measured circle, accompanying their march with simple repetitive chants; the picket line could look remarkably like the mechanical assembly lines the workers were

Fig. 15 Delivering ice for Allan Kaprow's *Fluids*, 1967, Pasadena. *Photograph by Bruce Breland.*

shutting down. Although they had stopped working, they continued working symbolically.

Charlie Chaplin observed this similarity wonderfully in his *Modern Times*, but the striking workers in the film were mainly interested in getting more money. That was sufficient reason for them to participate in the milling crowd and take their places on the picket line when they were scheduled. The anonymous developers of the picket-line art form probably did not consider it an art form but must have sensed that ceremony was a way to achieve specific results, even if it was not the only way. I consider the picket line an art form because my profession has taught me to do so.

Participation in anything is often a question of motive and use. Those who seek symbols in action normally don't participate in strikes but engage in the operations of analysis and interpretation. Because the union organizers of pickets need bargaining clout, they participate in making protest arrangements and pounding on the management's tables. Because the workers need buying power, they start marching and chanting. At least some of them do.

Communal art forms, including those the public would readily call artistic, typically contain a mix of professional director/performers who have high visibility, semiprofessionals who are visible but carry out relatively simple jobs, and unskilled enthusiasts who swell the ranks and provide excitement or commitment. This hierarchy is clear in the traditional July 4th parades of small American towns: there are the band leaders, musicians, and baton twirlers; there are the flag and float bearers; the civic leaders in shiny automobiles; and the children who break away from parents to run along with marchers whom they know.

In this kind of parade everybody knows everybody else. Thus the audience packed on the sidewalks has more than a passive role. Besides overseeing and appraising its relatives and friends in the procession, and releasing its children and dogs to run beside the drummers, it arrives early with food and drink, maps out preferred vantage places, dresses appropriately with patriotic paraphernalia, carries identifying insignia of local business affiliations, cheers, waves, and calls out familiarly to individual paraders, who acknowledge them in turn by nods, smiles, and winks.

As a group, the crowd, like the marchers, is made up of plain aficionados and real experts who occasionally arrange subacts such as skits and the unfurling and raising of banners and placards at appropriate moments for the enjoyment of the paraders, as well as for their immediate neighbors and the local press. Some of them wear costumes to stand out.

Communal performances like July 4th parades are planned and given on special occasions, requiring preparations and individuals or groups with skills to carry them out. They are also intended to convey expressive effects such as patriotism. But when the community's traditions are abandoned for idiosyncratic artistic experiments, the crowd of knowing supporters and participants shrinks to a handful. And even so, what the handful actually knows or is supposed to derive from the works is uncertain and mute, seeming to have to do with a shared openness to novelty, to being sensitized, to flexibility of stance rather than to possessing a body of hard information and well-rehearsed moves. What passes between the members of this tiny circle are subtle signals about the values of the group they belong to.

What, then, is participation in these productions? The early Happenings and Fluxus events that were in fact participatory—most were not (see my "Nontheatrical Performance" and Michael Kirby, *Hap-*

penings [New York, 1965])—were a species of audience-involvement theater akin to the radio and TV variety; they were also traceable to the guided tour, parade, carnival test of skill, secret society initiation, and popular texts on Zen. The artist was the creator and director, initiating audiences into the unique rites of the pieces.

Their formats, therefore, were essentially familiar ones in disguise, recalling "low" rather than "high" theater and, in the case of Zen, well-known meditational techniques. Even their subject matter was not particularly esoteric; it was a blend of American Pop elements, Expressionist/Surrealist film imagery, and anthologized koans. And these were collaged together, without transitions, in a manner that had become standard art fare everywhere.

What was unusual for art was that people were to take part, were to be, literally, the ingredients of the performances. Hence instruction in participation had to be more explicit than in communal performances and, given the special interests of the audiences, had to be at the same moment mysterious.

These audiences were mainly art-conscious ones, accustomed to accepting states of mystification as a positive value. The context of the performances was "art": most of the artists were already known, the mailing list was selective, a gallery was listed as sponsor, the performances themselves were held in storefront or loft galleries, there were reviews in the art pages of the news media; all bespoke avant-garde experimentation. The audiences were thus co-religionists before they ever arrived at a performance. They were ready to be mystified and further confirmed in their group membership.

But they were not used to the real-time close physicality of the experience. They were accustomed to paintings and sculptures viewed from a distance. Therefore an artist who wanted to engage them in sweeping debris from one place to another would have confederates begin to sweep and then pass the brooms around. The use of debris, on another level, reassured an art world then occupied with exploring the junk of our throwaway culture—*junk* was a password—and not only was the act of sweeping easy, but it was also a nonart act, disposable like its material.

Similarly, if the audience was to recite certain words, instruction sheets were given out in advance or cards were handed out during a piece. But the words would be either simple utterances, such as "get 'em!" or lists or random groupings that could be read on the spot. The

cues, vernacular like debris, also resembled contemporary poetry and echoed an art world's taste at the time for nonlinear clusters of elements.

The point is that the signals sent out by the artist and returned in acknowledgment by the participating audience were as appropriate to this segment of the society as the signals and cues sent to general TV audiences are appropriate to them. This may seem truistic, but participation presupposes shared assumptions, interests, language, meanings, contexts, and uses. It cannot take place otherwise.

The complex question of familiarity never arises in vernacular communal performances, in which the unfolding of events seems so innocent and folksy—even when those events are as aggressive as strikes. Everyone knows what's going on and what to do. It is the outsider-scholar who reads the complexity and writes the script out in full.

But it's the business of artists to be curious about their doings; and the question of how participation takes place did come up in the late fifties and early sixties. It was apparent to some of us that the level and kind of involvement was pretty trivial. Tasks on the order of sweeping or reading words remain relatively mindless as long as their context is a loose theatrical event prepared in advance for an uninformed audience. Familiarization, which could generate commitment, is quite impossible when a work is performed only once or a few times (as it usually was then). And the principal directorial role of artist and colleagues is locked in from the start, leaving only minor satisfactions to the spectator-participants (whose sole recourse would be protest or revolt if they cared that much—and some did). The theatrical model was plainly inadequate; a different genre was necessary.

Two steps were taken. One of them was to ritualize a mix of lifelike elements and fantasy, reject the staging area, and invite a number of people to take part, explaining the plan in a spirit of ceremony. Naturally, ritualism is not ritual, and it was evident to all that what we were doing was an invention, an interlude, coming not out of belief and custom but out of the artist. Its effect was vaguely archaic (thus tapping ample reserves of nostalgia), yet because of its real environments, which included traffic, food from the supermarket, and working TV sets, it was instantly modern. It worked. As a move, it eliminated the audience and gave the piece autonomy.

For some years this was the main route followed (not always strictly) by Kenneth Dewey, Milan Knížák, Marta Minujin, Wolf Vostell, and me. Knížák and Vostell continue to work well as ritualists. After 1966 I discarded the mode, mainly because in the United States there is no history of high ceremony (for Westerners) as there is in older cultures, and it began to seem pompous to go on. So I turned my attention to the mundane, which Americans understand perfectly.

The other step, actually overlapping the first, was suggested by certain small pieces by George Brecht, Robert Filliou, Knížák, and Sonja Svecová. These were to be, or could easily be, executed by one person, some in private, some in public. They referred in a general way to intellectual games, treasure hunts, spiritual exercises, and the behavior of street eccentrics, beggars, and petitioners. They prompted the idea that a group work could be composed, additively, of such individual activities with no attempt to coordinate them in any way. A performance could be simply a cluster of events of varying length in any number of places. (John Cage's interest in chance and the unique, rather than the organized, sound event, was a helpful model.) All that was needed was a half-dozen friends and a list of simple things to do or think alone. Examples: changing one's shirt in a park recreation area; walking through a city, crossing streets only with persons wearing red coats; listening for hours to a dripping faucet.

This approach worked for a while, except that participants felt arbitrarily isolated and tended to drift off into unmotivated indifference. The absurdity of doing something odd without an audience's approval, or of paying attention to tedium, was of course part of the problem, even for those professing interest. But what may have been missing was a grounding in ordinary experience that could replace the absent stimulation of an audience or cohesive crowd in a ceremony.

In the late 1950s Erving Goffman published *The Presentation of Self in Everyday Life*, a sociological study of conventional human relations. Its premise was that the routines of domesticity, work, education, and management of daily affairs, which because of their very ordinariness and lack of conscious expressive purpose do not seem to be art forms, nevertheless possess a distinctly performancelike character. Only the performers are not usually aware of it.

They are not aware of it because there is no frame around everyday transactions the way there is, literally, around a television program and, more figuratively, around a strike or parade. Repetitive daily oc-

currences are not usually set off from themselves. People do not think each morning when they brush their teeth, "Now I am doing a performance."

But Goffman gives ordinary routines quotation marks by setting them off as subjects of analysis. In this book and subsequent ones, he describes greetings, relations between office workers and bosses, front-of-store and back-of-store behavior, civilities and discourtesies in private and public, the maintenance of small social units on streets and in crowded gatherings, and so forth as if each situation had a prescribed scenario. Human beings participate in these scenarios, spontaneously or after elaborate preparations, like actors without stage or audience, watching and cuing one another.

Some scenarios are learned and practiced over a lifetime. Table manners, for instance, acquired from childhood at home, are regimented and simplified in boarding school or the army and are refined later on, let's say, for entertaining guests upon whom one wants to make an impression. The passage is from informal to formal to nuanced manners; most middle-class urbanites take part in the continuum and can move back and forth without giving much thought to the rich body language, positionings, timings, and adjustments of conversation and voice that accompany each mode.

The performance of everyday routines, of course, is not really the same as acting a written script, since conscious intent is absent. There is a phenomenal and experiential difference. Being a performer (like being a lawyer) involves responsibility for what the word *performer* may mean and what being a performer may entail. Nor are everyday routines managed by a stage director, although within the theatrical metaphor parents, officials, teachers, guides, and bosses may be construed as equivalents. But again, these mentors would have to see themselves as directors of performances rather than instructors in social mores and professions outside the arts. What is interesting to art, though, is that everyday routines could be used as real offstage performances. An artist would then be engaged in performing a "performance."

Intentionally performing everyday life is bound to create some curious kinds of awareness. Life's subject matter is almost too familiar to grasp, and life's formats (if they can be called that) are not familiar enough. Focusing on what is habitual and trying to put a line around what is continuous can be a bit like rubbing your stomach and tapping

your head, then reversing. Without either an audience or a formally designated stage or clearing, the performer becomes simultaneously agent and watcher. She or he takes on the task of "framing" the transaction internally, by paying attention in motion.

For instance, imagine that you and a partner are performing a prescribed set of moves drawn from the ways people use the telephone. You carry out this plan in your respective homes without intentional spectators. (Your families and friends, of course, may pass in and out of the scene.) You take into account that each of you is thinking of the other, just as telephone callers normally do. But both of you also know that you are especially tuned to nuances of voice, length of pauses, and possible meanings of the planned parts of the conversations, which would not be normal. And you focus, additionally, on such unconscious but typical behavior as reaching for the receiver (quickly or slowly, after two rings or three?), changing it from ear to ear, pacing back and forth, scratching an itch, doodling, replacing the receiver (slamming it?), nonessentials of the communication but constant accompaniments. The feelings produced under these conditions are not simply emotions; and the knowledge acquired is not simply casual information. The situation is too personal and off kilter for that. What is at stake is not so much conforming to expectations about people's telephone activity as closely experiencing its obvious and hidden features.

Up to this point I have contrasted audience participation theater in popular and art culture with participation performance relating to everyday routines. I'd like now to look more closely at this lifelike performance, beginning with how a normal routine becomes the performance of a routine.

Consider certain common transactions—shaking hands, eating, saying goodbye—as Readymades. Their only unusual feature will be the attentiveness brought to bear on them. They aren't someone else's routines that are to be observed but one's own, just as they happen.

Example: A friend introduces you to someone at a party, escorting him across the room. You stand about three feet from your new acquaintance, with your mutual friend between you, holding the new acquaintance's arm lightly at the elbow. You look at this man's face, avoiding his eyes; then to your friend's mouth, which forms the name; then back again to the mouth of the man. He says hello a bit over-

zealously and pushes out his hand with some force (which you inter-pret as nervousness); you feel yourself move back a fraction of an inch, automatically stiffening your hand for the impact as you raise it.

You move forward now. The hand is still coming. It seems to take too long. You shift your weight to your right foot because someone standing to your left with her back to you is talking on the telephone, and you can't move on that side, as would be natural to you. You're off balance now and feel the man's hand jam into yours, the fingers closing. It is a small hand and his fingers have to travel to make their grip felt. The hand is warm and dry. You wonder how you would have met his advance on your other foot.

You sense the man's fingers finally closing around yours, and you hesitate before responding, then do so perfunctorily. You lean back, echoing the forward motion of his handshake. Your forearm becomes rigid, but you force it to go limp. You realize that your friend is waiting for you to return the hello, but you've forgotten the courtesy in your examination of the encounter.

Trying to sound cheerful, you say the name. The man looks fleet-ingly to your friend for clarification. You forget to say "glad to meet you," and when you remember, it's too late. You're glancing now at the wrinkles of his hand, at his ring from some college, at the gray stain on his cuff. You pump his hand too many times. This upsets him.

He begins to withdraw, trying to disentangle himself without be-traying his initial expression of heartiness. Your friend steps into the silence with details of who each of you is. The woman on the telephone is listening to the person on the other end, and your friend's voice sounds too loud. She lights a cigarette and accidentally backs into you as she reaches for an ashtray, pushing you toward the man. He pulls away further. The woman doesn't notice and resumes talking. You're aware of her voice and dislike the cigarette smoke. You jerk your head in her direction, then bring it back to face the man. He has freed his hand and is lowering it to his side.

Now you shift your weight to a more comfortable position, rocking slightly on your heels. Your right hand is still in the air. You look at it as if it contained a message. You put it carefully in your pocket and raise your eyes to meet the man's. He stares, not comprehending, and blinks. Your glance swings aside to take in the room and others. He definitely sees this move as a sign-off. Your friend continues talking, searching your face and body for clues to your behavior. He isn't aware

himself that he feels something odd about you. You follow his eyes with yours and move a step to the right. Your feet are now planted firmly on the floor. This effectively puts your friend in a line between you and the man, cutting him off from view. He makes a polite excuse and leaves, but your friend remains and asks how your mother and father are feeling.

It is apparent to you that you have been using the situation as a study and have caused some minor confusion. You are normally sociable and wanted your scrutiny to pass unnoticed. But you decide not to explain anything since your friend has just been called away.

Suppose, next, that all three of you in the preceding exchange were involved intentionally as participants; suppose that there had been an agreed-upon plan to wait for some occasion when two of you who did not know each other would be introduced by your mutual friend. Normal behavior would then become exaggerated, would lapse and peak strangely. The everyday routine would be a routine that talks about itself.

Performances like this generate a curious self-consciousness that permeates every gesture. You each watch each other watch each other. You watch the surroundings in detail. Your moves are compartmented in thought and thus slowed down in perception. You speed up your actual pace to compensate; you will your mind to integrate all the pieces that have separated out while you take part in very real human affairs. You wonder who is being introduced, two people, you to yourself, or both? You are not projecting an image of a routine to spectators "out there" but are doing it, shaking hands, nodding, saying the amenities, for yourself and for one another.

In other words, you experience directly what you already know in theory: that consciousness alters the world, that natural things seem unnatural once you attend to them, and vice versa. Hence if everyday routines conceived as ready-made performances change because of their double use as art/not art, it might seem perfectly natural to build the observed changes into subsequent performances before they happen, because they, or something like them, would happen anyway.

Preparing an Activity, therefore, can be considered a naturally artificial act. It would include in its plan, or program, small retardations and accelerations of, say, handshaking motions; elaborations of pacing and juxtapositions of other routines that are ordinarily present, like saying goodbye; repetitions (echoing all routines' repetitiveness); re-

versals; displacements; shifts in setting, such as shaking hands on different street corners; and normal conversations and reviewings of what is going on. Traditional distinctions between life, art, and analysis, in whatever order, are put aside.

The Activity *Maneuvers* was assembled using just this approach. Its basic routine is the courtesy shown another person when passing through a doorway. The following program was given in advance to seven couples, who carried it out in the environs of Naples in March 1976:

1 A and B
 passing backwards
 through a doorway
 one before the other

 the other, saying you're first

 passing through again
 moving in reverse
 the first, saying thank me
 being thanked

 locating four more doors
 repeating routine

2 A and B
 locating still another door

 both reaching to open it
 saying excuse me

 passing through together
 saying excuse me

 both reaching to close it
 saying excuse me

 backing in reverse to door
 both reaching to open it
 saying after you
 passing through together

both reaching to close it
saying after you

locating four more doors
repeating routine

3 A and B
 locating still another door

 passing through
 one before the other
 the first, saying I'll pay you
 the second, accepting or not

 locating four more doors
 repeating routine

In briefing the participants beforehand I made some general re-
marks about daily social behavior and what *Maneuvers* had to do with
it. An orientation has proved not only useful but necessary, since in-
variably no one knows how to deal with such a project. Orientation
thus becomes part of the piece, as does any discussion during and after.

I pointed out that within the forms of politeness there is enough
room to transmit any number of complex messages. For instance, hold-
ing a door open for someone to pass through first is a simple social
grace, learned almost universally. But between persons of the same sex
or rank, there may be subtle jockeying for first or second position.
Either position may signify the superior one, depending on the partic-
ular circumstance.

In cultures that are facing changes in women's and men's roles, the
traditional male gesture of reaching for and holding open a door for
a woman can meet with either rebuke or knowing smiles. In another
vein, one can be shown the door (be ordered to leave) with almost the
same gross body movements as when being invited to go first. But
there is never any doubt about what is meant.

Maneuvers, I continued, was an exaggerated arrangement of such
competitive, often funny, exchanges between two individuals as they
go through doorways. With repeats and variations resembling those
of slapstick movies that are played backward and forward, it might
become unclear which side of a door was "in" and which "out." After

finding ten or more different doors to carry out these moves, the participants might find the initial question of being first or second problematical.

Each pair (A and B) went about the city and selected their own doorways. They had no necessary connection with the other participants carrying out the identical program. During the nearly two days allotted, they maintained their everyday routines as usual and fitted in the special routine of the Activity around shopping, eating, going to class, and socializing. As it happened, most of the fourteen participants shared classes at an art college and intermittently exchanged stories about what was going on.

Choices of doorways reflected the personalities and needs of the partners. Some preferred seclusion from the stares of passersby. They sought out alleyways, toilets, and suburban garages. Part of their admitted reason was embarrassment, but another part was the wish to internalize the process. Others enjoyed provoking curiosity in public and went to department stores, beauty salons, movies, and train stations. They later realized they wanted an audience regardless of its irrelevancy to the piece.

Despite these differences, all were struck by certain strange features of the work (which had been suggested to me when I was studying "doorway courtesies" as Readymades). There were four psychologically loaded twists on the verbal clichés that are traded when doorway courtesies are normally performed.

In part 1 the first person passing through a doorway backward hears "you're first," instead of the common "after you"; when the pair run the scene frontward, each says "thank me," presumably for acknowledging the other's primacy.

Part 2 starts out as straight vaudeville between A and B but is skewed by their later statement, in the reverse reruns, when both of them say "after you." This sounds proper but can only be sarcasm or irony in view of part 1's episode, implying that each secretly controls the maneuver by appearing to defer to the other. "Thank me?"

In part 3, which recaps part 1, A and B have a new chance to decide which one will go first. But when the decision is made, the first says, "I'll pay you." And the second can accept if the price is right or refuse if it isn't. "I'll pay you" can be taken to mean "I'll pay you to remain in second place," that is, "I can buy your subordination and flattery."

Refusal to accept the money may be a way of asking for more or of saying "I am not for sale." This statement caused the most consternation in the discussion after the Activity.

Throughout the three parts, the repetitions of the routine allowed A and B to switch their positions of first and second if they wanted to and to maneuver for whatever psychological advantages they thought they had achieved or lost. Courtesies were the tools.

Routine expressions like "please" and "thanks" are ceremonial "massages." Their equivalents were placed in this work in such a way as to call attention to their strategic capabilities. "You're first" elicits "thank me"; "excuse me" elicits further "excuse me's" (like the famous Alphonse-Gaston rendition); each can be translated into "pay me" and "I'll pay you." Courtesies are bills and payments for favors given and returned.

This account doesn't attempt to go into the hilarious squeeze plays that occurred in part 2 when A and B went forward and backward through doorways at the same time. Ungainly body contacts don't mix well with formalities and when they do accidentally (here on purpose), all you can say is "excuse me."

Neither does it speak of the importance of each environmental setting for the feel of the particular transaction as it happened. Obviously, a bedroom doorway will conjure one meaning for a couple and a bank doorway another. Fifteen such entrances and exits can add up to a rich experience.

Nor has it said anything about the effect of the piece upon couples of the same and the opposite sex. This, too, was critical and can be surmised to have provoked distinctive maneuvers between partners. And that all were Italians (except me) was significant.

Finally, I mentioned that the participants were drawn from a professional art background. Their prior investments of time, energy, and values were called into some (serious) question by what they did. I cannot say anything more than this now, but it would be interesting to compare the experience of a group of merchants, or a group of sociologists, doing the same Activity. The meanings construed, on human, professional, and philosophical levels, might be very different.

Performing Life

(1979)

Coming into the Happenings of the late fifties, I was certain the goal was to "do" an art that was distinct from any known genre (or any combination of genres). It seemed important to develop something that was not another type of painting, literature, music, dance, theater, opera.

Since the substance of the Happenings was events in real time, as in theater and opera, the job, logically, was to bypass all theatrical conventions. So over a couple of years, I eliminated art contexts, audiences, single time/place envelopes, staging areas, roles, plots, acting skills, rehearsals, repeated performances, and even the usual readable scripts.

Now if the models for these early Happenings were not the arts, then there were abundant alternatives in everyday life routines: brushing your teeth, getting on a bus, washing dinner dishes, asking for the time, dressing in front of a mirror, telephoning a friend, squeezing oranges. Instead of making an objective image or occurrence to be seen by someone else, it was a matter of doing something to experience it yourself. It was the difference between watching an actor eating strawberries on a stage and actually eating them yourself at home. Doing life, consciously, was a compelling notion to me.

When you do life consciously, however, life becomes pretty strange—paying attention changes the thing attended to—so the Happenings were not nearly as lifelike as I had supposed they might be. But I learned something about life and "life."

A new art/life genre therefore came about, reflecting equally the artificial aspects of everyday life and the lifelike qualities of created art. For example, it was clear to me how formal and culturally learned the act of shaking hands is; just try to pump a hand five or six times instead of two and you'll cause instant anxiety. I also became aware

that artworks of any kind could be autobiographical and prophetic. You could read paintings like handwriting, and over a period of time chart the painter's abiding fantasies, just as you might chart writers' thoughts from collections of personal letters or diaries. Happenings, and later Activities, being less specialized than paintings, poems, and the other traditional arts, readily lent themselves to such psychological insights.

Today, in 1979, I'm paying attention to breathing. I've held my breath for years—held it for dear life. And I might have suffocated if (in spite of myself) I hadn't had to let go of it periodically. Was it mine, after all? Letting it go, did I lose it? Was (is) exhaling simply a stream of speeded up molecules squirting out of my nose?

I was with friends one evening. Talking away, our mouths were gently spilling air and hints of what we'd eaten. Our breaths, passing among us, were let go and reabsorbed. Group breath.

Sometimes, I've awakened beside someone I loved and heard our breathing out of sync (and supposed that was why I awoke). I practiced breathing in and out, copying her who slept and wondered if that dance of sorts was echoing in her dreaming.

There's also the breathing of big pines in the wind you could mistake for waves breaking on a beach. Or city gusts slamming into alleyways. Or the sucking hiss of empty water pipes, the taps opened after winter. What is it that breathes? Lungs? The metaphysical me? A crowd at a ball game? The ground giving out smells in spring? Coal gas in the mines?

These are thoughts about consciousness of breathing. Such consciousness of what we do and feel each day, its relation to others' experience and to nature around us, becomes in a real way the performance of living. And the very process of paying attention to this continuum is poised on the threshold of art performance.

I've spoken of breathing. Yet I could have mentioned the human circulatory system, or the effects of bodies touching, or the feeling of time passing. Universals (shareables) are plentiful. From this point on, as far as the artist is concerned, it is a question of allowing those features of breathing (or whatever) to join into a performable plan that may reach acutely into a participant's own sense of it *and* resonate its implications.

Here is a sketch for a possible breathing piece. It juxtaposes the auditory and visual manifestations of breath, moves the air of the

environment (by fan) to render it tactile, and ties the rhythmic move-ment of breathing to that of the ocean. In the three parts of the piece the participant is first alone, then with a friend (but they are kept apart by a glass membrane), and again alone. The first part makes use of self-consciousness; the second changes that to awareness of self in another person; and the third extends self to natural forces but folds back on artifice in the form of tape-recorded memory.

1 alone, studying your face in a chilled* mirror
smiling, scowling perhaps

a microphone nearby
amplifying the sound of your breathing

a swiveling electric fan
directing the air around the room

gradually leaning closer to your reflection
until the glass fogs over

moving back until the image clears

repeating for some time

listening

2 sitting opposite a friend
(who has done the above)

a chilled pane of glass between you

your microphones amplifying your breathing
your fans turning at opposite sides of the room

copying each other's expressions

matching your breathing

moving gradually to the glass
until your images fog over

moving back until the images clear

repeating for some time
listening

*Literally, a mirror propped against, or standing in, ice.

3 sitting alone at the beach

drawing in your breath and releasing it
with the rise and fall of the waves

continuing for some time

walking along the waves' edge

listening through earphones
to the record of your earlier breathing

Since this piece has not been performed, I can only speculate what would happen in carrying it out. Breathing as an abstract idea is unexceptionable; like integrity it is desirable. And formally manipulating verbal exercises on it might even provoke mild curiosity. But breathing as a real and particular event can be an awkward and painful business. Anyone who has jogged seriously or done breathing meditation knows that in the beginning, as you confront your body, you face your psyche as well.

I suspect that the innocent playfulness and poetic naturism of the prescriptions in this piece could gradually become perverse and disturbing for participants, who might gain release from its deadpan literalness only by accepting a temporary alienation of the breath from self.

Consider what the piece proposes to do. It exaggerates the normally unattended aspects of everyday life (fleeting mist on glass, the sound of breathing, the circulation of air, the unconscious mimicry of gestures between friends) and frustrates the obvious ones (looking at ourselves in a mirror, breathing naturally, making contact with a friend, listening to the ocean waves). The loudspeaker, the mirror, the waves, the tape recording are all feedback devices to ensure these shifts.

Such displacements of ordinary emphasis increase attentiveness but only attentiveness to the peripheral parts of ourselves and our surroundings. Revealed this way they are strange. Participants could feel momentarily separated from themselves. The coming together of the parts, then, might be the event's residue, latent and felt, rather than its clear promise.

PART FOUR

THE EIGHTIES

The Real Experiment

(1983)

Guide: "There are no pictures here."
"I see," said the blind man.

Western art actually has two avant-garde histories: one of artlike art and the other of lifelike art. They've been lumped together as parts of a succession of movements fervently committed to innovation, but they represent fundamentally contrasting philosophies of reality.

A supposed conflict between art and life has been a theme in Western art at least since ancient Rome, resolved, if at all, in the dialectics of the artlike artwork—as, for example, in Robert Rauschenberg's statement: "Painting is related to art and life. Neither can be made. (I try to act in that gap between the two.)"

Simplistically put, artlike art holds that art is separate from life and everything else, whereas lifelike art holds that art is connected to life and everything else. In other words, there is art at the service of art and art at the service of life. The maker of artlike art tends to be a specialist; the maker of lifelike art, a generalist.

The usual questions of subject matter and style become relevant once you accept certain cultural givens, like the specialist notion of "art," the subnotions of "poetry" and "music," and the notions of "exhibit," "audience," "creativity," and "esthetic value." These are normally taken for granted. But Western culture appears to be changing so markedly that these givens are at best uncertain. What if they weren't "givens"? What if I had only a vague idea about "art" but didn't know the conventions that told me when I was in its presence or was making it? What if I were digging a hole—would that be art? What if I didn't know about audiences and publicity? What if I were to just go shop-

ping? Would that not be art? What if I didn't realize that art happened at certain times and in certain places? What if I were to lie awake imagining things in bed at 4 A.M.? Would that be the wrong place and the wrong time for art? What if I weren't aware that art was considered more marvelous than life? What if I didn't know an artist was meant to "create" art? What if I were to think art was just paying attention? What if I were to forget to think about art constantly? Could I still make, do, engage in art? Would I be doing something else? Would that be okay?

Of the two, artlike art and lifelike art, avant-garde artlike art occupies the attention of the majority of artists and the public. It is usually seen as serious and as a part of the mainstream Western art-historical tradition, in which mind is separate from body, individual is separate from people, civilization is separate from nature, and each art is separate from the other. Despite the occasional socio-cultural and spiritual interpretations of this art, artists in this tradition have tended to see their work as engaged in a professional dialogue, one art gesture responding to a previous one, and so forth.

Avant-garde artlike art is supported, tardily but steadily, by high culture's institutions, the galleries, museums, concert halls, theaters, schools, government agencies, and professional journals. These share the same separating point of view about art and life: that art could vanquish life's problems as long as it was far enough away from life so as not to be confused by it and sucked back into its mire. These institutions need artists whose work is artlike.

Avant-garde artlike art basically believes in (or does not eliminate) the continuity of the traditionally separate genres of visual art, music, dance, literature, theater, and so forth. The combinations of these genres that are commonplace in dance, film, and particularly opera are hierarchic arrangements, with one of the genres (dance, say, or music) presiding over the others and all the genres identifiably distinct, though interrelated. Either singly, or in satellite order, they need, and get the support of, galleries, museums, concert halls, theaters, schools, government agencies, and professional journals. Hands in gloves.

There is no essential difference between a Jean-Baptiste-Siméon Chardin painting hung in a museum and a Frank Stella painting hung in a museum. Similarly, there is no essential difference between the music of Mozart in a concert hall and the music of Karlheinz Stockhausen in a concert hall. Museum and concert hall embed the works

equally in late Western cultural history. Every time you walk into a museum or concert hall, it instantly triggers references to that history, and if you don't know much about it, you will miss much of the meaning of the art.

Call the museums, concert halls, theaters, journals, and so forth frames of mind. These frames of mind are what give the Chardin, Stella, Mozart, and Stockhausen their meaning. That is what tradition is, and it is the real content of the works. In fact, museums, concert halls, and theaters needn't have a thing in them; they are still the signs for art. Like the dog in Ivan Pavlov's conditioned-reflex experiment, we spontaneously salivate a million artworks when they are even mentioned.

Avant-garde lifelike art, in contrast, concerns an intermittent minority (Futurists, Dadas, Gutai, Happeners, Fluxartists, Earthworkers, Body artists, Provos, postal artists, noise musicians, performance poets, shamanistic artists, Conceptualists). Avant-garde lifelike art is not nearly as serious as avant-garde artlike art. Often it is quite humorous. It isn't very interested in the great Western tradition, either, since it tends to mix things up: body with mind, individual with people in general, civilization with nature, and so on. Thus it mixes up the traditional art genres or avoids them entirely—for example, a mechanical fiddle playing around the clock to a cow in a barnyard. Or going to the laundromat. Despite formalist and idealist interpretations of art, lifelike art makers' principal dialogue is not with art but with everything else, one event suggesting another. If you don't know much about life, you'll miss much of the meaning of the lifelike art that's born of it. Indeed, it's never certain if an artist who creates avant-garde lifelike art is an artist.

For these reasons, avant-garde lifelike art has never fit into traditional arts institutions, even when they offered their support. These institutions "frame" lifelike art right out of life into art (more or less ineptly, at that). "Look," I remember a critic exclaiming once as we walked by a vacant lot full of scattered rags and boxes, "how that extends the gestural painting of the fifties!" He wanted to cart the whole mess to a museum. But life bracketed by the physical and cultural frames of art quickly becomes trivialized life at the service of high art's presumed greater value. The critic wanted everyone to see

the garbage as he did, through art history; not as urban dirt, not as a playground for kids and a home for rats, not as rags blowing about in the wind, boxes rotting in the rain. Avant-garde lifelike art does very well in such real-life circumstances. It is not a "thing" like a piece of music or a sculpture that is put into a special art container or setting. It is inseparable from real life.

The root message of all artlike art is separateness and specialness; and the corresponding one of all lifelike art is connectedness and wide-angle awareness. Artlike art's message is appropriately conveyed by the separate, bound "work"; the message of lifelike art is appropriately conveyed by a process of events that has no definite outline. For each kind of art, the conveyance itself is the message, regardless of the details. Artlike art sends its message on a one-way street: from the artist to us. Lifelike art's message is sent on a feedback loop: from the artist to us (including machines, animals, nature) and around again to the artist. You can't "talk back" to, and thus change, an artlike artwork; but "conversation" is the very means of lifelike art, which is always changing.

It should be easy to distinguish the two avant-gardes, since they have such different ways of being in the world and in art. And now is probably as good a time as any for a cordial parting of the ways. Once you step aside from the traditional view of the arts, and there is no longer any conflict or competition, the word *avant-garde* sounds like a romantic vestige of battles fought to win prizes no longer desirable to an artist committed to living attentively. For instance, achieving a respected place in a museum or opera house nowadays may be flattering, but it is pointless, because it reframes the lifework as conventional art. By dropping thoughts of avant-gardism (a military metaphor at that) and competition with traditional modern art, we become free to recall some of the moves toward a lifelike art practiced not too long ago.

There was Body art, Multimedia and mass-media art, closed-circuit video and electric-light art, computer art, junk art, herbal art, zoo art, earth art, art to be eaten, and art that chemically changed or disappeared. We encountered art that emitted sound in response to our body heat and brain waves. We were invited to participate in Environments that could be altered and re-created by each of us. We were presented with idea art to be read and were encouraged to complete the artist's initiating propositions in our minds. We were sent to

the deserts, pointed to the sky, and submerged in water. We went to "school" where statistics, graphs, and maps instructed us in science, ecology, and sexual mores. We attended, and took part in, ritualistic performances, slice-of-life performances, meditational performances, and political performances. And we saw art emptied of everything except ourselves—who became the art by default.

The importance of these innovations was not just that they increased art-making possibilities enormously. All that refuse, technology, plant life, and hardware; all those intimate treatments of the artist's body; all those excursions along the highways and out into the countryside— all referred us again and again to their sources in the real world. It was those domains outside the world of art that compelled our fresh attention. It was the street, with its vital activity; the body, with its sweat and digestive noises; the mind, with its furious productions, that excited everyone.

The implications of it all weren't so apparent in the 1960s. But hindsight and more experience make it possible today to summarize the characteristics of an emerging lifelike art:

1. The key experiment was not simply the invention of new art genres by which the period is usually known but the recognition of the secularization of the entire art situation: genre, frame, public, and purpose.

2. The critical move in the experiment was the shift of art away from its familiar contexts, the studios, museums, concert halls, theaters, etc., to anywhere else in the real world.

3. Various performative modes became the effective way to deal with this shift to the actual environment. Performing was doing something, not acting in theater—moving furniture, for example, just to do it, or because you were changing apartments.

4. The structural models for the experiment were real (not merely implicit) processes: for example, seasonal changes; food that is grown, prepared, eaten, digested, and composted; thoughts that are transmitted, converted, and put into action.

5. The possible boundaries between lifelike art and the rest of life were kept intentionally blurred. Where the art was located, where

life was, and when one or the other "began" and "ended" were of no importance. Such distinctions were merely provisional.

6. The typical art public and critic used to going to exhibitions, concerts, and plays became irrelevant. Instead, there were small groups of travelers to far-off sites, participants in organized events, thinkers on commuter trains, and artists in their art by themselves. The emerging public for this lifelike art was no longer ideal and unified but was diversified, mobile, and particular in interests, like people in the real world.

7. Lifelike art did not merely label life as art. It was continuous with that life, inflecting, probing, testing, and even suffering it, but always attentively. (That's the source of its humor; when you look closely at your suffering, it can be pretty funny . . .)

8. The purpose of lifelike art was therapeutic: to reintegrate the piecemeal reality we take for granted. Not just intellectually, but directly, as experience—in this moment, in this house, at this kitchen sink . . .

A prescription didn't exist then. There were writings and manifestos, of course (by George Brecht, John Cage, Robert Filliou, Al Hansen, Dick Higgins, Michael Kirby, Jean-Jacques Lebel, George Maciunas, Claes Oldenburg, Nam June Paik, Daniel Spoerri, Ben Vautier, Wolf Vostell, me, and, somewhat later, Jerome Rothenberg), but they were not cohesive, nor were they always carried out in practice. That would have been too tall an order. Even if artists intuited what had to be done, the prospect of a clean break from everything in the high-arts world was not only frightening but unclear in method. The Western tradition in which artists were trained, and still are trained, provoked none of the key questions; neither did it provide alternative models.

Few availed themselves of detailed studies of non-Western cultures. Only the "arts" of these cultures were admired. Thus mistakes in interpretation were made. African carved figures, for instance, were seen through Cubist eyes as intensely expressive geometric *sculpture*; they were not seriously understood as a part of religious practice and a belief system quite different from ours—one that had no sculpture

as such. I'm not saying that what the Cubists saw and wanted to use was not valuable to the art of their time. I'm saying that certain non-Western cosmologies might have given us, in the late fifties and early sixties, an integrative alternative to our society of overspecialization. If we had studied more carefully the role of so-called art in cultures that usually didn't have a word for it, what was happening under our noses would have been clearer. Well, we weren't curious enough. Instead, we found that nonart could be transformed into high art on the Western model simply by framing it properly.

It follows that the easiest and most common course taken then was Duchamp's. We selected some aspect of nonart—stones from a riverbed, factory sounds, a tank of fish, ourselves—and put it, them, us on exhibit or on a stage.

The second course was slightly bolder. We selected certain nonart sites—a forest, a garage, a basement, a dead-end street—and then found ready made, or constructed, the equivalents of galleries, concert stages, and so forth. In these spaces that signified art we presented something more or less lifelike that only minimally engaged the surrounding environment.

The third course, not rare but less noticeable because it ignored publicity, was a sort of proto-conceptual art. We bracketed life with all that we knew about high art but restricted the art we made to our imagination. Whenever we found something interesting, we conceived an artwork. We saw people crossing the street, and they became modern dance. A family squabble was a modern play. A cliff face was modern sculpture. We entered into the "art" or not, as we wished.

But the problem was that these experiments concentrated mostly on enlarging the range of usable genres. I remember vividly both the excitement of feeling that the entire world was available for our art and the snags we got caught on trying to take in that world. We were so green then. We couldn't bypass the framing devices, perceptual clichés, and values of traditional modern art.

Here is what I mean. In the first example (the Duchamp model) we were drastically limited to what actually could fit into museums, theaters, and so on and to what actually could be managed in them. The Los Angeles freeways at rush hour, or airplane trips to various cities, or telephone calls made from our bedrooms, or long medita-

tional disciplines and personal ordeals simply couldn't fit. We were always obliged to put on a *show*. So most of life was excluded for the sake of high art.

In the second example (making galleries, stages, and so forth in the midst of life), we couldn't escape the habit of audiences that still came to see what we were doing (or to participate a little), just as they had always come to the standard exhibitions, concerts, plays, dances, and films. All the traditional esthetic habits of detached spectatorship, the usual hour or so of attention after dinner, all the expectations based on what they had learned about the arts were brought to the new situation intact. It was a little like slumming.

The third example (discovering high art everywhere) was the most sophisticated release from the tangible side of normal art production. It tacitly acknowledged that culture, like reality, is created in the mind and can be de-created. It was cheap and flexible and left nothing behind. Yet for all that, the artist doing this kind of mental framing was like the critic who saw Action painting in a rubble-strewn lot: that critic was an art lover who couldn't say good-bye to tradition. The connection the critic made was witty at the time, but with one foot in straight art and one foot in life, it was self-canceling.

In each of these steps toward a lifelike art, if the genre was strikingly fresh, the frame, the public, and the purpose of our choices were still typical of artlike art. It wasn't enough to discover that an elevator ride or a sandwich could be art; we had to ask where that art belonged, whom it was for, and why. The philosophical sense of what was happening was unclear to most of us, and the impression left upon the curious and interested was one of novelty rather than of a shift to a radically different worldview in which reality was a "seamless fabric."

So it was necessary to change the whole situation, not just the genre, which was the easiest part to change. It took some years to iron things out. Many lifelike artists continued to put together more or less artified packages of elements drawn from the everyday environment (most effectively from the political arena); a second generation has conventionalized this route into acceptable arts festivals, exhibitions, multimedia poetry readings, new-wave concerts, TV shows, and big-time show-biz performances. But for those artists tracking the "real thing," the investigation had to lead away from the traditional community of the fine arts as well as from the traditional community of the commercial arts.

Here is a real event that took place in 1975. An artist named Raivo Puusemp (who had begun in New York as a Conceptualist working at the socio-metric edge of the genre) ran for mayor in Rosendale, New York, and was elected. Although he lived there at the time, he was not a native or long-term resident of Rosendale and was considered a "political unknown."

Rosendale Village, a community of fifteen hundred people established in the seventeenth century, was in financial trouble, had serious water supply and sewage problems, and couldn't govern itself. Its only realistic solution had been known for some time: to disincorporate and become part of the geographically larger Rosendale Township. But disincorporation was an emotionally charged issue for many in the village; with no other alternatives apparent, bills went unpaid, sewage backed up into houses and polluted the local stream, and human initiative seemed paralyzed. Puusemp, who had been an art instructor in the area and was director of instructional resources at nearby Ulster Community College, believed he could do something positive about the village's problems. He would apply to Rosendale what he had been doing as an artist in group dynamics and predictive behavior. He would consider the project an artwork in the form of a political problem.

So he ran, successfully, for the office of mayor. His campaign didn't mention art. Nor did it mention disincorporation. Instead, it proposed an upbeat community involvement in the political process "that accentuated the positive" (as local newspapers described it).

During the next two years, Puusemp and his associate Mark Phelan, who was elected on the same ticket as trustee, guided Rosendale to its survival through dissolution. In a booklet published in 1980, entitled "Beyond Art: Dissolution of Rosendale, N.Y.," Puusemp documented the steps of that process through official records, legal letters, public notices, minutes of village meetings, referenda, and many accounts in area newspapers, which followed the events with great interest.

First, Puusemp persuaded residents of Rosendale to face their own disastrous condition and to see that if they did face it, they could not only save the village but also reduce local taxes and costs. Residents

got their first look at the line-by-line expenses of running a village government and saw precisely how much they could save by handling their affairs responsibly. Taxes, administrative procedures, services, and the police force were reorganized. Village assets were identified, assessed, and reviewed for possible liquidation and revenues. The water and sewage problems were solved when voters approved a bond issue and the village received federal and state assistance. Eventually residents saw that the inevitable next step for Rosendale was to cease being a separate entity. The moment at last was right, and they voted to dissolve.

Townspeople didn't discover, through their mayor, a new solution to their problems. They knew what their solution was. Neither did he urge them, romantically, to stick to their independence at a time when this would have been clearly futile. He came to Rosendale, detached from its history and personalities, and made it possible for everyone to see what had to be done. The vote to dissolve was theirs, not his.

But it must be added that besides helping the village to put its practical affairs in order, Puusemp was able to reduce long-standing factionalism and to reassure townspeople that dissolution did not have to mean the loss of neighborhood and community (as some had feared). Through the process of coming to grips with the village's troubles and deciding to dissolve, they spent more time together and assumed more conscious responsibility for their community than they had for a long time. In this small saga it was crucial that although Puusemp had approached the survival problem of Rosendale with a Conceptual artist's theory of social behavior in mind, he applied that theory in day-by-day human terms.

With the task accomplished, he felt that his usefulness had ended (and that the artwork was complete). He submitted his resignation as mayor for reasons of family health, and Mark Phelan succeeded him. The documents indicate that the news of his resignation was received sadly in the town. Puusemp left amid expressions of public appreciation and settled with his family in Utah, where today he is a marketer of ski resorts and travel tours. He says that he hardly ever thinks of art anymore but that the Rosendale project was significant for everything he did subsequently.

The story of Rosendale, New York, might never have been published if Puusemp's friend the performance artist Paul McCarthy hadn't urged him to publish it. McCarthy was right in supposing that

artists would welcome an account of what Puusemp had done; since the booklet appeared, it has been quietly making the rounds of those trying to break out of the conventions of their training.

The sequence of events in Rosendale, unlike so many innovative works of art of the sixties and seventies, was not simply a novel art event (or genre) that was otherwise encased in perfectly normal high-art contexts. Its genre was unusual, but so were its frame, its public, and its purpose. None of these resembled what we had come to recognize as art. That's why it is exemplary.

The genre was the village and its survival problems. The frame was concentrated in a geographical place, Rosendale, New York, and spread outward to Rosendale Township and Ulster County. The public, more properly the participants, were the townspeople, Mayor Puusemp, county officials, lawyers, representatives of the federal government, and the publishers and readers of area newspapers. The purpose, like that I have suggested for such art, was therapeutic: to cure a local illness and allow village life, and Puusemp's life, to go on more constructively.

Taken together, these four characteristics of lifelike art—the what, where, who, and why—make up what I call the whole situation, or as much of it as can be identified at present. Anyone can see that the four parts merge and that the artist merges with the artwork and those who participate in it. And the "work"—the "work" merges with its surroundings and doesn't really exist by itself.

If we look at the dissolution of Rosendale for a minute as if it were just another artwork, one of its most liberating implications for artists is the absence of the image of the famous artist at work. This most cherished of Western dreams—fame—has not come up yet in this essay, but here is the appropriate place. At no time did Puusemp announce that he was an artist and that he considered his term as mayor of a troubled village to be an artwork. Nor is it likely that his booklet would have been printed without Paul McCarthy's urging.

The reason this artistic submergence is so crucial should be self-evident. In practical terms, what's the point of saying you're an artist who is making art out of a village's troubles? You would confuse people, they might feel insulted, and you would never become mayor. But more basically, it is in the nature of lifelike art to reduce and

eliminate the fame associated with rock stars, socialites, and short-term politicians. If you view the world as a unity, with all things connected, including yourself and your work, then being celebrated with the exaggerated attention and flattery that go with stardom almost invariably leads to self-importance, separation, and, in time, isolation. We don't yet know how to honor someone, or to be honored, without ego getting in the way. It is enough to speculate here that the dissolution of Rosendale Village for the sake of its continued life was equivalent to the dissolution of Raivo Puusemp's political art career for the sake of his life.

Now consider a different example of lifelike art, one that was self-transforming and private. The Rosendale story began with political commitment and ended with personal reevaluation. This second activity began with subjective preoccupation and ended with a nearly mystical sense of nature. All of us are part herd animal and part lone wolf, so the two events should form a nice relationship, each illuminating the other. Since each was unmarked at the time as art of any kind, it is understandable that the artist of this work chooses to be nameless, simply to better emphasize the experiential aspect of what went on.

Each day of a week around 3 P.M., when the wind rose on the dunes, a woman took a walk and watched her tracks blow away behind her. Every evening she wrote an account of her walk in a journal. To begin each successive day, she read her journal story and then tried to repeat exactly what had happened. She described this experience, in turn, as faithfully as possible, until the week had elapsed. Half in jest she wrote in one passage, "I wanted to see if I could stop change."

Her journal entries were rich in details, including not only the facts of footsteps up and down the dunes, the blowing sand, the color of the sky, the time taken, the distance covered, and so forth, but her feelings as well. She described the sense of breaking the earth, of disturbing the immaculate and fragile crusts of glass particles; she wrote of her secret pleasure in making her marks in that remote realm free of others; she accepted with satisfaction the absorption of her tracks back into the earth as if they were herself.

There was also fear. She was afraid of the imbalance and disorientation she experienced in a vast space defined by rhythms but not

by boundaries. She was afraid of being lost. Now and then she was dizzy. The sting of the sand on her skin seemed an attack on her person. She was afraid, above all, of the vastness of nature and its indifference. Gripped so during these times, the woman often found herself walking nearly backward, with her head turned around, her eyes holding on to the last shallow craters of her steps before they were obliterated.

On the second day, for instance, she found it difficult to repeat what she had done and felt the day before. She thought that her path was different (the dunes, of course, had changed). Nevertheless, she persevered. She noticed that she was scuffing the sand in an effort to impress upon it her determination. Several times she reread her journal. It felt more and more "like a script to learn." She walked with purpose, looking not out but back "to confirm that my tracks were still there." She wrote of the "absurdity" of her whole plan, and of trying to laugh at herself. There was an unmistakable defiance in her outing that afternoon.

During the next days she developed a fascination for the job of re-creating her yesterdays, especially since the effort made her more attentive to the unavoidable facts of change.

> On Thursday I came upon a small depression with beach roses growing up the dune slope. I picked a few and twisted their short stems into my waist scarf. At the same time I was practicing at being lost as I had been on Wednesday. But on Wednesday I had been anxious to reach my house before dark; on Thursday I felt a child's delight at discovering the roses. Both feelings were in me at once. Now, on Friday, I couldn't find the roses, and I was again lost!

Once for an hour or so she believed she had really done what she set out to do; to stop change by reenacting her journal entry of the day before, which described a particularly fulfilling experience toward the end of the afternoon, rich with observations of plant life, insects, birds, and a magnificent sunset. This time she followed the earlier description of her movements: the exact way she had placed her feet, how she had leaned into the dunes, rolling down them like a child in a game, her head turned toward the sun, seeing everything again through the intense colorless light. She absorbed and radiated a transcendence she

associated with certain deserted seacoasts in late summer. She wrote that she was sure time had stopped.

The following day she intended to try again, but the wind died. Long lines of her footprints stretched across the dunes undisturbed, along with those of literally hundreds of animals. She felt alone in a crowd. "My tracks didn't belong there; I was an intruder," she wrote. She went through the motions and emotions of her previous bliss to little avail. The silence made her aware of the dragging of her feet in the sand, and of the hollow sound of her breath. Birds she couldn't see screeched everywhere. She noticed her shadow shrinking and elongating as she walked up and down the dunes. The journal entry for that day emphasized that she felt alien. "I was impatient to be finished. . . . Around 6 P.M., flocks of terns attacked and retreated and attacked, swooping to within a few yards of my head. . . . I kept looking at the length of my stride, counting my steps for no reason. I was terribly aware of time."

The wind blew again on the sixth and seventh days. Oddly, she said, she could not remember most of the details of her walks, only that what happened seemed very clear and matter-of-fact. Her remarks were concise: "I walked without fatigue or hurry. I saw the sand blowing off the tops of the dunes. The gray sky lay flat against the horizon. I ate an apple I brought with me."

Only one segment of her journal was particular, however. Repeating the depressing events and mood of the fifth day was problematical. The wind had erased her earlier footprints, and she couldn't hear anything beyond her immediate body. The terns seemed to have vanished. She tried to restore her feeling of disconnectedness, tried over and over to walk in the same nervous manner. And to some degree, she wrote, she succeeded as an actor might "become" a role. "I carried out the forms of my walk and my daydreams yesterday, but I was outside of them watching." In a postscript she noted with some irony that "relating to the repetitions of the previous days was a little like relating to a third cousin twice removed."

The sun appeared intermittently between the clouds, and the woman unbuttoned and buttoned her sweater with the rise and fall of the temperature. She was aware of the dunes extending everywhere, always moving. She was able to see them literally flowing to the east,

as masses of sand were blown up one side of a crest and dumped down the other. Once she stood still for some minutes and was buried to her ankles. Another time she allowed herself to be pushed along a dune's lip by the wind at her back and by millions of granules eroding under her feet. "The dunes, too, move in rest."

Her journal entry on the last night concluded: "I ate dinner about 8 o'clock, and now I'm going to bed."

What does this add up to? For the art buff, who might at least accept the practicality of Puusemp's efforts as mayor of a small village, the dune walks have no apparent conclusion. They were unobserved, their transformations of the normal were not notably inventive, and one is left with the woman merely going to bed. There is the point. She went to bed qualitatively changed. The meaning of her week was internalized; it was "experienced meaning," in the phrase of the psychologist Sheila Bob, not just intellectual meaning. It was manifest in her self-image, and possibly in her subsequent behavior, not in an objective artwork. The reader may say, "so what, everything has meaning—my lunch, your remarks, last year's weather reports." And again that's the point! If only we paid attention; but we don't. Exercises of the sort the woman designed for herself may make this attention possible.

The event described took place around the same year as the Rosendale dissolution. Like it, the woman's experiences bear no resemblance to the artlike arts. The genre was a succession of treks over some sand dunes. Overlapping the genre, the frame was an amorphous area of these dunes stretching for miles, certain prevailing weather conditions, a seven-day duration, and the fixed point of the woman's house not far away. Overlapping the genre and frame was an audience of one (if we can use that word *audience* at all): the woman observing herself carrying out a project she had planned. And the purpose, overlapping everything else, was self-knowledge.

Now, to go on analyzing the imprecise parts of an imprecise whole would become tedious. I've gone this far to show how the last generation's most experimental art (experimental because it was lifelike) often stopped short of realizing its vision because it still clung to habits associated with artlike art. I wanted to specify which habits these were

and to describe two lifelike artworks that weren't clinging to such habits.

With this in mind, I'd like to acknowledge a question that many will want to ask about an art that is like life. The question is misleading, but it comes up frequently, out of habit. It is this: if lifelike art doesn't resemble art as we've known it, but resembles real life, what then makes it art? Wouldn't it be perfectly reasonable to say that what happened in Rosendale was simply the politics of a small town, and the dune treks were simply a series of nature walks? Saying this wouldn't necessarily disparage either of them; it would only distinguish them from what art is and does. That sounds fair enough, if by *art* we still mean artlike art. We'd have to agree, in that case, that there is nothing in particular that makes the two events art. They are really two life situations, which might be more appropriately studied by the social sciences, if they were to be studied at all.

But let's say that art is a weaving of meaning-making activity with any or all parts of our lives. (Though awkward and a mouthful, the statement emphasizes purposive and interpretive acts instead of mere routine behavior, whether such acts are politics or nature walks.) This definition shifts the model for art from the special history of the field to a broad terrain embracing not only lifelike art but religious, philosophical, scientific, and social/personal exploration. The grave concern of a growing number of speculative theologians, scientists, political thinkers, and new-age futurologists is to try to make sense out of the countless disconnected, and sometimes very dangerous, pieces of our culture and to rediscover the whole. Lifelike art can mean a way (one way) of sharing responsibility for what may be the world's most pressing problem.

In this holistic sense, the Rosendale events and the dune walks are art. If the definition still seems arbitrary, just remember that this "sense of the whole" evolved out of traditional art's roots. The artlike arts, responding to internal developments as well as to global pressures, produced a lifelike art. Lifelike art is art by parentage, and that is what causes it so many of the problems I mentioned before. It hasn't evolved long enough to be a mutant. Artists may have to remind themselves constantly to heed its essential nature: to be a means for integrating them/us into what the anthropologist Diane Rothenberg and the poet Jerome Rothenberg have called "the symposium of the whole." Ulti-

mately, the "art" of lifelike art may be as vestigial as our appendix; but for the present we may neither deny it nor glorify it.

What is at stake now is to understand that of all the integrative roles lifelike art can play (for example, in popular entertainment, education, communications, politics, or social organization), none is so crucial to our survival as the one that serves self-knowledge. Self-knowledge is where you start on the way to becoming "the whole," whether this process takes the form of social action or personal transformation. The expression "to know yourself," stated so flatly, is vague, encompassing anything from relatively light insights that come up in the course of a day to the hard and long process of existential comprehension that can slowly turn a person's life around. What I have in mind when I say "self-knowledge" is the latter. It is the passage of the separate self to the egoless self. Lifelike art in which nothing is separate is a training in letting go of the separate self. The Rosendale dissolution and the dune treks are not presented here as pinnacles of enlightenment (there probably are no such things); they are just steps along the way, and the artists' eyes may have opened up a little.

Self-knowledge is necessary and often painful work. But it is not new work, or the work of lifelike art alone. It has been at the core of artlike art as well. All those statements about art being a "calling," a "way of life," a "spiritual path," a "search for truth," a "revelation," the "conscience of the age," the "collective dream," the "forces of nature," an "archetypal act," and a "mythmaking" refer to the transcendental assumptions underlying artists' practice of art in the first place.

But we heard little of these vestiges of the seer role of art after World War II. Writings and daily talk about art during the sixties and seventies tended to become impersonal and quasi-intellectual, borrowing heavily from neo-Marxism, cultural structuralism, and semiotics. The practice of art seemed professionalistic, while on the popular, newsy level it seemed all about careerism. The suprapersonal implications of art making, however, were never absent from private conversations; they just dropped out of public discourse. Yet this is exactly the predicament artlike art is stuck in: its frames, physical and cultural,

have become so fixed and so confining that any residual "spirit" it might appeal to is virtually inaccessible.

Consider: if lifelike art restores the possibility of the practice of art as a practice of enlightenment, it complements what various psychotherapies and meditational disciplines have always done. Lifelike art can be thought of, not as a substitute for these, but as a direct way of placing them in a context of contemporary imagery, metaphor, and site. What occurred in Rosendale Village and on the dunes is normally excluded from the therapeutic session and from, say, the daily practice of *zazen* (the Japanese form of Buddhist sitting meditation), both of which are carried out under the guidance of a teacher. Lifelike art is self-conducted and self-responsible. Lifelike art can be, for therapy and meditation, a bridge into daily affairs. It is even possible that some lifelike art could become a discipline of healing and meditation as well. Something like this is already happening. If it develops more intentionally (and we don't know if it will), we may see the overall meaning of art change profoundly—from being an end to being a means, from holding out a promise of perfection in some other realm to demonstrating a way of living meaningfully in this one.

Suppose you telephone your own answering device and leave a message that you called—you might learn something about yourself.

Suppose you offer to sweep a friend's house, and then spread the gathered dust through your own place—you might learn something about friendship.

Suppose you watch a clear sky and wait for a cloud to form—you might learn something about nature. Suppose you wait longer, for the sky to clear—you might learn something else about yourself.

Art Which Can't Be Art
(1986)

It's fairly well known that for the last thirty years my main work as an artist has been located in activities and contexts that don't suggest art in any way. Brushing my teeth, for example, in the morning when I'm barely awake; watching in the mirror the rhythm of my elbow moving up and down . . .

The practice of such an art, which isn't perceived as art, is not so much a contradiction as a paradox. Why this is so requires some background.

When I speak of activities and contexts that don't suggest art, I don't mean that an event like brushing my teeth each morning is chosen and then set into a conventional art context, as Duchamp and many others since him have done. That strategy, by which an art-identifying frame (such as a gallery or theater) confers "art value" or "art discourse" upon some nonart object, idea, or event, was, in Duchamp's initial move, sharply ironic. It forced into confrontation a whole bundle of sacred assumptions about creativity, professional skill, individuality, spirituality, modernism, and the presumed value and function of high art itself. But later it became trivialized, as more and more nonart was put on exhibit by other artists. Regardless of the merits of each case, the same truism was headlined every time we saw a stack of industrial products in a gallery, every time daily life was enacted on a stage: that anything can be estheticized, given the right art packages to put it into. But why should we want to estheticize "anything"? All the irony was lost in those presentations, the provocative questions forgotten. To go on making this kind of move in art seemed to me unproductive.

Instead, I decided to pay attention to brushing my teeth, to watch my elbow moving. I would be alone in my bathroom, without art spectators. There would be no gallery, no critic to judge, no publicity.

Fig. 16 Gathering grains of sand for Allan Kaprow's *Trading Dirt*, 1989, along the coast of Holland. *Photograph by Allan Kaprow.*

This was the crucial shift that removed the performance of everyday life from all but the memory of art. I could, of course, have said to myself, "Now I'm making art!" But in actual practice, I didn't think much about it.

My awareness and thoughts were of another kind. I began to pay attention to how much this act of brushing my teeth had become routinized, nonconscious behavior, compared with my first efforts to do it as a child. I began to suspect that 99 percent of my daily life was just as routinized and unnoticed; that my mind was always somewhere else; and that the thousand signals my body was sending me each minute were ignored. I guessed also that most people were like me in this respect.

Brushing my teeth attentively for two weeks, I gradually became aware of the tension in my elbow and fingers (was it there before?), the pressure of the brush on my gums, their slight bleeding (should I visit the dentist?). I looked up once and saw, really saw, my face in the mirror. I rarely looked at myself when I got up, perhaps because I wanted to avoid the puffy face I'd see, at least until it could be washed and smoothed to match the public image I prefer. (And how many times had I seen others do the same and believed I was different!)

This was an eye-opener to my privacy and to my humanity. An unremarkable picture of myself was beginning to surface, an image I'd created but never examined. It colored the images I made of the world and influenced how I dealt with my images of others. I saw this little by little.

But if this wider domain of resonance, spreading from the mere process of brushing my teeth, seems too far from its starting point, I should say immediately that it never left the bathroom. The physicality of brushing, the aromatic taste of toothpaste, rinsing my mouth and the brush, the many small nuances such as right-handedness causing me to enter my mouth with the loaded brush from that side and then move to the left side—these particularities always stayed in the present. The larger implications popped up from time to time during the subsequent days. All this from toothbrushing.

How is this relevant to art? Why is this not just sociology? It is relevant because developments within modernism itself led to art's dissolution into its life sources. Art in the West has a long history of secularizing tendencies, going back at least as far as the Hellenistic period. By the late 1950s and 1960s this lifelike impulse dominated the

vanguard. Art shifted away from the specialized object in the gallery to the real urban environment; to the real body and mind; to communications technology; and to remote natural regions of the ocean, sky, and desert. Thus the relationship of the act of toothbrushing to recent art is clear and cannot be bypassed. This is where the paradox lies; an artist concerned with lifelike art is an artist who does and does not make art.

Anything less than paradox would be simplistic. Unless the identity (and thus the meaning) of what the artist does oscillates between ordinary, recognizable activity and the "resonance" of that activity in the larger human context, the activity itself reduces to conventional behavior. Or if it is framed as art by a gallery, it reduces to conventional art. Thus toothbrushing, as we normally do it, offers no roads back to the real world either. But ordinary life performed as art/not art can charge the everyday with metaphoric power.

Right Living
(1987)

It has always interested me to see how far an earlier artist's innovations can be extended. In a crucial sense, the extensibility of a new move, its capacity to keep on ramifying, is the measure of its value. This distinguishes the truly generative idea from the mere fad.

For example, Mondrian saw in Cubism the precursor to a nonfigurative, transcendent formal language. This lofty sense of abstraction continued to resonate through Newman and Reinhardt and well into Minimalism.

In contrast, Duchamp picked up from that same Cubism's collages and constructions the ironic possibility that the artist's selective appropriation of commonplace materials and mass-produced images might replace the artist's traditional skill and individual creativity. The result was the Readymade, framed (in every sense of the word) as art by the gallery context. The idea of ready-made art continued through Surrealism to Assemblage, Happenings and Events, Pop art, Body art, Land art, right up to the present. Like pure abstraction, it has been a fundamental "generator" in modern art.

But radical moves leave some things behind. Mondrian had no taste for the multiviewed illusions and puns of the everyday world in Cubism. Duchamp, for his part, had little interest in its rich formal play. Innovative jumps are often neither fair nor balanced.

Given the wide effect John Cage has had on a number of arts besides music, how has he been generative? The answers each of us gives may not be fair or balanced or particularly pleasing to Cage. But they can begin to map out the broad outlines of his resonance.

From my vantage point, Cage made two principal experimental moves in music making: the sustained practice of chance operations to arrange and select the sounds and durations of a piece, and the

welcoming of noise into a composition as equivalent to conventional musical sound.

Although it is clear enough that intense interest in both chance and nonart appeared across the whole range of the arts earlier in the century, Cage's focus upon them was more thoughtful and systematic in the forties and fifties. And perhaps the moment in history was more receptive. Artists of all kinds were attracted by his example, and numbers of them became students in his classes (I was one).

It was apparent to everyone immediately that these two moves in music could be systematically carried over to any of the other arts. But the more interesting prospect, as I saw it, was to follow the lead of these ideas well beyond the boundaries of the art genres themselves.

Consider: if chance operations and the appropriation of noise could summon to one piece of music fragments of Beethoven and scratchy noises equally, then such chance operations could also bring into combination or isolation any of the art genres, or none of them at all! But this could be problematical. A chance plan that might call for doing a piece in a concert hall, a gallery, and a kitchen simultaneously simply couldn't be realized. Some external decision would have to be made in the interest of practicality. In other words, the chance method was wonderfully productive of fresh auditory experience, but Cage applied it at his own discretion and almost always within the social, physical, and temporal limits of the concert situation.

Since I had to make practical decisions regarding what domains would be used for an event, the chanciness and uncontrollability of the everyday environment appeared more attractive than the relative predictability of the galleries, stages, and formats of the traditional modern arts. Once in the streets or on the telephone, chance operations could of course be easily used, but after some time the sheer magnitude of unforeseeable details and outcomes for any projected event in the real world was so much greater than what a chance score might provide that devising a method to suspend taste or choice became superfluous. A simple plan was enough: "Taking a walk for three hours. Turning left every hundred steps" . . . Suppose you turned left into a wall or into oncoming traffic? A decision would be necessary on the spot.

Thus "chance" was a given of the environment once you left the art context, and "noise" as a metaphor of everything excluded from art was extensible to all events and places on earth and in the head. In

short, as Cage brought the chancy and noisy world into the concert hall (following Duchamp, who did the same in the art gallery), a next step was simply to move right out into that uncertain world and forget the framing devices of concert hall, gallery, stage, and so forth. This was the theoretical foundation of the Happening, and for some years Bodyworks, Earthworks, Information pieces, and Conceptualism variously extended that idea.

But in the years since the fifties it has seemed to me that Cage's example was far more significant, more bountiful, than its impact on the arts might suggest. Emerging in his works, writings, and teaching at that time was a worldview very different from the one we were used to. For Western artists the prevalent myth of the tragic sufferer held sway over everyone's imagination. (Miró's work was less than top-drawer simply because it was full of humor!) The real world was terrible, so the artist's calling was to create in fantasy a better world or, if not a better, at least a more critical one. To accomplish this task often meant going through hell, and the lives of the best artists one knew then were hardly models for the young.

In Cage's cosmology (informed by Asiatic philosophy) the real world was perfect, if we could only hear it, see it, understand it. If we couldn't, that was because our senses were closed and our minds were filled with preconceptions. Thus we made the world into our misery.

But if the world was perfect just as it is, neither terrible nor good, then it wasn't necessary to demand that it should improve (one begins to know what to do with difficulties without making such demands). And if our art was no longer required to provide a substitute world, it was okay to give up trying to perfect and control it (hence the chance operations and noises). What happened for some of us was that our newly released art began to perform itself as if following its own natural bent. It may have occurred to us that we might live our lives in the same way.

Most Westerners would find this hard to accept, while for those who accept its wisdom it is much easier said than done. But here, I believe, is the most valuable part of John Cage's innovations in music: experimental music, or any other experimental art of our time, can be an introduction to right living; and after that introduction art can be bypassed for the main course.

PART FIVE

THE NINETIES

The Meaning of Life

(1990)

Two men are drinking in a bar. Between them is a half bottle of whiskey. One of them, a pessimist, says it's half-empty. The other, an optimist, says it's half-full.

The experimental artist today is the un-artist. Not the antiartist but the artist emptied of art. The un-artist, as the name implies, started out conventionally, as a modernist, but at a certain point around the fifties began divesting her or his work of nearly every feature that could remind anyone of art at all. The un-artist makes no real art but does what I've called lifelike art, art that reminds us mainly of the rest of our lives.

A woman decides to go and find a smudge somewhere. The idea is to remove the smudge and take it away with her. A few days later she sees a cigarette ash crushed on a sidewalk and sweeps it up into her jacket pocket. After a week goes by she shows someone the inside of her pocket. Maybe she tells how she took away a smudge. There's not much to see.

If un-arting is a divesting of "nearly" all the features of recognizable art, what still remains is the concept "art"; the word is there in "un-artist." That word and all the countless paintings, sculptures, concerts, poems, and plays it briefly calls up were part of the un-artist's earlier commitment. So art, for a while, will linger as a memory trace, but not as something that matters.

This may make sense if we recall that the profession of art itself has played a major role in its own unloading. The innovative side of its history in the West is marked by repeated inclusions of nonart:

junk, noises, pop themes, mass products, new technologies, perishables, fleeting events, politics, streets, deserts, bathrooms, telephone booths . . . The un-artist, therefore, is the offspring of high art who has left home.

As un-art takes a lifelike form and setting, as it begins to function in the world as if it were life, we can speculate that art and all its resonances may one day become unnecessary for today's experimenter, even as the point of departure it has been. And that might not be so bad, since the attraction of artists to nonart over the last century suggests that the idea of art as a thing apart has not always been satisfactory; that at certain times the rest of life is more compelling. That's why art cannot be entirely forgotten and why, at the same time, it can be left behind.

Harry deals in California real estate and has a good life. One day at lunch he looks around him at the quiet patio and the flowering bougainvillea, then at his partner, Mike. "Mike," he says, "do you know what the meaning of life is?" Mike says no and changes the subject.

For the next few months Harry worries about the meaning of life. Finally he tells Mike he's going to quit real estate to search until he finds the answer. Mike tries to talk him out of it, but Harry has made up his mind. He puts his affairs in order and disappears from the face of the earth.

Years later, Mike is eating lunch at the same restaurant and a bum puts a hand on his shoulder and says in a wheezy voice, "Mike, it's me, Harry!" Harry is a scarecrow, one eye missing, teeth gone, a filthy mess. Mike wants to shake him off, but Harry sticks to him like glue. Harry says, "It's been a long trip, I did time in jail, I got all kinds of diseases, I almost died in Tibet, I was robbed and beaten up . . . but I found the meaning of life!"

Mike looks him over and figures he has to play along to get rid of him. So he says, "Okay, what's the meaning of life?" Harry stares deep into Mike's eyes and says, "It's the hole in a bagel."

Mike doesn't appreciate the answer, so he tells Harry that the meaning of life can't be the hole in a bagel.

Harry slowly takes his hand off Mike's shoulder and gets an amazed look on his face. He says to Mike, "Aha! So life's not the hole in a bagel!" . . . And he walks out of the patio.

What's the meaning of this story? Is Harry really right; that is, is he on the track of life's meaning, even if it isn't exactly the hole in a bagel? The story does cast him as the seer who, after his brief reunion with skeptical Mike, probably goes on and on searching. In the great quester tradition, Harry has made a binding pledge to that search. Since he has gone through hell, now he must be essentially right. But Mike could be more right: he knows that Harry is crazy.

Suppose, instead, that both are equally right. Mike is a responsible man. He shares with Harry the management of a corporate giant known for its prizewinning shopping centers. Mike genuinely believes in productive work as a supreme virtue. He knows that the meaning of life cannot be simply the hole in a bagel. Harry, however, is a visionary at heart. Though he is remarkable at business and a respected member of his community, he has always sensed that there is something more, some deeper truth. Harry has read books, but books are not enough. He must find the truth himself, away from the life he's led. Looked at this way, he and Mike are doing what each believes is necessary. They both know the meaning of life.

Now suppose both are wrong. Mike only understands virtue that is socially approved. He is unconsciously smug about being a model (i.e., wealthy) citizen, and he secretly despises those who do not have the same ambition while envying anyone who is more outstanding than he is. Harry, too, who had presumably put his affairs in order before going on his pilgrimage, actually leaves Mike in the lurch. He had a family who loved him. There are colleagues and friends who suffer from his absence, not to mention that as the architectural brains behind the success of his firm, he has severely jeopardized its future. Searching for the "meaning of life" is for Harry just an excuse to abandon his real-life responsibilities. Neither man is admirable, so neither can possibly know the meaning of life.

If the two men can be right, wrong, and partly right or wrong, is the meaning of the story that nothing in life is clearly this or that? Perhaps, but that's obvious. What is central to this story is that while Harry may be driven by an impossible dream, he is flexible about its

details: if the hole in a bagel won't do, then something else will. Mike may be the practical man, but that's why he can accept reality as it appears to him: after Harry leaves, he manages anyway. We really don't know from the bare story the small particulars of their separation. Harry may not have had a family at all, and his leaving the business may have been quite decently arranged. Mike, for his part, may have decided to merge with another real estate conglomerate to expand the business. The greatest part of the story is what we choose to add to it.

And that's the story of lifelike art. Lifelike artists are either Harry or Mike, or both at once, playing at life's daily routines. They find life's meaning in picking a stray thread from someone's collar. And if that isn't it, they find it in just making sure the dishes are washed, counting the knives, the forks, the cups and saucers as they pass from the left hand to the right.

How different this is from "artlike artists," whose art resembles other art more than anything else. Artlike artists don't look for the meaning of life; they look for the meaning of art. And when they think they've found it, they become very discouraged if told they're wrong. They don't go willingly on to some other answer, as Harry did; and they're hardly free of doubts, like Mike. Most of the time they stick to their guns and even fight.

A man commits a crime and is sentenced to life in prison. When he arrives at the prison gate, he is met by an older inmate who has been assigned to supervise his adjustment to prison routine. After he has checked in and been given a uniform, they proceed to the mess hall for lunch, where the new inmate is introduced to the other prisoners. They begin eating, and after a few minutes he hears someone say "Fourteen!" Everybody laughs. Then he hears "Eleven!" followed by good-natured groans. Then "Ninety-two!" and giggles. Then "Twenty-seven!" Howls and tears. This goes on through the whole meal.

The new man gets more and more confused. So he leans over to his mentor and whispers, "What's going on?" The older man replies, "We're telling jokes. But we've told them so many times that we know them by

**heart. So to save time, the jokes have numbers. That
way we can tell a lot more jokes."**

**The new inmate nods and realizes he's going to be
eating with these men for a long time and might as well
learn the ropes. So he says, "Sixteen!" and looks
around at everyone. Dead silence. He leans over again
and says, "What's wrong?" The older prisoner says,
"Simple. You didn't tell it right."**

It is serious business telling jokes by numbers. A person needs a lot of knowledge and training in joke history to tell a joke by announcing one plain number. Do it properly and it becomes a whole world. Just hear a "five" or a "two hundred and seventy-eight" from a real jokester and you'd know it was a scream.

After years in the prison there are no new jokes introduced. There couldn't be, for example, a "crocodile tears" joke with the number "minus thirteen" if it didn't already exist. It would have no history; therefore no one would know it was a joke. But a classic that has been told to death can provide countless opportunities for witty takeoffs.

Given a repertory of, say, three hundred jokes among twenty prisoners at a table who have lived together for an average of fifteen years and share about eleven hundred breakfasts, lunches, and dinners a year; and supposing that each prisoner has the skill to make at least ten variations and quotations from the others' joke styles—they have about sixty thousand jokes to enjoy.

Formidable. Only a professional can appreciate the finely tuned sequences of numbers required at each meal. To the men at the table, pauses speak volumes. Voices rise and fall. Facial expressions, gestures, and eye contacts inflect the weight of all twenty responses to each number. The attentive prisoner can perceive in their giggles and groans massive ironies and learned critiques. On one occasion a covertly planned strike against prison work conditions and growing resentment over the declining quality of the food are simultaneously encoded in certain multiples of "three"; thus to the expert listener every joke containing these numbers resonates politically. No wonder, then, that the new man fails to get a laugh out of his mates. "You didn't tell it right," his mentor says. Telling it right really counts in that prison.

Out in the ordinary world, however, it isn't so important to tell it

right. There are no experts who know the meaning of life. Who could say with certainty that life is a screwdriver, or a bottle cap? The punchline may never be delivered. But on the rush-hour freeways listening to the news describing the rush-hour freeways, there you can hear the wisdom of the shaggy dog.

Two friends spend the day visiting. Whenever it seems right, one says to the other, "You're up" or "You're down," and they continue whatever they've been doing or talking about. "Up" and "down" depend on whether one friend is on a higher or lower level (such as a step on a stairway) or is feeling good or bad. These two kinds of ups and downs might coincide or not. But the friends pay attention to such judgments. They learn from each other how they are. Otherwise, their day is perfectly ordinary.

The friends spend another day together. At some point one says to the other, "Give me some money." The other friend complies with an amount. Sometime later, the one who has complied says, "Give me my money back," and the money is returned. Later in the day, one of the friends says, "Give me a kiss," and the other complies. Still later, the one who has complied says, "Give me my kiss back," and the kiss is returned. Otherwise, their day is perfectly ordinary.

Let's take a look at these ordinary days. On one of them the friends are digging a cesspool. The household plumbing has become clogged and repairs can't be put off. It's hot that day and they must chop through layers of clay with a crowbar and pickax. Down eight feet it's difficult to shovel, and the dirt and rocks have to be pulled out from above by a pail with a rope tied to the handle. Now and then one of the friends says to the other, "You're up," or "You're down."

Some weeks go by, and a colleague of theirs passes away. They attend the funeral. The church is packed. Candles glow on the altar. The choir is singing, and sweet sadness fills every pew. As the minister intones the virtues of their departed comrade, one of the friends says quietly, "Give me some money." Later, at the reception, she says, "Give

Fig. 17 Shaggy dog. *Photograph by Mary Bloom.*

me a kiss." Of course the money and the kiss are returned upon de-mand.

As I said, such interactions have almost nothing to do with art as we know it, except that those who engage in them are aware of their not-too-distant art parent. So if they play with what artists do when they are *not* being artists, they know that this could be construed as a fading discourse of sorts with high art. But that is hardly interesting, because what most artlike artists do when they're not making art is about the same as what most other people do when they're not doing something special: bending to tie a shoelace, scratching an itch politely, waving to someone across the street, making the weekly telephone call to a parent—that is to say, the small routines of everyday life. Hence intentional involvement in these routines is not meant to appropriate yet more nonart into art than did artists of the fifties and sixties, nor is it to affirm some deeper connection uniting artists and all of hu-manity (though that is a nice thought). It is, rather, to imply that these ordinary events are inherently compelling once you pay attention to them.

What happens when you pay close attention to anything, especially routine behavior, is that it *changes*. Attention alters what is attended. When you wash your hands in the bathroom, for instance, do you wet your hands for three seconds, four, or longer? Do you pick up the soap with your left hand or your right? Do you work up a lather with three revolutions of your hands or more? How fast do your hands turn? How long do you rinse? Do you look into the sink or at the mirror as you wash? Do you lean backward to avoid the splashing water? Do you shake your hands to rid them of excess water before reaching for a towel? Do you look at yourself in the mirror to see if you're pre-sentable?

If you began accounting for all these operations in sequence while you were still washing your hands, you'd notice that they seem to take longer than they should and that everything happens awkwardly, or at least disjunctively. You may never have given any thought to how many movements you make automatically, or to their physical sensa-tions. You might become fascinated with the soap bubbles, with the drying motions of your hands, with looking at these in the mirror rather than directly. Soon you realize it is all very strange; you are in a territory of the familiar unfamiliar.

How, you may wonder, does someone else do it? How do you find

out? Could you ask an acquaintance, "Please, may I watch you washing your hands?" Would you propose this in a private bathroom or a public one? If the proposition were accepted, could you depend on the "normalcy" of the demonstration? Where would you stand, close by or behind? Would you copy the washer's movements in order to remember them, with your hands in the air, looking in the mirror at him looking at you? Or would you put your hands in the same sink with his? How would you feel about being handed a wet towel?

By now your curiosity may be turning into play. You wash and soap longer than necessary. The soap bar slips out of your hands. You reach for it but your partner grabs it. Laughing, you both begin to wash each other's hands as well as your own. You talk about hand washing and wonder about people who wash their hands when they're not dirty (when they want to clean up spiritual dirt). What would happen, one of you says, if every time you shook hands with someone you made a point of washing immediately before and afterwards?

The two of you agree to experiment. During the following days, whenever you shake hands with anyone, you interrupt the spontaneous movement of hands by suddenly pulling away and explaining quickly that before and after handshakes everyone washes. This will leave hands dangling in the space between you. But you swiftly unpack your portable water basin, pour warm water from a thermos, produce a bar of soap, and proceed efficiently to wash your hands and the other person's, followed by drying with a small towel. The hand shaking then follows ceremoniously and the washup is repeated.

Depending on how curious the person is, it could provoke the question, "What was that all about?" You could suggest a cup of coffee together and talk about the meaning of life. And that's one way to do lifelike art.

A man decides to walk one hundred steps in one direction, then one hundred steps in another direction, and so on, one hundred times. If his steps take him to a blank wall or into the path of an oncoming car, he has to make another decision.

Some friends get together. Each chooses to be a climber or a stooper. Once they've chosen, they go

about their normal business. But they carry a roll of Scotch tape in their pockets, and here and there they stretch it across a doorway, an alley, or a couple of trees or over some truck wheels.

Climbers stretch their first tape at waist level and find some way to climb over it. Next time it is fixed an inch or so higher, and the time after, another inch, and so forth. This gradual raising of the tape continues through the day or even the week until climbing is impossible.

Stoopers stretch their first tape at about eye level, and then they stoop under it. The next one and the following ones through the day or week are gradually lowered around an inch at a time. As the tape approaches the floor or ground, they might have to crawl under it, until stooping is impossible.

Two commercial housecleaners want to do something nice. They arrange to clean each other's kitchen floors. The plan is to do this by using only Q-Tips and spit. It takes a very long time, thousands of Q-Tips, and lots of spit. They have to work on their knees, with their eyes close to the floor. Crumbs, hairs, dead bugs, and other interesting things appear.

Finally, both kitchen floors are spotless. Later, when they tell a friend about it, she says, "What, you cleaned your floors with dirty spit?"

These events, of course, are themselves the meaning of life. Inasmuch as lifelike art participates in its everyday source, purposely intending to be *like* life, it becomes interpretation, hence "meaning." But it is not life in general that is meaningful; an abstraction can't be experienced. Only life in particular can be—some tangible aspect of it serving as a representative, for example, a ripe summer tomato. Harry, you'll recall, was very concrete when he said life's meaning was the hole in the bagel. He could poke his finger through it!

Nonetheless, a bagel hole is only one instance of life's meaning. Its experience vanishes in the second when Harry's finger is withdrawn. All that is left is a thought. Besides that hole, there are leaking faucets,

credit cards, stomachaches, and flyswatters, in endless profusion. That's why Harry had to let himself be forced, by the resistance of all the Mikes in the universe, to rediscover the meaning of life again and again in something else.

But while words are used to refer to that meaning, they are only tokens of experience. "The hole in a bagel," to Harry, stood for years of trekking, foolishness, and discarded revelations encountered across the world. He could just as easily have said "potshot."

So if you asked about the meaning of the preceding events, you could consider a number of reasonable answers. Cleaning a friend's kitchen floor with Q-Tips and spit, for example, instead of doing it more efficiently, could mean (a) seeing life from another perspective; or (b) testing your friendship; or (c) making the simple complicated; or (d) putting yourself (your spit) wholly into the job; or (e) being free to cheat since no one will see you; or (f) being on the track of something big; or (g) getting some exercise . . . The same range could be applied to the other two events, and to all human events in general.

"Meaning" here is not only variable and unfixed but also inventive. It is what we add, by imagination and interpretation, to what we do. Harry was not merely, or incidentally, robbed and jailed on his arduous pilgrimage. He was robbed of the meaning of life and jailed by it, equally. He saw everything that happened to him as directly related to his search. He was creating a life story. Mike, in his own fashion, did the same: he related everything to maintaining his idea of the status quo. That was his story.

Lifelike artists, similarly, are conscious inventors of the life that also invents them (at least they try to be conscious as often as they can). They experiment with meanings, sometimes as casually as trying on different shirts, sometimes as seriously as deciding whether or not to go to a former lover's wedding. The questions always are, What is the sense of this trip, this meeting, this job, this argument? How is it experienced?

You and a friend cook for each other once a week. Everything goes well for a while. One day, however, you say to your friend, "There's got to be more to it than this," and you stop your weekly arrangements. Later on you telephone your friend and say, "I know what's missing." "What?" your friend asks. "It's collecting the lint

under our beds." But she says, "That's not what's miss-
ing." "Oh," you say. "I'll get back with something else."

The next day you call and say, "I know what's missing
now!" "What?" "It's taking a walk with you all day and
stepping on your shadow." Your friend says, "That'll fix
things up, if I can step on yours."

Fine. You do this once a week for some time, and
everything goes well as you step on your friend's
shadow and she steps on yours. But eventually your
friend says, "There's got to be more to it than this," and
you both stop treading on each other's shadow. Some-
time afterward she calls and says, "I know just what's
missing." You ask her what it is and hear that it's wear-
ing each other's underwear for a few weeks. You tell her
that's not what's missing. "Well, okay, I'll get back to you
soon," she says. A week later she telephones and says,
"I know what's missing now." And you ask, "What?"
She says, "Collecting the lint under our beds." You
agree and spend a lot of time under the beds. But this
too lasts only so long, and one day you say, "There's got
to be more to it than this." So lint collecting is called off.

Your next suggestion, to spend an evening a week
smiling at one another, is rejected. Later you call and
say, "Now I really know what's missing." "Yeah?" she
says. "Let's cook for each other once a week!" you say.
This new idea is accepted quickly, and it goes on for a
while until your friend says, "There's got to be more to it
than this." And, well . . .

Is playing at life, life? Is playing at life, "life"? Is "life" just another
way of life? Is life playing, or is my life playing? Am I playing with
words and asking real-life questions?

Life in birds, bees, and volcanoes just is. But (to paraphrase an
earlier point) when I think about life, it becomes "life." Life is an idea.
Whatever that idea might be—playing or suffering or whatnot—it
floats, outside of time, in my thoughts. But actually playing at life in
any form happens in real time, moment by moment, and is distinctly
physical. I scrub my friend's kitchen floor with Q-Tips, my knees hurt,
I run out of spit, I look for beer . . . If I think about life under those

conditions, it begins to resemble a hair, a crumb, a dead fly. And that's another idea.

So lifelike art plays somewhere in and between attention to physical process and attention to interpretation. It is experience, yet it is un-graspable. It requires quotation marks ("lifelike") but sheds them as the un-artist sheds art. If once again I recall Harry the quester, I wonder if he was looking for the meaning of life or the meaning of "life." He could have been confused about the word.

A man owns a used-car dealership. Every morning when he arrives at work, he goes around the lot kicking the car tires. Exercise, he says.

A college student collects ballpoint pens. She has sev-eral thousand. Whenever she sees one lying on the ground or forgotten on a school desk, she picks it up for her collection. Each day, around five o'clock, she tele-phones her answering machine and leaves a detailed message describing the ballpoint pens she's found. Then when she returns home, she sits down and listens to her message as she examines the pens one by one.

A man leaves a mirror outdoors all night. The tempera-ture is well below zero. The next morning, he goes out and holds the mirror close to his face to look at himself. It fogs over instantly.

Another man wants to possess his shadow. He sees it lying on the ground, extending out from his feet. But every time he bends down to catch hold of it, it shortens and changes shape. Furthermore, as the sun is setting at that time of day, his shadow grows longer and longer. No matter how hard he tries to fix his shadow so that he can grasp it, it eludes him. Then the sun sets and the man's shadow disappears entirely.

To make bagels you start with 1 package of dried yeast mixed with a pinch of sugar in ¼ cup of warm water. Let this stand for 5 to 10 minutes. Then, in a warm bowl, add to the yeast solution 2 teaspoons of salt and ⅔ cup of peanut oil and mix thoroughly. To this gradually add 3 cups of unbleached white flour to make a stiff, but not dry, dough. Knead for 10 to 15 minutes (here is where strong fingers and shoulders make a difference!). Put the dough in a greased bowl, cover with a plastic bag, and let it rise for 50 minutes or until it has doubled in size. Now cut the risen dough into 16 to 18 pieces and roll each one into a "rope" half an inch in diameter. Join the two ends of each rope into a circle around a couple of fingers, and smooth the joints. Then throw a handful of salt into 2 quarts of water in a wide pot and bring it to a gentle boil. Meanwhile, preheat your oven to 450 degrees, and oil a large cookie sheet. Now boil the bagels 2 to 3 minutes on each side, drain them, and brush them with a mixture of 1 egg beaten with a tablespoon of cold water. Sprinkle with coarse salt. Arrange the bagels on the cookie sheet and bake them 15 to 20 minutes or until golden brown. You'll like them!

SELECTED BIBLIOGRAPHY OF
ALLAN KAPROW'S WRITINGS ON ART

1952 "Piet Mondrian: A Study in Seeing." Master's thesis, Columbia University.

1958 "The Legacy of Jackson Pollock." *Art News* 57, no. 6: 24–26, 55–57.

"Notes on the Creation of a Total Art." In catalog for Environment, Hansa Gallery, New York (November).

"One Chapter from 'The Principles of Modern Art.'" *It Is* (New York), no. 4: 51–52.

1960 "Some Observations on Contemporary Art." In catalog for the exhibition New Forms-New Media I. Martha Jackson Gallery, New York (October).

1961 "'Happenings' in the New York Scene." *Art News* 60, no. 3: 36–39, 58–62. Reprinted in *Design Annual* (Bombay), July 1962, and, in Dutch with the title "Happenings in New York," in *Randstad* (Amsterdam), nos. 11–12 (1966): 250–60.

Statement. In catalog for the exhibition Environment, Situations, Spaces. Martha Jackson Gallery, New York (June).

1963 "Impurity." *Art News* 61, no. 9: 30–33, 52–55.

Untitled essay on George Segal. In catalog for George Segal exhibition, pp. 16–19. Ileana Sonnabend Gallery, Paris (October–November).

"The World View of Alfred Jensen," *Art News* 62, no. 8: 28–31, 64–66.

"Effect of Recent Art upon the Teaching of Art." *Art Journal* 23, no. 2: 136–38.

1964 "Segal's Vital Mummies." *Art News* 62, no. 10: 30–33, 65.

"Should the Artist Be a Man of the World?" ["The Artist as Man of the World"]. *Art News* 63, no. 6: 34–37, 58.

1965 "Daniel Spoerri." In catalog for Daniel Spoerri exhibition. Green Gallery, New York (March).

Statement in "Recent Kinetic Art." In Katherine Kuh, *The Nature and Art of Motion*. New York: Braziller.

1966 "Hans Hofmann." *Village Voice*, February 24, 1–2.

"The Happenings are Dead: Long Live the Happenings!" *Artforum* 4, no. 7: 36–39. Reprinted in French in *Aujourd'hui: Art et architecture* (Paris, January 1967).

"Experimental Art." *Art News* 65, no. 1: 60–63, 77–82.

Assemblages, Environments, and Happenings. New York: Harry N. Abrams.

Untitled manifesto. In *Manifestos*, 21–23. A Great Bear Pamphlet. New York: Something Else Press.

Letter to the Editor. *Tulane Drama Review* 10, no. 4: 281–83.

"The Creation of Art and the Creation of Art Education." *A Seminar in Art Education for Research and Curriculum Development*. Edward L. Nattil, Project Director, Cooperative Research Project. Pennsylvania State University, University Park, Pennsylvania, v-002, pp. 74–85.

1967 "Where Art Thou, Sweet Muse? I'm Hung Up at the Whitney." In "Death in the Museum." *Arts Magazine* 41, no. 4: 40–41.

"The Best Use of the Past (and Present) is Misuse." Statement printed without title in "Jackson Pollock: An Artists' Symposium, Part 1." *Art News* 66 no. 2: 32–33, 59–61.

"The End of the Concert Hall." Introduction to a dialogue between Max Neuhaus and students. *Statesman* (State University of New York at Stony Brook), May 3.

"Pop Art: Past, Present, and Future." *Malahat Review* (University of British Columbia), no. 3: 54–76.

"What Is a Museum?" Dialogue with Robert Smithson. *The Museum World*, no. 9: 94–101.

"Pinpointing Happenings." *Art News* 66, no. 6: 46–47.

1968 "The Shape of the Art Environment." *Artforum* 6, no. 10: 32–33.

"Nam June Paik." Catalog essay for Paik exhibition, Bonino Gallery, New York (April).

1971 "The Education of the Un-Artist," part 1. *Art News* 69, no. 10: 28–31.

1972 "The Education of the Un-Artist," part 2. *Art News* 71, no. 3: 34–39.

1973 "Stephen von Huene." In the exhibition catalog *Sound Sculpture*. Vancouver, B.C.: Vancouver Art Gallery.

"Dr. MD." In the exhibition catalog *Marcel Duchamp*. New York: Museum of Modern Art.

1974 "The Education of the Un-Artist," part 3. *Art in America* 62, no. 1: 85–89.

"Video Art: Old Wine, New Bottle." *Artforum* 12, no. 10: 46–49.

"Formalism: Flogging a Dead Horse," *Quadrille* (Bennington College) 9, no. 1: 24–28.

"A Stone Dropped into a Still Pond." Catalog essay for Barbara Smith exhibition, University of California, San Diego (November).

1975 "Animation: Stephen von Huene's Sound Sculptures." In *Sound Sculpture*, edited by John Grayson. Vancouver, B.C.: A.R.C. Publications.

1976 "Non-Theatrical Performance." *Artforum* 14, no. 9: 45–51.

1977 "Participation Performance." *Artforum* 15, no. 7: 24–29.

"Roy Lichtenstein." Introductory essay and commentary in the catalog for the Lichtenstein exhibition, California Institute of the Arts (April–May).

1979 "Milan Knížák (Who Never Fell in Love with Art)." Introduction to *Milan Knížák, Vollständige Dokumentation*. Berlin: Edition Ars Viva!

"Performing Life" and reprints of *Routine* (1973), *Maneuvers* (1976), *Testimonials* (1976), and *Standards* (1978). In *Performance Anthology—Source Book for a Decade of California Performance Art*. San Francisco: Contemporary Art Press.

1983 "The Real Experiment." *Artforum* 12, no. 4: 37–43.

1984 "Once Again, Learning Life." *Journal of Education* (Boston University) 166, no. 2: 196–98.

1986 "Art Which Can't Be Art." In the exhibition catalog *Allan Kaprow 1986*. Dortmund: Museum am Ostwall (August 24–October 5), 17–19.

1987 "Right Living." In the exhibition catalog *A Tribute to John Cage*, for Chicago International Art Exposition. Cincinnati, Ohio: Carl Solway Gallery (May–June).

1988 "Horse Feathers Still." In the exhibition catalog for Nouveau Realists. Zabriskie Gallery, New York/Paris (May 17–July 8).

1989 Untitled essay on Andy Warhol ["The Disturbing Lesson of Andy Warhol"]. In the catalog for the exhibition Andy Warhol, A Retrospective. Museum of Modern Art, New York (February 6–May 2).

"The Persimmons of Mu Ch'i" (in German). *Zeit Magazin* (*Die Zeit*, Hamburg), April 14.

1990 "Tail Wagging Dog." *The Act* (Against the Spectacle—Private and Inter-Personal Experiment, Social and Political Activity, New York) 2, no. 1.

"The Meaning of Life," *Artforum* 28, no 10: 144–49.

1991 "Pierre Restany." Facsimile of handwritten article. In the catalog for the exhibition Pierre Restany—Le Coeur et la raison, Musée des Jacobins, Morlaix, France (July 12–October 10).

"Introduction to a Theory": *Beauty Parlor* (1957/58); *Apple Shrine* (1960); *Stockroom* (1960); *Yard* (1961); *Words* (1962); *Push and Pull* (1963); *Eat* (1964). New commentaries on the reinvention of the past. In *Bull Shit* 1, news bulletin for the exhibition 7 Environments, Fondazione Mudima, Milan (September).

INDEX

Abstract Expressionism, 29, 47, 66, 70, 92, 127

Abstraction, xiii, xiv, 223; Art art and, 101; neoclassical, 66

Abstract Symbolism/Colorfield painting, 67

Academic formalism, xvii, 156

Academic positions, for artists, 52, 178

Academic training, 76

Acconci, Vito, 139, 140, 149

Action painting, 17, 64, 66, 176, 208

Activities, 110, 128, 142, 174, 196; *Calendar*, 120; *Charity*, 122; *Maneuvers*, 191–94; preparing, 190–91; *Runner*, 115; *7 Kinds of Sympathy*, 165–68

Activity Happening, 87

African carved figures, 206–7

Agon, play in form of, 121–22

Albers, Josef, 66

Alm, Helen, 137

America, 22, 23–24; Action painting, 17; melodrama, 24; melting pot, 73; museums, 56; pragmatism, xi, xxiv; success, 22–25

Antiart, 81, 99–100, 101

Antiartist, 229

Antiform, xv, 90–93, 156–57

Antiformalism, xiv, xv, 156–61

Antigeometry, 93

Antihero, Jarry's portrait of, 141

Antin, David, 146–47

Aristocrats, 48, 56

Aristotle, 154

Arp, Jean, 29, 35

Art, 81–83, 99, 128, 201–2; artlike, 201–6, 215–16, 217–18; Body, 204, 223; de-

arted, 128; defined, xxiii, 216; developmental, 68, 69–70; dying, 102; Earth, 204; easy, 98; Happenings and, 16–26, 62, 64–65, 87; high, 140, 206, 207–8, 219, 230, 236; intelligent, 127; Land, 223; and life, 75, 81, 82, 87, 111, 140, 201, 204; mass-media, 204; middle-class, 57; modern, 68, 69–70, 71–72, 207, 223; nonart dialectic with, 98–99; participatory, xiv, xvii–xviii, xxii–xxiii, 152–53, 181–94; performance, 174–76; privacy of, 125; quasi-, 62, 87, 127; reciprocity in, xvii–xviii; seer role, 125, 217; Site, 98; social context and surroundings, 94; total, 10–12, 62; un-artists and, 104, 229–30, 236; video, 148–53, 204; work, 118, 126. *See also* Antiart; Art art; Avant-garde; Experimental art; Lifelike art; Nonart; Un-artiness

Art art, 68, 98, 100–102

Art artists, 74, 75, 102

Artaud, Antonin, 48

Art criticism: psychology of process in, 27; and un-art, 107–8

Artists, 81–82; academic positions for, 52, 178; anti-, 229; Art artists, 74, 75, 102; artlike, 232, 236; as Beats, 47–48; Body, 203; as creation, 144–45; developmental, 69; experimental, xxiii, 69–78, 229–30; and failure, 19–20; and fame, 22–26, 51–52, 211–12; as geniuses, 47–48; as intellectuals, 47–48; leadership positions, 51–53; modern, 46–58; performance, 177–79; postal, 203; replicated, 144–45; as

247

Whitman, Robert, 92, 137; *American Moon* (illus.), 21
Whitney Museum, Anti-Illusion: Procedures/Materials, 101
Whole, "sense of"/"symposium of," 216–17
Williams, Emmet, *Sweethearts*, 134
Wilson, Robert, 173
WOR-FM, 84
Work: art, 118, 126; education and, 120; home, 116–19; play vs., 115, 116, 119, 122–23, 126
Workweek, 117–18
Worldview: Cage's vs. myth of tragic

sufferer, 225; nonart, 208. *See also* Culture; Philosophy; Value

Young, La Monte, 102–3; *Anthology*, 61; *Draw a Straight Line and Follow It*, 134

Zazen, 218
Zen, xxiv, xxv, 127–28, 218; Cage and, xxiv, 140, 160; Fluxus events and, 170, 184; Happenings and, 184; and Pollock, 7
Zoo art, 204

Compositor:	Wilsted & Taylor
Text:	10/11 Granjon
Display:	Granjon
Printer:	Malloy Lithographing
Binder:	John H. Dekker & Sons